Hannah Wilke

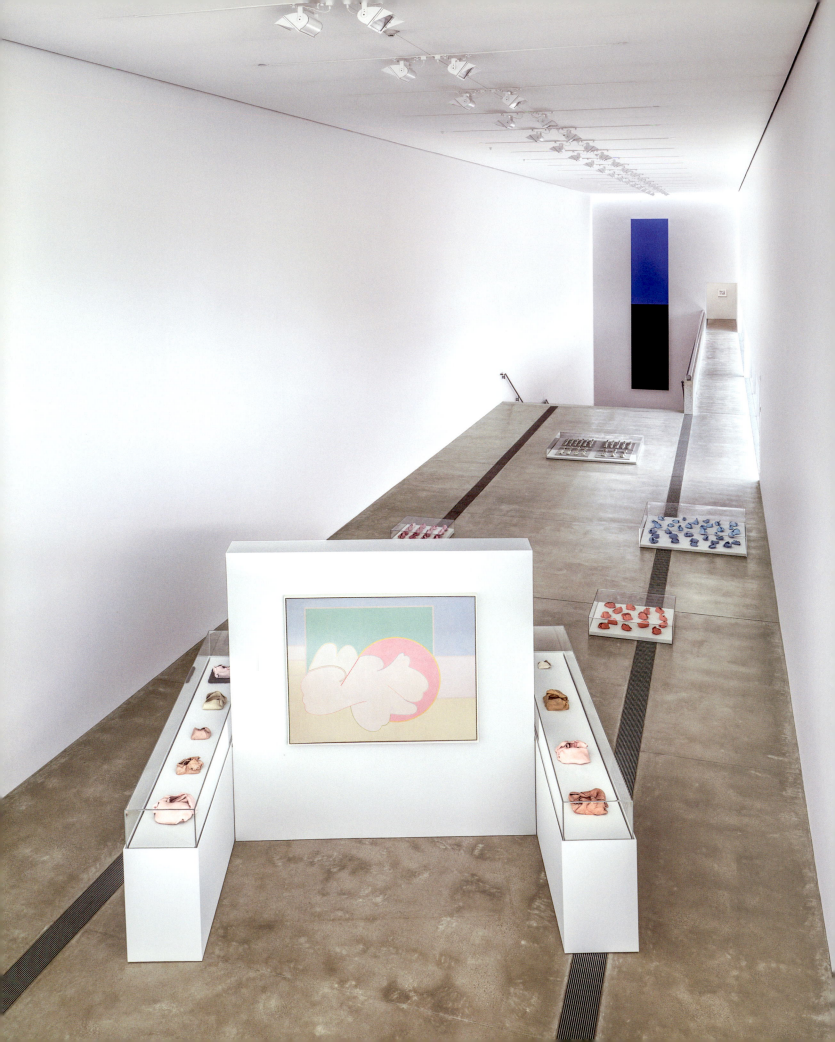

Hannah Wilke:
Art for Life's Sake

Edited by Tamara H. Schenkenberg and Donna Wingate

Texts by Glenn Adamson, Connie Butler, Hayv Kahraman,
Nadia Myre, Cindy Nemser, Jeanine Oleson, Catherine Opie,
and Tamara H. Schenkenberg

Pulitzer Arts Foundation
In association with Princeton University Press
Princeton and Oxford

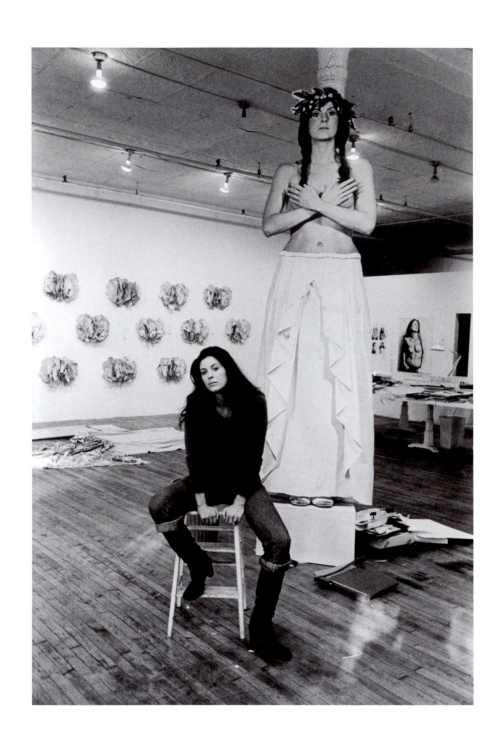

Director's Foreword

Hannah Wilke's innovative art and her trailblazing, highly individualized feminism were intimately connected. Over the course of her career, she developed a new visual language to express the vitality and vulnerability of the body and push against repressive norms of gender and sexuality. Her achievements deeply inspired and guided the Pulitzer Arts Foundation's exhibition *Hannah Wilke: Art for Life's Sake* and this accompanying publication. Wilke's groundbreaking expressions of her ideas about self-love, affirmation of life, and women's agency remain compelling today. We are honored to present this significant exhibition of her work, which considers her accomplishments in the context of the contemporary moment. In recognition of the ongoing resonance of Wilke's work, the Scintilla Foundation awarded this exhibition a generous grant. The Pulitzer also joined the Feminist Art Coalition, an initiative for art projects that foreground feminist history, thought, and practice.

Tamara H. Schenkenberg, Pulitzer Curator, organized the exhibition, which features nearly 120 works spanning Wilke's career. I appreciate her immense dedication, sensitive visual storytelling, and nuanced analysis. I thank Katherine B. Harnish, Pulitzer Curatorial Assistant, for critical and extensive support throughout the research, writing, and editing processes, especially for her work on the chronology and bibliography. My gratitude extends to those who shared their expertise and unique perspectives for this catalogue: art historians Glenn Adamson and Connie Butler; artists Hayv Kahraman, Nadia Myre, Jeanine Oleson, and Catherine Opie; Hannah Wilke's nephew Andrew Scharlatt, for his incisive research and coordination of archival materials; and Wilke's sister Marsie Scharlatt for her work on the chronology and all aspects of the catalogue. We are very pleased to include a previously unpublished interview between Wilke and art historian Cindy Nemser, which we accessed with the help of Tracey Schuster, Head of Permission and Photo Archive Services, and Emily Park, Library Assistant, the Getty Research Institute. Danielle Kronmiller, Pulitzer Curatorial Administrative Assistant, transcribed the interview, and Donna Wingate and Marsie Scharlatt edited it with great thoughtfulness.

Without the generous collaboration of the Hannah Wilke Collection & Archive, Los Angeles, headed by Marsie Scharlatt and Andrew Scharlatt, this exhibition could not have happened. The Scharlatt family, including Emmy Scharlatt and Damon Scharlatt, has my earnest appreciation for their gracious lending, commitment to this exhibition, and passionate stewardship of Wilke's legacy.

I greatly appreciate Alison Jacques, of Alison Jacques, London, who has represented the Hannah Wilke Collection & Archive internationally for more than a decade. I am grateful for her invaluable assistance, as well as that of Michael Brzezinski, Director, and Fiona Amitai, Senior Director, who facilitated many of the loans. I also thank Michael Solway, of Solway Jones, and

Marc Selwyn and Andy Brown, of Marc Selwyn Fine Art, for their representation of the Hannah Wilke Collection & Archive.

I warmly thank Donald and Helen Goddard for their substantial support of this exhibition and conscientious preservation of Wilke's work and memory. Their generous loans are deeply appreciated and have contributed to this project significantly. Ronald Feldman Gallery has long represented Wilke's work and championed her career, and Ronald and Frayda Feldman have my sincere appreciation for this indispensable work. I also thank Marco Nocella, Director at Ronald Feldman Gallery, for his deep knowledge of Wilke's work and his instrumental cooperation.

Hannah Wilke: Art for Life's Sake brings together works from numerous institutions and private collections. For their generous loans, I gratefully acknowledge Maria Balshaw, Director of Tate; Mary Ceruti, Executive Director of the Walker Art Center; Shezad and Miranda Dawood; Gail and Tony Ganz; Donald and Helen Goddard; Claudia Gould, Helen Goldsmith Menschel Director of The Jewish Museum; Michael Govan, CEO and Wallis Annenberg Director of the Los Angeles County Museum of Art; Marguerite Steed Hoffman; Alison Jacques; Cameron Kitchin, Louis and Louise Dieterle Nippert Director of the Cincinnati Art Museum; Edward Lee; Glenn D. Lowry, David Rockefeller Director of The Museum of Modern Art; Larry and Susan Marx; Heidi and Erik Murkoff; Marsie Scharlatt; Marsie, Emanuelle, Damon, and Andrew Scharlatt; Tom and Alice Tisch; Teresa Tsai; Olivia Walton; Michael and Sharon Young, and those lenders who wish to remain anonymous.

We are indebted to the many talented and thoughtful people who collaborated or consulted on this publication. We are grateful to our collaborators at Princeton University Press, in particular, Michelle Komie, Publisher, and Kenny Guay, Editorial Assistant, for their support throughout the publication process. We also thank Donna Wingate and Marc Joseph Berg of Artist and Publisher Services, this catalogue's diligent and thoughtful editors; Jayme Yen, for this stunning book design; Gina Broze, image rights specialist; and Tom Eykemans, Leah Finger, Kim Kent, Adrian Lucia, and Kestrel Rundle, our expert publication coordinators at Lucia | Marquand.

The Pulitzer's talented staff have supported this exhibition in numerous ways. My profound appreciation goes to Registrar Natalie M. Foster, Lead Preparator Steve Gibbs, Assistant Registrar and Publications Manager Brittny Koskela, Director of Exhibition Design and Installation Shane Simmons, Curatorial Associate Heather Alexis Smith, Associate Curator Stephanie Weissberg, and our gifted colleagues in Marketing and Communications, Public Engagement, and Visitor Services. In closing, I extend my admiration and gratitude to Board Chair Emily Rauh Pulitzer and to all members of the Pulitzer's Board of Directors. Such substantial projects are made possible through their astute and enthusiastic support.

Cara Starke

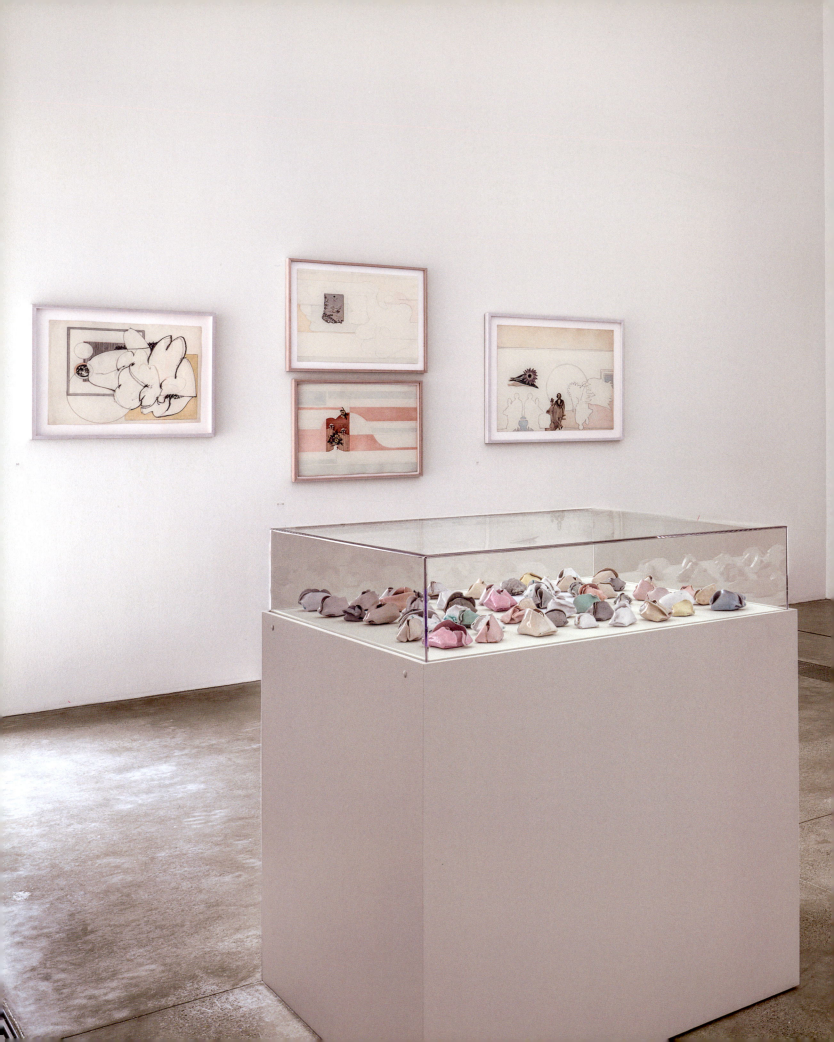

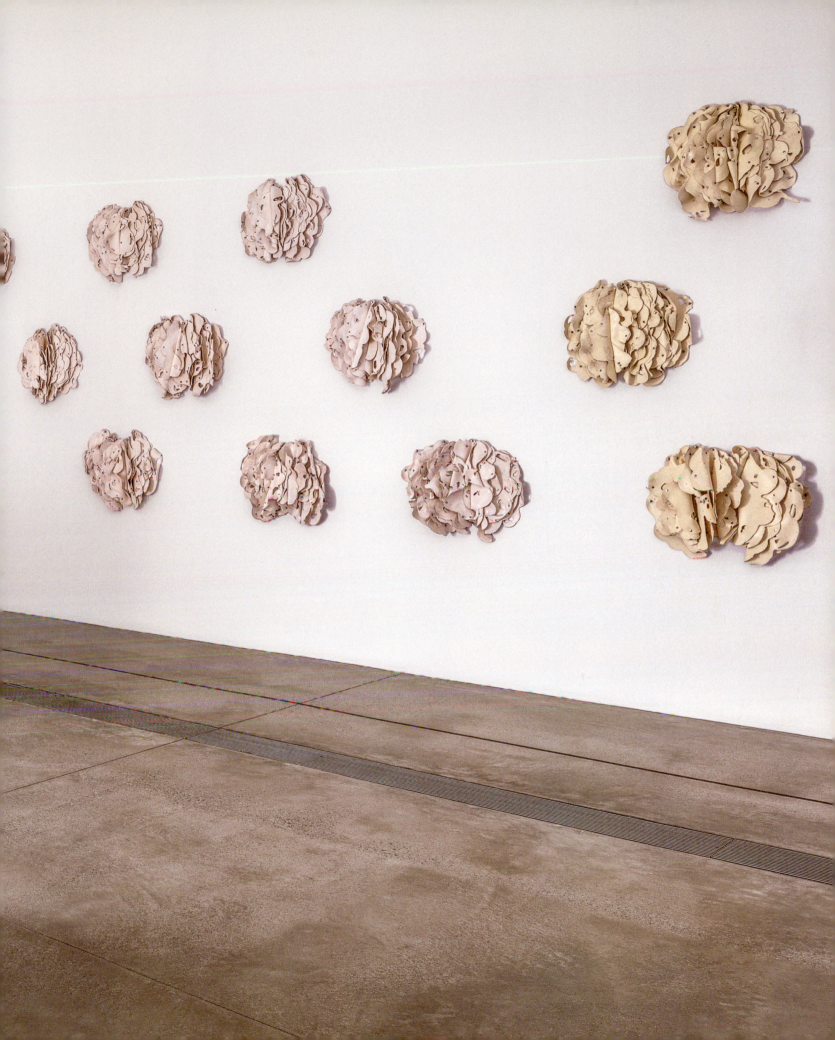

EROS
AND
ONENESS

Tamara H. Schenkenberg

The American artist, feminist trailblazer, and provocateur Hannah Wilke (1940–1993) rattled the art world with her bold vaginal- and vulva-themed sculptures and unabashed, boundary-crossing art practice in sculpture, photography, video, performance, painting, and drawing.[1] Almost as soon as she began showing her art—and all throughout her three-decade career, cut short by her untimely death from cancer in 1993—critics and scholars alike had characterized her work as erotic, a useful description that deserves greater scrutiny.[2] Having delved deeply into Wilke's work, the existing materials, and documentation on this remarkable woman to organize *Hannah Wilke: Art for Life's Sake* for the Pulitzer Arts Foundation, it is my hope here to expand upon these extant ideas of eroticism in her work, and to anchor them in the distinct motivations and techniques of the artist.

What makes Wilke's art erotic? As she insisted, and as her work bears out, it is not simply a question of subject matter. Looking closely at the development of her work during the early years of her practice, it becomes clear that the erotic found its way into her approach to form and not merely into her iconography.

In 1960, long before she was known as Hannah Wilke, a young Arlene Hannah Butter constructed *Five Androgynous and Vaginal Sculptures* while still a student at Stella Elkins Tyler School of Fine Arts near Philadelphia (FIG. 1). Working with her hands, fingers, and simple tools, she shaped clay into vessel-like forms to suggest bodily orifices and genitalia. Wilke started

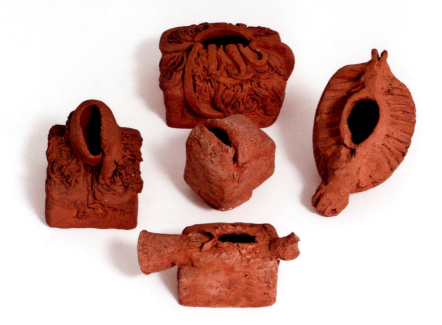

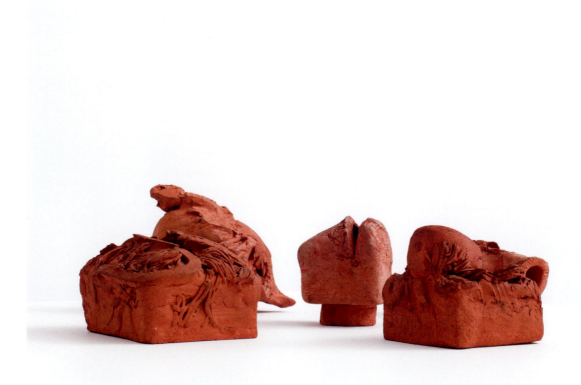

FIG. 1
Five Androgynous and Vaginal Sculptures, ca. 1960–64
Terracotta
Dimensions variable

her sculptures with a flat base and built up the sides by attaching slabs of clay, smoothing over the seams to create objects that appear solid except for their narrow, ovoid mouths at the top. The evocative surfaces of these particular forms come from Wilke's repeated scorings and dense clottings of extruded clay to accentuate the sensuous, bark-like terracotta. Through these richly varied textures Wilke endowed the work with a hefty sense of physicality, despite the modest scale of the individual objects. By the mid-1960s, she came to call this type of square-based sculpture her "boxes"—a term that refers to their underlying form but also acts as a pun with its playfully provocative double-meaning as slang for vagina.

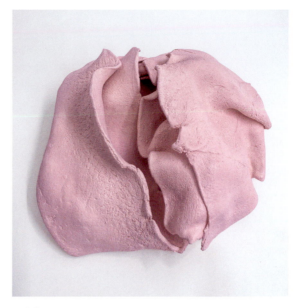

FIG. 2
North American Candle Snuffer, ca. 1967
Terracotta
4 ⅞ × 10 ⅛ × 11 ¼ inches (12.4 × 25.7 × 28.6 cm)

Six years later, in 1966, Wilke started exhibiting her work in New York galleries. In the intervening period, her life underwent significant changes. After the sudden death of her father in 1961, she returned to New York (her birthplace) in 1965, started a new job, and divorced Barry Wilke—a man who, ashamed of the erotic nature of her artworks, routinely demanded that they be moved to the back room when visitors arrived.[3] While Wilke had supported herself as a high school art teacher in Pennsylvania and continued to do so in New York until 1970, there was a resolute shift in her career ambitions in the mid-1960s. It was at this point that she committed to making a living as an artist.[4] Perhaps as a part of these changes in her identity, she also began using her middle name, Hannah, instead of Arlene.

The work Wilke was producing at this point in her career shows her continued interest in the body and sexuality, but it expressed this subject matter through an entirely different approach. In *North American Candle Snuffer* (ca. 1967), for example, and her vaginal mid-1960s work in general, the quality of denseness is still present, but the vessel form gives way to layers (FIG. 2). The difference is profound. Here is Wilke in 1966, describing the shift in the first major review of her work:

> My earlier works were beautiful and sensual but *dead* [*emphasis mine*]. They didn't say "hi." Now the boxes are different. They have character and personality. Each is an expression of a different kind of mood. They flicker and fade, like, you know, human relations.[5]

It is significant that Wilke described her early works as "dead," faulting them for refusing to dialogue with the world around them. She contrasted these sculptures with her evolving approach to the box form—as seen in *North*

American Candle Snuffer—that she continued to develop into the late 1960s and early 1970s. By that point, she stopped smoothing over the seams of her slab construction so that the attached clay sheets became almost petal-like layers, creating much more open structures. Wilke described these new types of boxes in animate terms, having "character and personality." And indeed, we can see a new liveliness in the way the sculpture seems to be in the process of unfolding, revealing its complex nature to those who are willing to take the time.

The emphasis on life became a key aspect of Wilke's practice from this moment in the mid-1960s until her death in 1993. Because of this, Wilke's approach to addressing the body and sexuality stands apart from other artists who explored erotic art during and after the sexual revolution. Wilke was also dedicated to expressing the erotic from a woman's perspective, which is another major distinguishing factor, one that has been well established.[6] Not only did she sidestep the long tradition of objectifying the body understood to be female as a site of cisgender male scopic pleasure and help to establish vaginal and vulvic iconography alongside the more omnipresent phallic form, she also sought to articulate desire and sensuality that went beyond sexual arousal or attainment. By situating the body as a conduit for sexual pleasure *and also* as a dynamic, active entity unto itself, Wilke aligned her work with a far more layered concept of Eros, an idea grounded in the theoretical literature and radical cultural shift of her time.

In this essay, I will draw on Wilke's engagement with Eros toward a new line of interpretation. I will also explore the related concept of oneness—which describes the kind of interconnection that an embrace of Eros makes possible—that Wilke developed later in her career as a way of conceptualizing the idea of shared humanity. Through a close consideration of Wilke's works as well as her own words (especially from the previously unpublished interview with the influential writer and art historian Cindy Nemser, included in this volume on page 88), I will try to reveal a greater depth of meaning and the impressive internal cohesion between form and content in Wilke's project while also establishing a connective thread across her varied practice, showing how she turned to Eros as a wellspring for creativity and as a means for imagining a more just society in the latter half of the twentieth century.

◆

Over the course of her career Wilke embraced Eros as a critical concept in her work via multiple meanings of the term. Eros, of course, represents the libidinal drive and sexual gratification, but for Wilke, it also included a much broader understanding of the body as a means of connecting with life. She understood Eros as calling for a frank, intimate relationship to the body as a source of—and a basis for—life, and for a freedom from repression that enabled sensuous connections between the self and the world, leading to experiences of pleasure, joy, and fulfillment. As she succinctly put it, "Eros has to do with affirming life."[7]

Wilke's exploration of the vital connection between the body and life attained greater urgency due to her early and frequent experience with death through the loss of family members.[8] This informed her critical reading of a number of texts that became foundational to the sexually liberated, countercultural movement of the American postwar period. Of particular importance to her were written works from the 1950s by the social theorists Norman O. Brown and Erich Fromm, including Brown's *Life Against Death: The Psychoanalytical Meaning of History* (1959) and Fromm's *The Art of Loving* (1956). (She kept heavily annotated copies of these in her personal library.)[9] Wilke's own writings and interviews make clear that she especially related to the way Brown and Fromm broadened Freud's ideas about Eros (related to sexual instinct) into a more sweeping life instinct or drive for life, creativity, love, reproduction, and self-fulfillment.[10] Their expanded notions of Eros, aimed at overturning the repression of the body, critiqued and offered an alternative to the widespread alienation, anxiety, dissatisfaction, and conformity that Wilke saw in postwar American society.

Wilke adopted this view of Eros as a philosophy of personal liberation to free the body as well as the mind. As a mode of thought with healing powers, she saw it as counter to the coercive and dehumanizing forces of destruction and repression bolstered by patriarchy and the capitalist economic order, and as a pathway to more authentic forms of self-expression. In this way, Eros began to serve as a catalyst for a new form of art and political life, premised on interconnection, reciprocity, equality, and freedom. Wilke was not alone in her exploration of the personal, social, and political potential of Eros. From the late 1950s through to the 1970s, the discourse around Eros left a mark on the postwar generation—including the artist Carolee Schneemann, the composer John Cage, as well as writers Thomas Pynchon and Audre Lorde—who used it to explore and generate a new kind of knowledge, premised on the physical and psychic pleasures of the flesh.[11]

Eros, Wilke realized, had the potential to profoundly impact repressive realities for women across all sectors of society, including the art world. As she said in her 1975 interview with Cindy Nemser, "I think women will express something they might not have expressed before and maybe we have a better chance than men of making innovative statements."[12] Indeed, one of Wilke's most noted contributions to American art in the postwar period is her focus on subject matter that had long been eschewed as taboo: the vagina.[13] With this focus, she sought to draw a sharp contrast between her sculptures and works made by an earlier generation of women artists, such as Georgia O'Keeffe, who resisted sexual readings of her paintings, pointing instead to the form and style of her work. In contrast, Wilke openly acknowledged references in her work to the vagina and vulva—even as she preferred mostly abstract over graphic representations. Along with several other women artists of her generation, Wilke linked this iconography to her own experience of being a woman. She attempted to take what society had declared shameful, tasteless, and inferior and reclaim it as something positive and empowering—all while giving it a

beautiful form. Wilke voiced this intention in multiple interviews and writings, stating her desire to "wipe out the prejudices, aggression, and fear" associated with words like "pussy, cunt, box," which she often used to describe her forms.[14] In this way, she was aligned with a number of artists, poets, and performers—including Lenny Bruce, Anita Steckel, and Allen Ginsberg—who sought to push against the conservative attitude toward so-called obscenity and censorship.[15]

Wilke's groundbreaking use of vaginal and vulvic iconography as a feminist intervention is one testament to her embrace of Eros, but it is not the only one nor, in her mind, was it the most important. In her typical tongue-in-cheek fashion, she quipped, "Well, if I'm going to become the Pubic Princess of a new movement, I sincerely hope it will also include the awareness of its being innovative sculptural form, and not merely new subject matter."[16] As this suggests, Wilke's commitment to Eros can be found in the content as well as in the form of objects she created:

> Eros has to do with internal feeling…like when someone touches you in just the right way….I'm talking about light, about gravity, about expansion…making something sag, come down—that subtle change of weight, the idea of movement, pushing, pulling, opening up, closing. That's what creates Eros, these movements.[17]

This passage offers the clearest description of how to locate Eros in her work, pointing us in the direction of movement.

Wilke was at times frustrated by critics' oversight of the formal qualities of her work.[18] Taking her concern seriously, I'd like to offer a formal argument. A close examination of Wilke's work across decades and a wide range of media reveals how she mobilized basic visual elements—such as form, line, space, and perspective—to convey the revitalizing power of Eros. This new insight about the centrality of movement in Wilke's work upholds earlier scholarship that locates "the gesture" as a cornerstone of her practice, but it shifts the conversation to a different register.[19] Wilke believed that art could lead to Eros and that she, as the artist, could make choices to bring forth that experience into the world. I view these choices as a sophisticated set of formal strategies that permeate throughout Wilke's practice, imbuing it with movement and life. In this way, at the most primal level—the level of visual language—we find ample evidence of Wilke's commitment to Eros.[20]

We can begin our exploration of Wilke's engagement with Eros by returning to the period in the mid-1960s as she was moving on from her early experiments in clay, which she described as "dead," to her layered works. With *San Antonio Rose* (1966), one such sculpture, she created a lively tension between the inside and the outside (FIG. 3). Wilke described this new type of form as being "more about layers, skin-like layers and softness evoking flesh."[21] Layers here are represented by thick sheets of clay wrapped around a square base. Wilke coiled and nestled them into the sculpture's interior, which she articulated as a space of whirling energy. She then leavened the pull of the

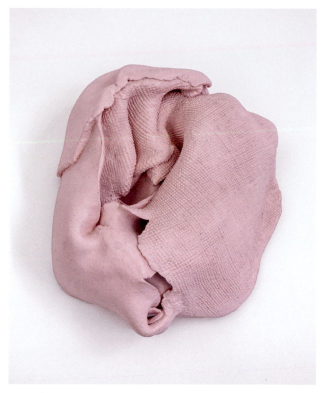
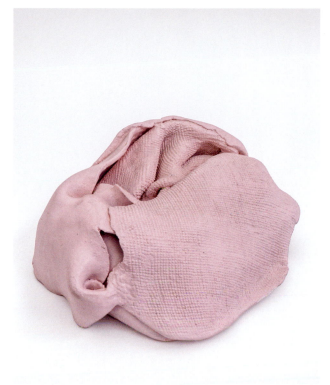

FIG. 3
San Antonio Rose, 1966
Painted terracotta
8 × 11 × 10 ½ inches (20.3 × 27.9 × 26.7 cm)

accumulated mass at the center through her handling of the clay on the exterior, as if it was fabric, in loosely hanging drapes and folds. The resulting push and pull—between the active interior and relaxed exterior, as well as between the two sides of the sculpture, one imprinted and the other smooth—creates a formal interplay that leads the eye across the work in dynamic motion.

A few years later, with *Yellow Rose of Texas* (1970), Wilke conveyed movement in a different way by suggesting a release of tension (FIG. 4). Instead of a dense overlay, her construction spills over. Here, she barely guided the clay into its position, staking out a slippery middle ground between form and formlessness. Along with the soft, yellow hue, her unfussy treatment of the clay endowed the sculpture with lightness, which she accented through uneven and cracked edges that create an undulating silhouette. These lips respond to the laws of gravity, rising and falling around the negative space that Wilke centered as a key part of the composition and as an active companion to the outer sheets of clay that direct us in and out of the cavity, especially when seen in the round. Her willingness to let go and the appearance of effortlessness demonstrated in this sculpture anticipates the sense of ease and vitality of

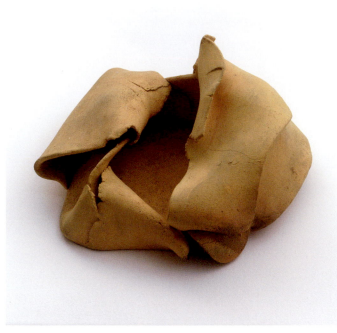

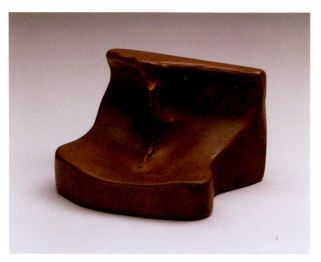

FIG. 5
Marcel Duchamp, *Female Fig Leaf*, 1950
Electroplated copper over plaster
3 ½ × 5 ¼ × 5 inches (8.9 × 13.3 × 12.7 cm)
The Museum of Modern Art, New York, Gift of Jasper Johns

FIG. 4
Yellow Rose of Texas, 1970
Painted terracotta
5 ¼ × 9 ½ × 9 inches (13.3 × 24.1 × 22.9 cm)

Wilke's later work in clay as she continued to defy the weight and solidity of traditional sculpture that her feminist practice sought to subvert.

Wilke's boxes invite a comparison to several works by Marcel Duchamp, an artist with whom Wilke consistently engaged through her work. Take, for example, his *Female Fig Leaf* (FIG. 5), most likely a positive cast of the imprint taken from the groin of the naked figure from his final project, *Étant donnés* (1946–66). By reversing the concave and convex spaces of the vagina, Duchamp punned on a fig leaf's ability to conceal by making visible the vaginal opening that is generally hidden from view. Wilke's boxes play a similar game of revealing the unseen, but through an entirely different spatial order. Although fleshy, her works eschew the solidity of Duchamp's work in metal in favor of layers that open up the sculptural object. The resulting negative spaces are far from inert voids, however. Wilke set up clay layers in creative and reciprocal tension to these openings to enliven the sculpture so that it could, as Wilke put it, "say hi." These activated depths thereby counter Freud's definition of the vagina as "lack," emphasizing instead its form as a lively expression of the vitality of Eros.

Parallel to the evolution of ceramic sculptures, Wilke's dynamic (and somewhat lesser-known) works on paper from the same period further clarified her ongoing efforts to introduce an ever-greater sense of movement into the work as an index of Eros. An early untitled drawing from 1960 (FIG. 6) shows a similar density to *Five Androgynous and Vaginal Sculptures* created in the same period (FIG. 1). Stylistically, this work bears resemblance to the paintings of Abstract

FIG. 6
Untitled, 1960
Pastel, paint, and pencil on board
20 × 29 ⅞ inches (50.8 × 75.9 cm)

Expressionists such as Robert Motherwell, with his biomorphic forms and floating fields of color. In this shared language, we see the seeds of Wilke's interest in movement. Fields of red pigment push toward and even exceed the edges of the composition, creating a sense of seeping horizontality. These densely saturated fields give way to bulging forms that outline areas of blank paper, sparsely populated by twitching lines and smaller, rounded shapes. Although the imagery teeters on abstraction, Wilke suffused it with bodily connotations that sidestep any singular reading, interchangeably alluding to breasts, buttocks, scrotums, knees, shoulders, and phalluses. The fluid movement among body parts calls to mind the fast-paced sequences of Carolee Schneemann's 1965 film

FIG. 7
Carolee Schneemann, still from *Fuses*, 1965
16mm film, transferred to video (color, silent), 18 min.
Private collection

Fuses in that it captures the desiring energy of sexual union along with an openness toward a body that blurs gendered distinctions (**FIG. 7**). "I edited the sequences," Schneemann has said, "so that whenever you were looking at the male genital it would dissolve into the female and vice versa."[22] Similarly, in Wilke's drawing, the suggestive slippage of forms evokes a sense of motion as

FIG. 8
Untitled, ca. mid-1960s
Pastel and pencil on paper
18 × 24 inches (45.7 × 61 cm)

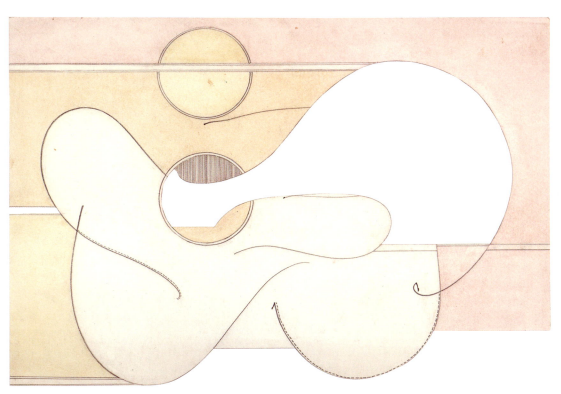

FIG. 9
Untitled, ca. late 1960s
Pastel and pencil on cut-out paper
16 × 23 inches (40.6 × 58.4 cm)

an amorphous colliding and merging, which not coincidentally occurs in the portions of the composition that read as openings in the red expanse. Seen here in its nascent form, the strategy to convey movement through openings is one that Wilke continued to hone as her practice developed.

In later drawings from the mid-1960s, Wilke further opened and lightened her compositions, with air and space contributing their potential suggestions of movement (FIG. 8). Despite a vast shift in style, we see the same bulging forms infused with bodily connotations, although now streamlined. The dense scattering of marks and textured impasto of primary colors give way to finely penciled horizontal bands. Against this background of delicate shades of pink, Wilke suspended an inchoate form, which she intersected with circles that further lend the work an air of soaring and sweeping motion. Like a lung constantly filling with and emptying of breath, the void at the center is the site of gentle flux. Here, the luminosity of the paper shines through, showcasing—much like with *Yellow Rose of Texas* (FIG. 4)—Wilke's interest in filling the negative space with meaning and erotic lyricism.

Wilke sought to breathe movement into her drawings by exploring the potential of the void in other ways as well. This is evident in a body of works on paper from the mid- to late 1960s that have never been on display, in which Wilke followed her interest in openings to its logical extreme, actually cutting the sheet. In one such untitled work, she echoed iconographic elements that mark this period—compositions of horizontal strips flooded by subtle pastel colors and interrupted by a free-flowing, biomorphic form—but this time she also cut into the drawing along the bottom and center (FIG. 9). In doing so, she opened up the arrangement, literally shedding weight and allowing air and light to pass through the surface. This act of cutting also disrupts the paper as the domain of solidity and stasis, activating the space with perforations to underscore the rhythm of expansion and contraction that is already present in the image.

Concurrently, Wilke also experimented with an additive approach in a number of collages to convey movement through a call-and-response-like interplay between parts of the composition. A prime example is *Wishing You a Very Happy Easter*, which consists of two elements: a drawing featuring her repertoire of curving lines commingling with softly hued, horizontal bands, and a sentimental, vintage Easter greeting card (FIG. 10). She traced the lacy contours

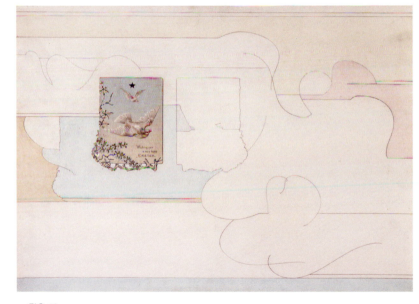

FIG. 10
Wishing You a Very Happy Easter, 1971
Pastel, pencil, and collage on paper
18 × 24 inches (45.7 × 61 cm)

of the card, mirroring it in its entirety to the right and drawing a partial outline below and to the left of the card. In this way, Wilke riffed on the idea of implied movement, prompting us to imagine her hand sliding the card across the paper before arriving at its final position. Calling on viewers to look again and again at the card and the way in which her drawing echoes and elaborates on it—seeming to dance around it—she asked us to negotiate these two visual fields and their different spatial and material realities. This kind of responsive movement visualizes the relational quality of Eros as a mode of connection that, just like greeting cards, brings us together with other people and the world at large.

Through her play with doubling, mirroring, repetition, and especially the dichotomy between various physical planes, Wilke's greeting card collages are related to an innovative body of work made with vintage postcards and kneaded erasers. Here, she stretched and folded kneaded erasers into delicately shaped vulvas, strategically placing these tiny sculptures onto postcards depicting cityscapes, landscapes, and architectural monuments. For Wilke this simultaneously implied that women have been erased from the public sphere while imaginatively presenting the exciting potential of their inclusion. Her wryly subversive intervention has been described by one reviewer as "a fantasy of female power and creativity infused into the world of architecture and nature,"[23] or, in other words, a corrective way of visualizing a society that is inclusive of women. Such a society, as conceived by Wilke, would be the natural result of the widespread embrace of Eros, where women would be free from the repressive nature of patriarchy.[24]

We can see this message of freedom and release at the formal level through Wilke's placement of kneaded eraser sculptures, which seem to flout the traditional rules of gravity and perspective. She described these works as "things floating that shouldn't be floating."[25] We can see such weightless and soaring suspension in works such as *Seashore* from 1975 (FIG. 11). On the one hand, Wilke placed the erasers in this work as a complement to the postcard image, echoing and nuzzling them against the sinuous geometry of the coastline. On the other hand, their different sizes and orientations result in meandering lines and drifting patterns that convey a tumbling sense of restlessness. Wilke mobilized these jauntily erratic swarms to disrupt the tranquil postcard panorama in humorous defiance of the burdens of gravity. She practiced a more harmonious mode of incursion in *Roma Coliseum* of 1974 (FIG. 12). Here the erasers repeat and extend the oval structure of the amphitheater beyond the space of the postcard to bring to life the unrepresented parts of the historic landmark. She thus completed the loop, overcoming the division between disparate pictorial surfaces that are marked by a contrast between a flat postcard and architectonic and fleshy erasers. Both kneaded eraser postcard assemblages imagine the revolutionary potential for women to move and create without societal restrictions weighing them down.

Wilke's sculptures in latex from the 1970s are perhaps the most dramatic realizations of her interest in activating line, layering, expansion, and gravity.

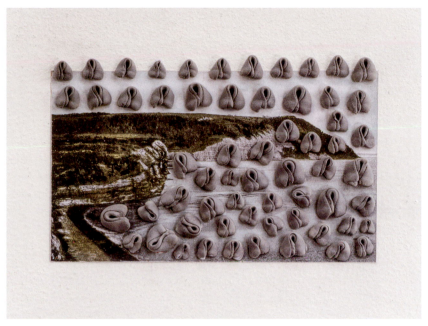

FIG. 11
Seashore (detail), 1975
Kneaded erasers on postcard and painted board in Plexiglas box
Overall 15 ¾ × 17 ¾ × 2 inches (40 × 45.1 × 5.1 cm)

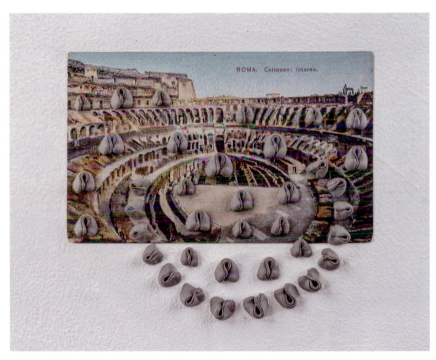

FIG. 12
Roma Coliseum (detail), 1974
Kneaded erasers on postcard and painted board in Plexiglas box
Overall 15 ¾ × 17 ¾ × 2 ⅛ inches (40 × 45.1 × 5.4 cm)

She created this body of work by pouring, folding, and snapping together layers of the pliable material. Like many other artists of the Post-Minimalist generation, including Robert Morris and Lynda Benglis, she engaged in ideas of process and leveraged the malleability of soft materials toward innovative form. All of Wilke's latex works create the effect of blossoming and unfolding, but over the years of her engagement with this material, we see an evolution in the kind of movement she imbued in her sculptures. Initially, she poured latex into long strips that, when gathered together into a sculpture, yielded fluid forms, gracefully drooping with pendulous weight (**FIGS. 13 AND 14**). In contrast, she eventually turned to pouring circles—which resembled her earlier cut-out works on paper (**FIG. 9 AND P. 147**)—that in their assembled multilayered forms tended to hang more horizontally, as seen in *Pink Champagne* (**FIGS. 15 AND 16**). This, coupled with their projecting, uneven undulation, shored up a different type of movement: a gentle propulsiveness that has been described as "unfolding outwards"[26] toward viewers but also

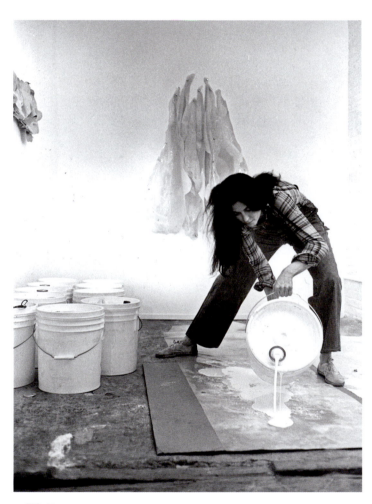

FIG. 13
Hannah Wilke pouring latex in her Broome Street studio, New York, 1972
Hannah Wilke Collection & Archive, Los Angeles

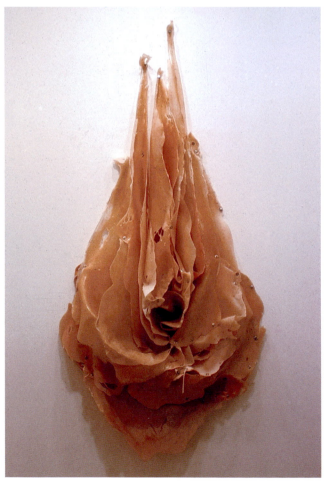

FIG. 14
Venus Cushion, 1972
Latex
Artwork no longer extant
Image, Hannah Wilke Collection & Archive, Los Angeles

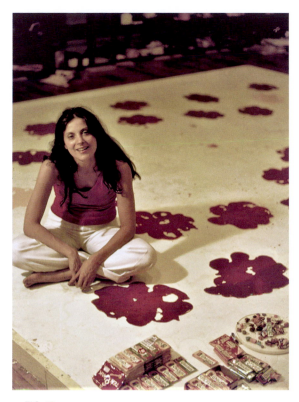

FIG. 15
Hannah Wilke in her Greene Street studio, New York, 1975
Hannah Wilke Collection & Archive, Los Angeles

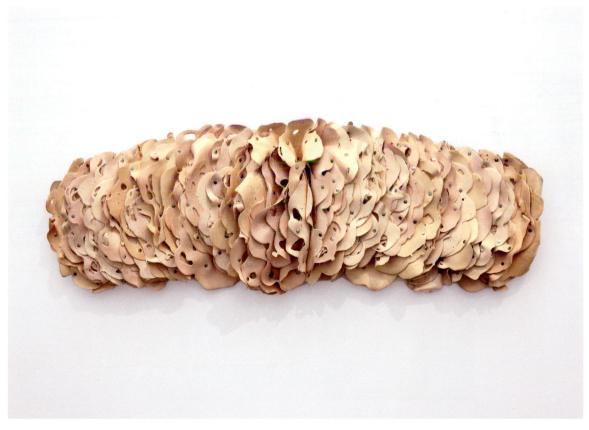

FIG. 16
Pink Champagne, 1975
Latex with snaps
18 × 54 × 7 inches (45.7 × 137.2 × 17.8 cm)
Collection of Marguerite Steed Hoffman, courtesy Alison Jacques

as "floating upward, like a cloud."[27] This multidirectional expansion comes out of the wall and reaches forward, seemingly in pursuit of a sensuous exchange. As the critic Douglas Crimp said, they "provoke an irrepressible desire to touch them."[28]

The latex sculptures unabashedly celebrate the body, especially the flowing softness of labia. Indeed, Wilke spoke about these works as giving form to the experience of orgasm, which she described as "a feeling of getting beyond oneself."[29] But she also clarified that her latex sculptures had to do with "…movement, liquid movement…That's more important than saying it's a cunt, because *the idea of life is about movement* [emphasis mine]."[30] Underlying both of these statements was Wilke's concept of Eros, the desire to connect with and experience the world through the body as an instrument for pleasure.

Wilke reinforced this idea by photographing herself topless in front of a number of latex works. By posing with her sculptures, Wilke asserted her agency over the representation of her own body, critiquing, as she did so often in her photographic work, the objectification of women's bodies in art and in society. Here, she also highlighted the more formal, physical, and psychic connections between her body and sculpture but further, perhaps, sought to capture a more reciprocal flow of energy between herself, her sculptures, and the world that surrounds them (**FIGS. 17 AND 18**). This joyful convergence was extended to the viewers as well. As Wilke explained, "When you look at the layers of latex, you can still see each individual layer and become part of it."[31]

The idea of a sensuous union between artworks and viewers brings us back to Wilke's sculpture in clay and the new mode of form-making that she had developed in the early 1970s. This body of work, which she described as "one-fold" or "two-fold" sculptures, refers to her handling of the material, whereby she shaped a flat circle of clay into a three-dimensional form with just a few swift movements of her hand. Works such as an untitled sculpture

FIG. 17
Hannah Wilke with *Ponder-r-rosa 4, White Plains, Yellow Rocks*, 1975
Hannah Wilke Collection & Archive, Los Angeles

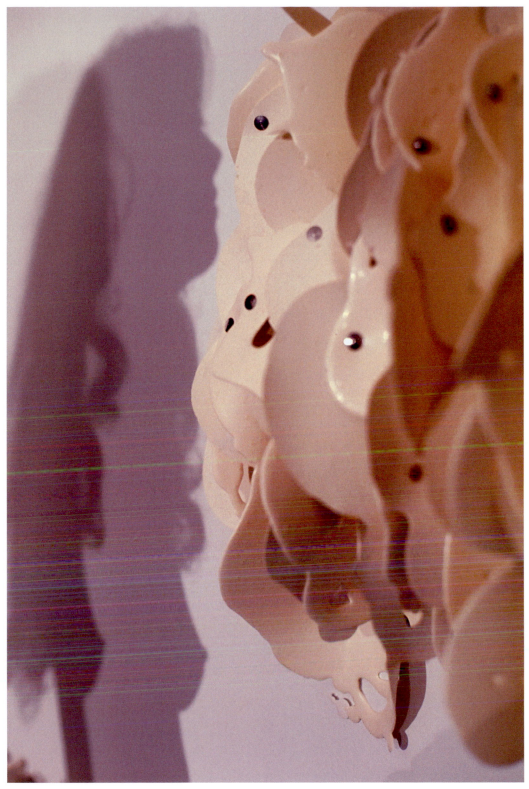

FIG. 18
Hannah Wilke's shadow and latex work on wall from
Ponder-r-rosa 4, White Plains, Yellow Rocks, 1975
Hannah Wilke Collection & Archive, Los Angeles

from the early 1970s lay bare Wilke's simplified technique, inviting us to imagine her fingers deftly tucking in and folding the clay (**FIG. 19**). This approach synthesizes the seemingly incompatible strategies of Abstract Expressionism and Minimalism. Here Wilke transposed the painterly language of gestural abstraction onto her work in sculpture by emphasizing the immediate effects of quick and spontaneous action on the malleable sculptural material.[32] She also embraced the pared-down forms of Minimalism (i.e., geometric circles of clay) while offering an alternative rendition of seriality—a repetition invested in handmade, organic variation of form rather than the impersonal precision of mechanical reproduction. Wilke employed this innovative technique in the making of both stand-alone sculptures and multipart works, such as *Just Fifteen* (**FIG. 20**).

This major new direction in her sculpture doesn't simply represent an evolution of her technique and form. It also demonstrates an additional manifestation of her exploration of Eros that she described as "oneness"—a term that synthesizes and captures the very essence of her approach to life and art:

> Much sculpture in this century since David Smith has been about part against part but my sculpture is about oneness. One circle of clay or gum or latex rubber becomes a three-dimensional form through human gesture. It's like cell division, the instant and constant transformation of simple life forms to complex life forms, all similar but each distinct. That life giving is what we tend to forget about in our destructiveness and prejudice, and it is, I think, the essence of feminism, and what religion should be about.[33]

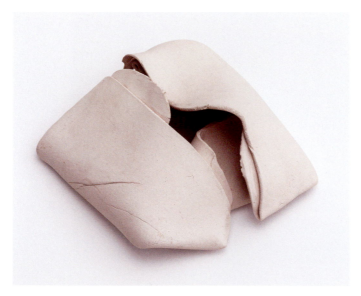

FIG. 19
Untitled, ca. early 1970s
Terracotta
2 ⅜ × 4 ½ × 5 inches (6.1 × 11.4 × 12.7 cm)

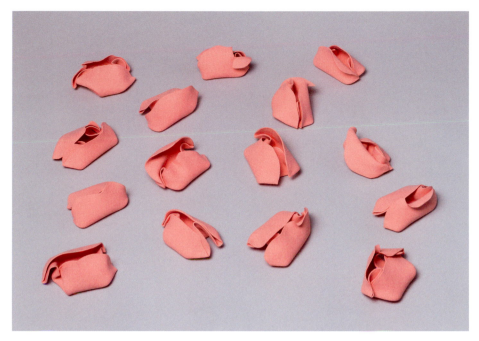

FIG. 20
Just Fifteen, 1977
Unglazed ceramic on compressed wood particle board
Base: 39 × 39 inches (99.1 × 99.1 cm); ceramic pieces vary
approximately 4 × 5 × 7 inches (10.2 × 12.7 × 17.8 cm)

Oneness was Wilke's retort to the type of sculpture premised on the division and analysis of constituent parts. In *Baby Blue* (1977; p. 135) and other serial one-and two-fold sculptures, Wilke used repetition and subtle variation to convey this concept. Each sculptural element, the result of the same process of making, is nonetheless unique: some seem to speak with open lips while others are pinched tight, some spill over to one side, some have more scalloped edges, et cetera. Even with their distinctive appearances, they are all connected to each other, and, through their interrelationships they form a new, collective whole. Visually, their interactions establish a staccato movement—also high-lighted by the interplay of the negative and positive space of the sculptures and the base—creating an impression of outward extension.

Wilke used the metaphor of cell division to explain the interconnection and reciprocity of oneness. Like her serial sculptures, each cell is its own entity, yet it is related through biological kinship and interdependence to all the others. Oneness is the kind of full, sensuous connection with life and among lives that Eros both reveals and affirms. It is both a philosophical approach to living as well as a metaphor for the act of artistic creation.

Wilke's concept of oneness paralleled "at-onement," a key insight in Erich Fromm's *The Art of Loving*, a text that (as previously stated) critically informed her practice. For Fromm, at-onement is the answer to the fundamental dilemma of human existence, "the question of how to overcome separateness, how to

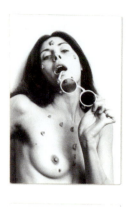
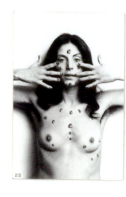
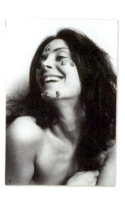
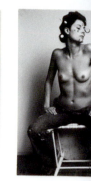
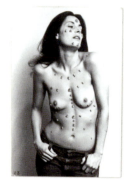
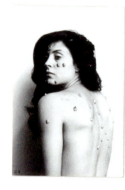
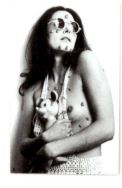
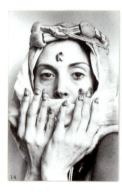
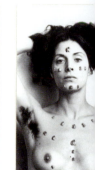
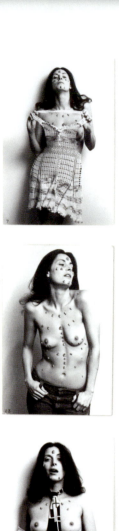
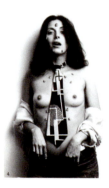
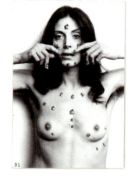
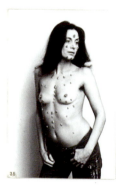
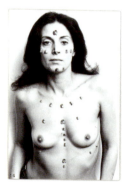
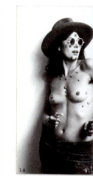
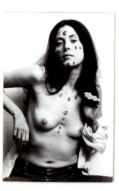
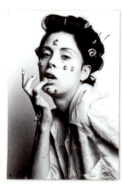
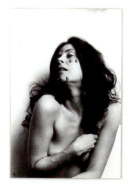
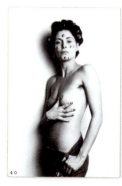
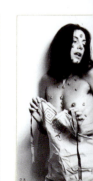

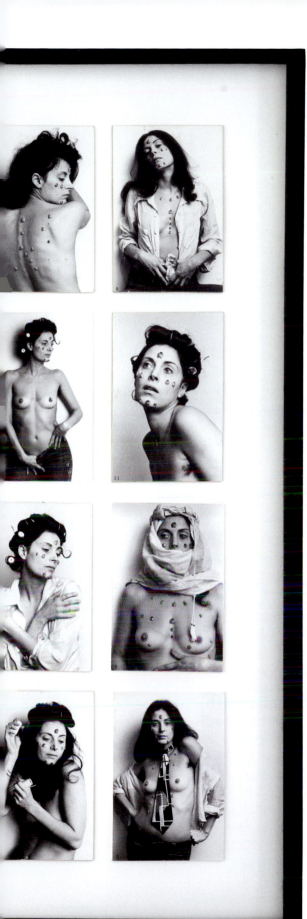

achieve union, how to transcend one's own individual life."[34] Both Fromm and Wilke located oneness (or at-onement) in human relationships, but for Wilke, the concept was much broader, encompassing the indivisibility and reciprocity between art and life.

In her conversation with Nemser, Wilke posited ideas about "sameness" as the inverse of the pursuit of oneness. "I make the same object over and over again, and it's always different, as opposed to making the same object the same, which to me is frightening, regimented, fascist art."[35] Wilke here insisted on the capacity of repetition to breed difference as an antithesis to the oppressive, immobilizing conformity that she associated with fascism. She addressed this tension between sameness and difference in one of her most iconic, multipart works, *S.O.S. Starification Object Series* (1974), which marked one of her first forays into photography.

In a group of twenty-eight photographs that are a central part of this series and installation, Wilke assumed the role of a glamorous model, striking poses that adopted and parodied the language of fashion and advertising (**FIG. 21**). While the repetition of her half-naked body against the white background engenders a particular rhythm, the tableau comes across as somewhat stilted. In contrast to the fluid, free-flowing motion enacted by her sculptures, the twisting and turning of her body in some of these photographs reads as posed and over the top—lacking spontaneity and authenticity of expression. The awkwardness in these images subverts the sense of easy pleasure, whimsy, and entertainment upon which commercial photography and its manipulation of consumer desire is predicated.

Wilke's irreverent play with gender stereotypes connects her to the work of early twentieth-century artists that came out of Dada

FIG. 21
S.O.S. Starification Object Series: An Adult Game of Mastication (detail), 1974
28 gelatin silver prints, each 7 × 5 inches (17.8 × 12.7 cm)
Musée National d'Art Moderne, Centre Pompidou, Paris. Purchase and gift of the Centre Pompidou Foundation, 2007, and partial gift of Marsie, Emanuelle, Damon and Andrew Scharlatt, Hannah Wilke Collection & Archive, Los Angeles

and later Surrealism, such as Duchamp with his alter ego, Rrose Sélavy, but also the German artist Hannah Höch with her critique of commercial portrayals of women (**FIGS. 22 AND 23**). In her work, including *Mädchen am Meer* (Girl on the Beach) from 1965, Höch used the disjunctive powers of photomontage to expose the capitalist and patriarchal underpinnings of the emerging mass media, calling particular attention to the commodification of women's bodies. Her diminishing and fragmenting of the figure into coiffed hair, demure smile, slender neck, and prominent décolletage borders on the grotesque, underscoring the dangerous effects of mass media's tendencies to contort and exaggerate women into sexualized objects in order to uphold the economic structures of value and exchange.

Wilke's images similarly unmask a confluence of oppressive systems that co-opt and coerce human, and especially women's bodies—systems that are fueled by a phenomenon that she described as visual prejudice:

> [P]rejudice starts with the way we look at each other.... We judge each other according to the way we see, the way we hear, the gestures of humanity or inhumanity come out unconsciously, or even against our own better judgment. So what I am saying is that people are first visually prejudiced and that's why I made myself very visual.[36]

By mirroring the ways in which popular culture commodifies individuals in *S.O.S.*, Wilke sought to trap our gaze, tempting us toward visual prejudice against her, with the hope of eventually leading us to interrogate our own complicity with oppressive systems—capitalist, sexist, and patriarchal. By representing herself as circumscribed by staid stereotypes and mock props, Wilke revealed the modern body as constrained and confined by roles, norms, values, and objects that are imposed rather than freely chosen. Despite the multiplicity of expressions across this series of images, the accumulation and repetition of the seductive—though in many instances lifeless—guises she assumed overpower traces of individuality, while making explicit the dehumanizing loss of the self.

However, despite the appearance of uniformity, Wilke as a protagonist in these images was not a fully obedient body. A close look reveals the presence of small, folded chewing gum sculptures—which she also created as

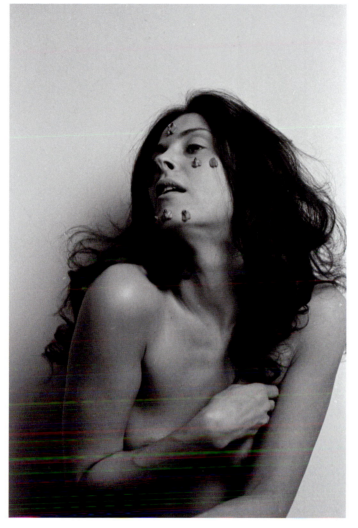

FIG. 22
S.O.S. Starification Object Series, 1974
Gelatin silver print
7 × 5 inches (17.8 × 12.7 cm)

FIG. 23
Hannah Höch, *Mädchen am Meer*, 1965
Collage
12.6 × 10.2 inches (32 × 26 cm)
Landesbank Berlin AG

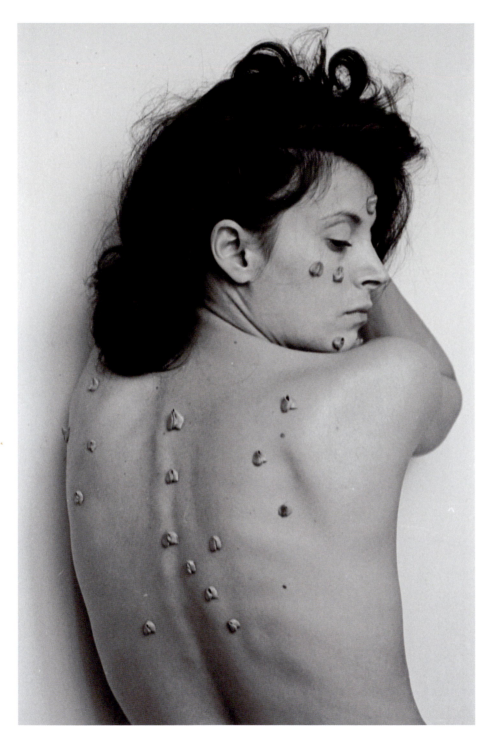

FIG. 24
S.O.S. Starification Object Series (Back), 1974
Gelatin silver print
40 × 27 inches (101.6 × 68.6 cm)
Solomon R. Guggenheim Museum, New York; Purchased with funds contributed by the Photography
Committee and The Judith Rothschild Foundation, 2001

FIG. 25
Untitled, 1984
Gum sculpture in Plexiglas box
2 ½ × 2 ½ × 1 inches (6.4 × 6.4 × 2.5 cm)

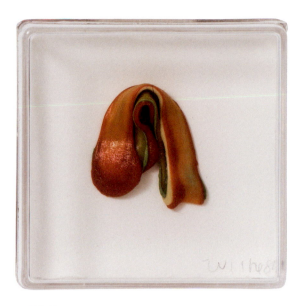

FIG. 26
Untitled, 1984
Gum sculpture in Plexiglas box
2 ½ × 2 ½ × 1 inches (6.4 × 6.4 × 2.5 cm)

stand-alone works of art—placed across her body in an array of patterns to unravel the static imagery (**FIGS. 24, 25, AND 26**). Their inclusion introduces an element of uniqueness within the culture of conformity, especially given the handmade character of each and every folded gum sculpture. Taken together, these tiny vulvas create visual dissonance, often to a jolting and enlivening effect, which has the potential to trigger critical thought and independent thinking. Wilke here seems to suggest that her art can be harnessed as an antidote to uniformity and stultifying sameness, or, to put this another way, as the revitalizing expression of difference and therefore as a source of Eros, for life, toward an expression of individuality and oneness.

On another level of this multivalent work, the gum sculptures in *S.O.S.* resemble and allude to scars. "All people are scarred by their religion, their culture, their particular caste system," Wilke proclaimed.[37] In her writings and interviews, she described the gum sculptures as signs of both the physical and psychological violence, trauma, and suffering experienced throughout humankind, making the gum a site of interconnection as well.[38] Reflecting the mantra of feminists of her generation, "the personal is political," she also deployed these tiny artworks to make us look closer at her in a state of

vulnerability, daring us to see her as a complex and scarred flesh-and-blood individual. In this way Wilke insisted on art's capacity to act as a tool of political resistance, to inspire agency, and to dislodge the lifeless systems of oppression and control.

Wilke's emphatic embrace of the powers of Eros and oneness, a kind of unity that celebrated individuality, was likely shaped by her personal history. As she told one interviewer, "I guess I've experienced so much death that I'm interested in life, and affirming life. Reaffirming life."[39] Here she alluded to the passing of a great number of family members during her childhood and young adulthood. But Wilke also had to contend with death on an existential level as it related to her identity as a Jewish-American woman born during the Second World War.

> As a Jew I would have been destroyed had I been born in Europe. It's incredible to think this happened during my lifetime and I am still alive....I've been scarred as we all have been by this inhumane history.[40]

These tragedies pointed toward a greater urgency to lead a fully embodied, pleasure-filled existence and to enter into a deeper union with Eros, with life.

The vital importance of Eros came into sharper relief in the late 1970s and early 1980s as her mother, Selma Butter, went through a decade-long and ultimately fatal struggle with breast cancer. This prompted Wilke to revise her earlier statement by reframing death as a part of the cycle of life that unfolds over time:

> [My] sculptures were circles that, when folded, became three-dimensional objects. They are about oneness, about cell division. Where one cell becomes hundreds of cells that ultimately comprise a life. The art begins as a minimal, geometric form, which is then transformed gesturally into singular symbols for life itself. Later they also became symbols of the cell division that may consume us, cancer. Regeneration. Degeneration.[41]

Here Wilke introduced a new layer of meaning to her concept of oneness, expanding it to include a continuity of the cycle of birth and growth but also decay and death.

The closeness of life and death in Wilke's oeuvre has been recognized by scholars, including Lowery Stokes Sims, who astutely observed that her work "reminds us of the fragility of her existence, the absurdity of life, but also of its extraordinary presence in the face of death."[42] By the early 1980s, this manifested itself in Wilke's sculptures through her application of paint to the surfaces of both the ceramic sculptures and their wooden bases. As her mother's

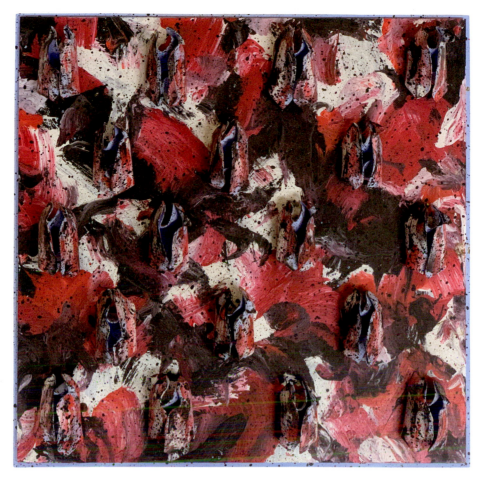

FIG. 27
Generation Process Series #16, 1982
Acrylic on ceramic and wood
3 ½ × 19 ½ × 19 ½ inches (8.9 × 49.5 × 49.5 cm)

health deteriorated, Wilke's colors brightened.[43] We see the effects of this heightened palette in a sculpture that is part of the *Generation Process Series*, which was included in *Support Foundation Comfort*, Wilke's 1984 memorial exhibition honoring the woman who gave her life (FIG. 27). The paint in this and other works from this period acts as connective tissue, joining sculpture to sculpture, sculpture to base, and even fusing the two media of sculpture and painting. The viewer's eye, moving between the three-dimensional ceramics and the painted flat base, traces a dialogue between these two realms, which are united yet also distinct. The variegated surfaces and experimental brush-work further activate the lush coloration, blurring the boundaries between sculpture and painting. The drifting of one entity into another recalls the close bond between parent and child as well as the cycles of regeneration and degeneration that govern the natural world.

Such a clear-eyed embrace of the vulnerability and the state of constant change that characterizes the human condition is also echoed in a series of remarkable watercolors that Wilke started painting in 1986 (FIG. 28 AND PP. 188–89). Each of these drawings focuses on a disembodied face that Wilke evoked through sweeping and interweaving layers of brushstrokes and vibrant, almost jangling colors. She arrayed these marks into faces that seem to float in the center of the page, creating a simplified and pared-down composition that eschews any superfluous details. Consequently, the image doesn't quite coalesce or feel anchored, seeming instead to almost magically hover over the paper substrate. In this way, it calls to mind Roy Lichtenstein's *Brushstrokes* series (1966; FIG. 29), but in contrast to his ironic jab at Action Painting, Wilke's earnest allusion leverages its expression toward the realm of sensuality and emotion.[44]

For Wilke, the fluidity in these drawings connected to her grief and her process of coming to terms with the loss of the profound physical and psychic bond that she shared with her mother:

> I realized that what I had done in the last few days, because I had been quite depressed, was to make gestural layered watercolors of only my face in which I took away my hair, creating circular patterns. But these portraits really became portraits of my mother, who had lost all of her hair from chemotherapy. I guess I was fusing myself into her because I am her. She created me, and I am bringing her back to life by being me.[45]

The unmooring of the human form in these drawings also poignantly speaks to Wilke's sense that something was wrong in her own body, prior to receiving her own cancer diagnosis in 1987.[46] After learning that she had non-Hodgkin's lymphoma, Wilke shared with an interviewer, "I felt an immense loss of self."[47] This sentiment brought new meaning to the watery quality of medium in the series that was already underway, which she subsequently titled *B.C.* for "before cancer." Although the sheer presence of these works is undeniable, they remain elusive and amorphous. Despite, or perhaps because of, the lively nature of her brushstrokes, Wilke's face never attains a sense of solidity. Instead, the dynamic, almost effortless interplay between line, color, and form that Wilke offered reads as unbounded, light, and fluid. Like her early cut-out drawings and latex sculptures, there is a porous effect; the faces seem to invite in the light and air and world around them.

Even so, the works in the series feel emphatically physical—especially as they become increasingly large, up to six feet tall—with brushwork that seems to caress her face rather than delineate it, creating forms that spill over, alluding to the bodily abundance, sensuality, and movement that informs so much

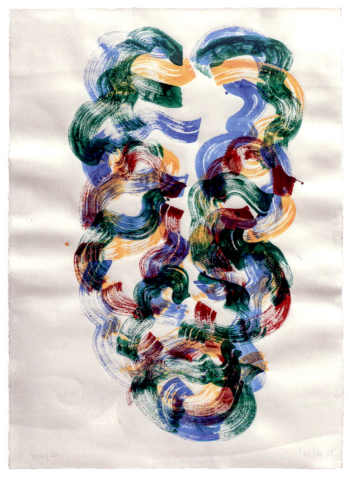

FIG. 28
B.C. Series, Self-Portrait, May 22, 1988, 1988
Watercolor on Arches paper
71 ½ × 51 ½ inches (181.6 × 130.8 cm)

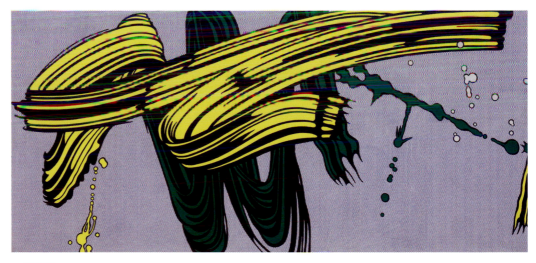

FIG. 29
Roy Lichtenstein
Yellow and Green Brushstrokes, 1966
Oil and Magna on canvas
84 × 180 inches (213.4 × 457.2 cm)
Museum für Moderne Kunst, Frankfurt

of Wilke's work. With these self-portraits Wilke envisaged herself as ever-changing, vitally open to life without denying her own mortality, seeking a sense of oneness and interconnection with the self and the world, and perhaps inviting her viewers to do the same.

◆

Over the three decades of her career, Wilke forged a multidisciplinary, feminist practice that was as eclectic and diverse as it was cohesive, grounded in the layered and shifting meanings of Eros—as sexual charge, life force, and locus of creative agency. Her articulation of this idea depended on the return to the body as a site of inspiration, affirmation, and resistance. In this way, Wilke infused the erotic with new meaning through a range of poetic, playful, and often humorous meditations on pleasure and joy but also on loss, memory, and human connection. These ideas resonate across her different bodies of work and are firmly grounded in her visual language, which shows a deep feeling for movement through the effects of opening, flowing, reaching, floating, and expanding. This commitment to Eros gave force to Wilke's voice and vision, resulting in a bold legacy of objects that continues to inspire and provoke to this day.

Wilke's ongoing exploration of movement, as an index of Eros and oneness, is echoed in the concluding chapter of Norman O. Brown's *Life Against Death*, which envisions a new kind of human condition, shorn of repression and open to fluidity, mobility, and lack of stasis. Getting there, according to Brown, includes art, which "seduces us into the struggle against repression."[48] Wilke answered Brown's call by creating work that sought to "seduce" viewers on multiple levels through the development of a formally innovative and materially experimental practice that activated the eye and appealed to the body. In so doing, she compellingly advocated for the radical embrace of Eros, leading us away from commodification and conformity and toward a more profound and joyful engagement with life. "I have always used my art to have life around me," Wilke proclaimed. "Art is for life's sake."[49]

NOTES

1 Along with many of her peers in the 1960s and 70s, Wilke directly linked the vagina to her experience of being a cisgender woman. The intervening decades have brought an understanding of a much broader spectrum of relationships between anatomy, gender, and sexed embodiment (that a person's genitals do not determine their sex or gender), which expands from Wilke's historical positioning of her then radical iconography.

2 In 1966, Wilke contributed work to the New York City Art Teachers Association (NYCATA) group exhibition *Hetero Is…* an exhibition focused on erotic art. In Lucy Lippard's review of this show, she comments on the erotic potential of Wilke's sculpture for the way it merges male and female forms into dynamic androgyny. Lippard, "Eros Presumptive," *The Hudson Review* 20, Spring 1967, 91–99. In the mid-1970s, Barbara Rose included Wilke in her survey of women's erotic art: Barbara Rose, "Vaginal Iconology," *New York*, May 20, 1974, 58–59. More recently, Rachel Middleman took Rose's article as a starting point for a chapter on Wilke in her book, *Radical Eroticism: Women, Art, and Sex in the 1960s* (Oakland: University of California Press, 2018), 117–45. See also Eleanor Nairne, Jo Applin, Michael Findlay, Amy Tobin, and Anne Middleton Wagner, *Eva Hesse and Hannah Wilke: Erotic Abstraction* (New York: Acquavella Galleries and Rizzoli International, 2020).

3 Wilke recalls this in an interview with Ernst Weber, "Artist Hannah Wilke Talks with Ernst," *Oasis d'Neon* 1, no. 2 (1978): n.p.

4 Hannah Wilke, interview by Cindy Nemser, February 18, 1975, transcript (2013.M.21), Getty Research Institute, Los Angeles. A version edited by Donna Wingate with Marsie Scharlatt appears elsewhere in this publication, pp. 88–107.

5 Lillian Roxen, "H. Wilke Ceramic Erotica," *Comment* [Sydney, Aust.], August 1966, 9.

6 See, especially, Middleman, *Radical Eroticism*, 117–45. Middleman lays out the context of erotic art as it existed in the 1960s, and she argues that Wilke challenged that category, which was then dominated by figurative work designed to appeal to the heterosexual male gaze.

7 Wilke, interview by Nemser, p. 100 in this publication.

8 For further details refer to the chronology on p. 225 of this volume.

9 Brown, *Life Against Death: The Psychoanalytical Meaning of History* (Middletown, CT: Wesleyan University Press, 1959); and Fromm, *The Art of Loving* (New York: Harper & Row, 1956).

10 Wilke specifically used the language of Eros in several interviews, including the interview with Nemser; and Weber, "Artist Hannah Wilke." See also Wilke's quotes in Avis Berman, "A Decade of Progress, But Could a Female Chardin Make a Living?" *Artnews* 79, October 1980, 77. The theme of Eros is also an undercurrent in her 1986 interview with Linda Montano, "Hannah Wilke Interview," in *Performance Artists Talking in the Eighties* (Berkeley: University of California Press, 2000), 137–41; and her interview with Chris Heustis and Marvin Jones, "Hannah Wilke's Art, Politics, Religion and Feminism," *The New Common Good* (May 1985): 1, 9–11. See also Wilke's 1980 statement "Visual Prejudice," in *Hannah Wilke: A Retrospective*, ed. Thomas H. Kochheiser (Columbia: University of Missouri Press, 1989), 141.

11 See Randy Kennedy, "Let's Get Lost: Rediscovering a Radical Scholar as Art Shaman," *Ursula* 1 (Winter 2018), https://www.hauserwirth.com/magazine/24065-lets-get-lost-rediscovering-radical-scholar-art-shaman. See also Philip M. Longo, "An Army of Lovers: Eros as Attachment in Writing of the American Sexual Revolution" (PhD diss., Rutgers University, 2013).

12 Wilke, interview by Nemser, p. 105 in this publication.

13 Wilke's contributions to the development of feminist art and vaginal iconography in the 1960s and 70s is discussed in several major monographs on the artist. See the "Feminism" section of Joanna Frueh's essay in *Hannah Wilke: A Retrospective*, 40–49;

Nancy Princenthal, *Hannah Wilke* (Munich: Prestel, 2010), 19–45; Rachel Middleman, "Rethinking Vaginal Iconology with Hannah Wilke's Sculpture," *Art Journal* 72, no. 4 (Winter 2013): 34–45; and Saundra Goldman, "'Too Good Lookin' to Be Smart': Beauty, Performance, and the Art of Hannah Wilke" (PhD diss., University of Texas at Austin, 1999), 23–74.

14 In multiple interviews and writings, Wilke talked about wanting to create a positive image to undo the negative connotations embedded in words like "pussy, cunt, box." This sentiment is most eloquently articulated in her 1977 essay "Intercourse With…" reprinted in *Hannah Wilke: A Retrospective*, 139. On the subject of Georgia O'Keeffe's iconography, Wilke stated: "O'Keeffe is a wonderful artist. Her flowers reminded people of vaginas, which she denied. But in 1985, it was important for me to say that the flowers in my work were vaginas." This quote appears in Heustis and Jones, "Hannah Wilke's Art," 9.

15 Starting in the early 1970s, Wilke participated in the Fight Censorship group, a group of feminist artists who fought against the double standard for women who depicted erotic themes and subject matter in their work. For more on the Fight Censorship group, see Richard Meyer, "Hard Targets: Male Bodies, Feminist Art, and the Force of Censorship in the 1970s," in *WACK!: Art and the Feminist Revolution*, eds. Cornelia H. Butler and Lisa G. Mark (Los Angeles: Museum of Contemporary Art, 2007): 366–68.

16 Hannah Wilke, "Letters to the Editor," *Art-Rite*, Spring 1974, 7.

17 Wilke, interview by Nemser, p. 100 in this publication.

18 See Wilke's interview with Ruth Margolin, "An Interview with Hannah Wilke," *Forum* (November/December 1989): 9–11.

19 Goldman and Tracy Fitzpatrick have proffered important critical readings of Wilke's engagement with the idea of gesture as movement and an index of her interaction with materials in her sculptures and works on paper. See Fitzpatrick, ed., *Hannah Wilke: Gestures* (Purchase, NY: Neuberger Museum of Art, 2009). See also Goldman, "'Too Good Lookin' to Be Smart'." See also Goldman's essay connecting the gesture as an index of movement to life: "Gesture and the Regeneration of the Universe," in *Hannah Wilke, A Retrospective*, eds. Donald Goddard, Kirsten Dybbøl, and Elisabeth Delin Hansen (Copenhagen: Nikolaj, Copenhagen Contemporary Art Center, 1998), 6–43.

20 Relatedly, as movement in the form of gesture has often been explored in the context of Wilke's performance and video, this essay will largely focus on other bodies of work.

21 Wilke, quoted in Ruth Iskin, "Hannah Wilke in Conversation with Ruth Iskin," *Visual Dialog* 2, Summer 1977, 17.

22 Carolee Schneemann, *Imagining Her Erotics: Essays, Interviews, Projects* (Boston: MIT Press, 2001), 33.

23 Iskin, "Hannah Wilke in Conversation," 17.

24 Wilke talks about feminism as the potential basis for a religion or political stance, celebrating procreativity and creativity, dissolving mind-body and male-female dualism, balancing power dynamics, and addressing social and humanitarian concerns. See Heustis and Jones, "Hannah Wilke's Art," 1, 9–11.

25 Wilke, interview by Nemser, p. 105 in this publication.

26 Leslie Dick, "Hannah Wilke," *X-Tra* 6, no. 4 (Summer 2004): 26.

27 Goldman, "'Too Good Lookin' to Be Smart'," 70.

28 Douglas Crimp, "Reviews and Previews," *Artnews* 71, October 1972, 83.

29 Wilke, quoted in Iskin, "Hannah Wilke in Conversation," 17.

30 Wilke, interview by Nemser, p. 93 in this publication.

31 Ibid.

32 Wilke often shared that Willem de Kooning, who purchased one of her latex works in 1972, pointed out that there had not been any abstract expressionist sculpture until then. See Wilke, "Letters to the Editor," 7.

33 Wilke, quoted in Heustis and Jones, "Hannah Wilke's Art," 1.

34 Fromm, *The Art of Loving*, 9.

35 Wilke, interview by Nemser, p. 97 in this publication.

36 Wilke, quoted in Heustis and Jones, "Hannah Wilke's Art," 11.

37 Ibid.

38 For a reading of this work that is critical of the universality Wilke seemed to be striving for, see Carla Freccero, "De-Idealizing the Body: Hannah Wilke, 1940–1993," in *Bodies in the Making: Transgressions and Transformations*, ed. Nancy N. Chen and Helene Moglen (Santa Cruz, CA: New Pacific Press, 2006), 14. Freccero writes, "Although this piece has some of the essentializing and universalizing 'sisterhood is global' tendencies of a certain era of US liberal feminism, it is also more progressive than some forms of liberal feminism today, for it does not assume the posture of the enlightened western woman maternalistically pitying her third-world sisters."

39 Wilke, quoted in "Artist Hannah Wilke Talks with Ernst," n.p.

40 Wilke, quoted in Heustis and Jones, "Hannah Wilke's Art," 11.

41 Wilke, quoted in Montano, "Hannah Wilke Interview," 140.

42 Lowery Stokes Sims, "Body Politics: Hannah Wilke and Kaylyn Sullivan," in *Art and Ideology*, ed. Fred Lonidier (New York: New Museum of Contemporary Art), 49. In this quote, Sims is specifically referring to *Portrait of the Artist with Her Mother, Selma Butter*, 1978–81.

43 Ernst Weber, "Oasis d'Neon Video Magazine Talks with Artist Hannah Wilke," a one-hour videotape filmed at Wilke's Greene Street studio, March 21, 1985.

44 It is notable that during this same period, Wilke made a series of works called *Brushstrokes*, composed of her own hair that fell out due to chemotherapy.

45 Wilke, quoted in Montano, "Hannah Wilke Interview," 140–41.

46 Goldman, "Gesture and the Regeneration of the Universe," 38.

47 Cassandra Langer, "The Art of Healing," *Ms.* 17, January/February 1989, 132.

48 Brown, *Life Against Death*, 64.

49 Wilke, quoted in Heustis and Jones, "Hannah Wilke's Art," 11.

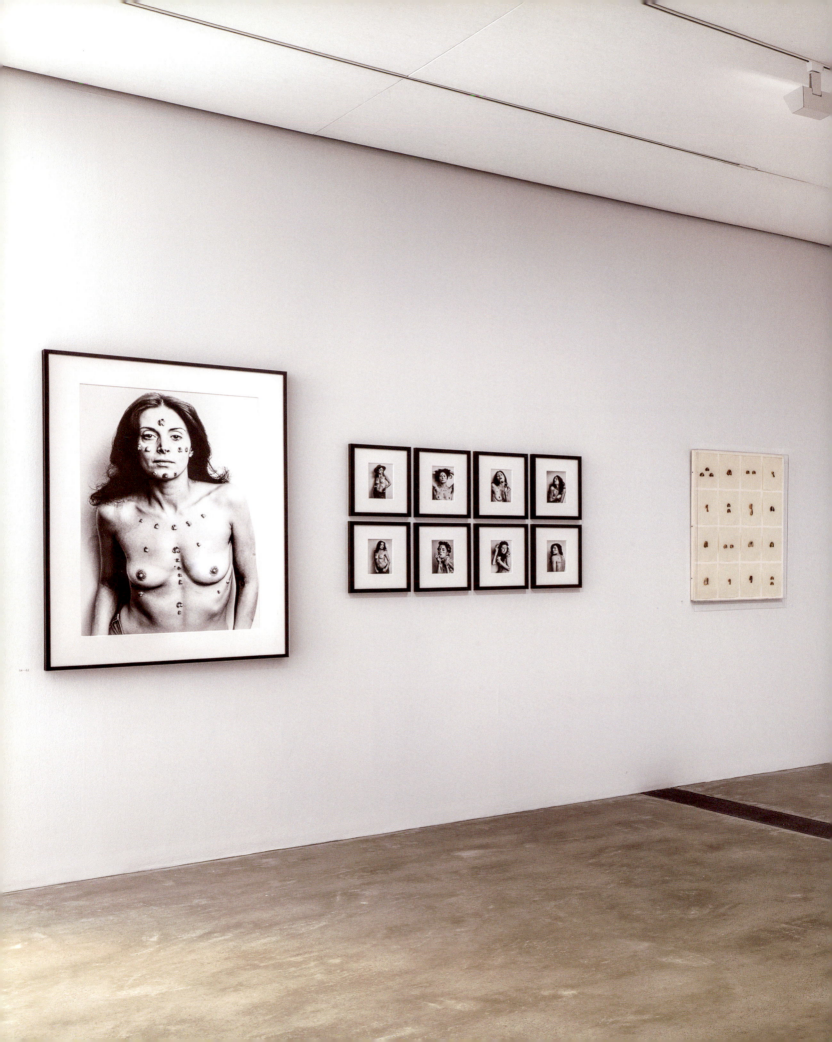

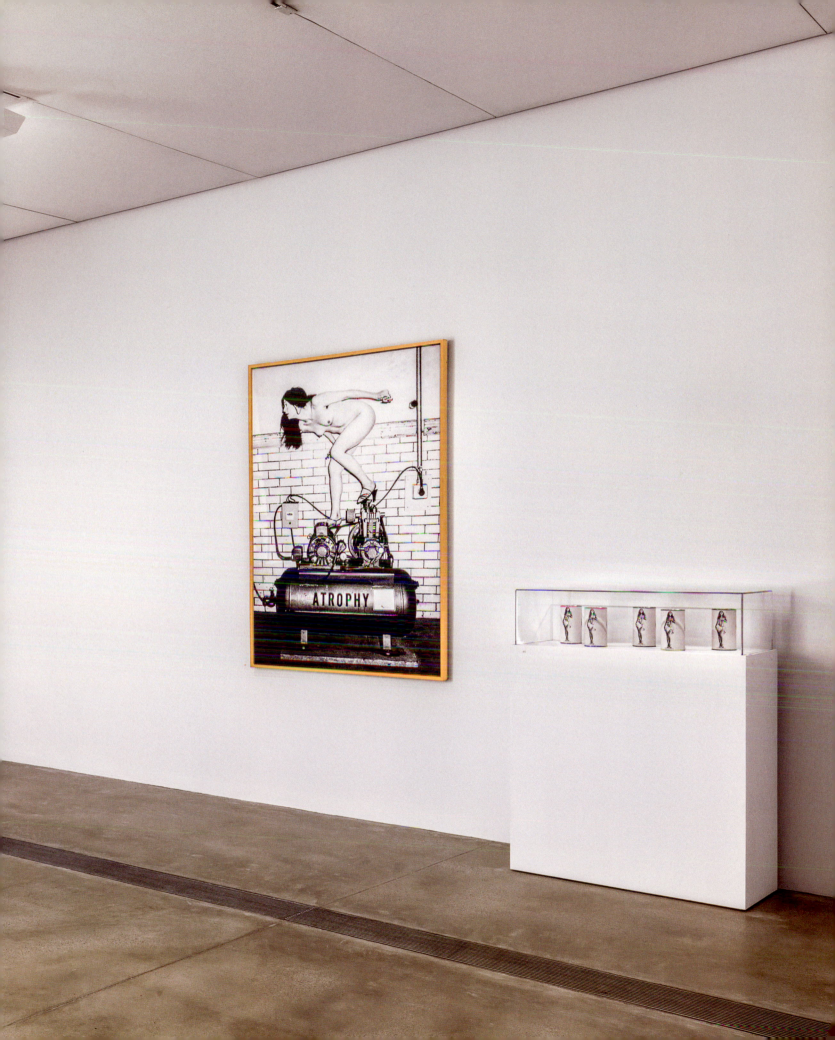

ELECTIVE AFFINITIES

Hannah Wilke's Ceramic Sculptures in Context

Glenn Adamson

In January 1978, as Hannah Wilke was preparing for an exhibition at New York's P.S. 1, Institute for Art and Urban Resources, she delved deep into Johann Wolfgang von Goethe's novel *Elective Affinities*. Published in 1809, the book teeters on the fulcrum between the Enlightenment and Romanticism, adopting modern chemistry as a metaphor for the volatility of human relationships. Goethe used his title, scientific in origin—it refers to molecules that bond only in particular circumstances—to describe the mysterious attractions and repulsions that guide the heart. Wilke liked this idea. She adopted the name *Elective Affinities* for one of her multipart ceramic sculptures, eighty-six porcelain forms on four painted boards (**FIG. 1**). She also copied some lines from the book and posted them, along with quotations from other sources, onto a chalkboard as part of her exhibition *So Help Me Hannah: Snatch Shots with Ray Guns*. From Goethe, she chose this passage:

> It is just the most complicated cases which are the most interesting. In these you come first to see the degrees of the affinities, to watch them as their power of attraction is weaker or stronger, nearer or more remote. Affinities begin really to interest only when they bring about separations.[1]

These lines were likely meaningful to Wilke in relation to her recent breakup with the artist Claes Oldenburg, which had left her hurt and angered.[2] But her choice to use Goethe's title for her own ceramic sculpture was something else: "Elective Affinity" perfectly describes Wilke's relationship with clay.

Hannah Wilke made clay her own, working with it in a manner radically unlike most other artists in the discipline. In terms of sheer craft, she was totally fluent. Wilke made her living partly by teaching ceramics at the School of Visual Arts in Manhattan, and her work in the medium is far more skillful than might

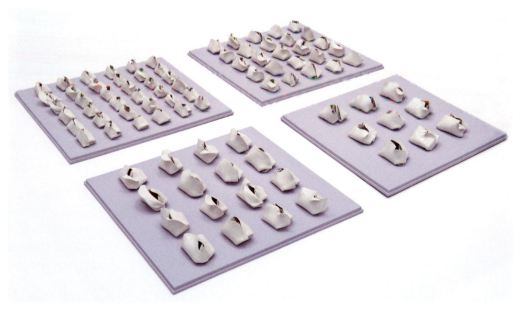

FIG. 1
Elective Affinities, 1978
Porcelain and wood
Overall display dimensions variable

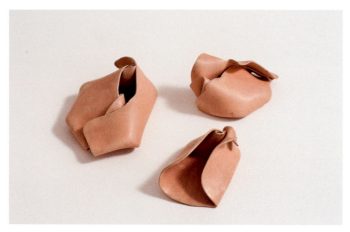

FIG. 2
Untitled, 1977
Unglazed ceramic
2 ½ × 6 ⅜ × 3 ⅝ inches (6.5 × 16.3 × 9.2 cm)
2 ⅛ × 4 ⅛ × 2 ¾ inches (5.5 × 10.5 × 7 cm)
2 ⅜ × 4 ⅞ × 3 ⅛ inches (6 × 12.5 × 8 cm)
Hannah Wilke Collection & Archive, Los Angeles

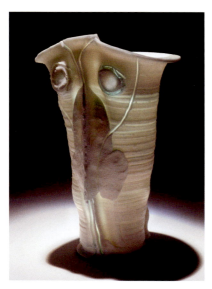

FIG. 3
Rudolf Staffel, *Light Gatherer*, ca. 1970
Unglazed porcelain with cobalt and copper and
incised decoration
8 ¼ × 5 ⅜ inches (21 × 13.7 cm)
Philadelphia Museum of Art, Gift of June and
Perry Ottenberg, 2006, 2006-92-6

initially be evident. From her first, groundbreaking vaginal forms of the early 1960s to the delicately layered works from later in the decade, the serial compositions of the 1970s, and the larger brightly polychromatic sculpture of her late career in the 1980s, she developed an idiosyncratic but sophisticated vocabulary of touch, palette, and texture. Wilke eschewed the potter's wheel in favor of handbuilding, forming thin sheets of clay into complex shapes, working swiftly and assuredly (**FIG. 2**). Clearly, Wilke felt a strong connection to clay. Recalling her first experiences working with it, she said, "it was a natural material that wasn't bastardized. Clay folds, moves, is alive and malleable. I also liked the idea of rescuing clay, a material that nobody liked."[3] Despite this stated intention, though, she maintained a studied distance from other ceramic artists of her time—even those few whose work did have evident connections to her own. Partly, this can be explained as a tactical avoidance of marginalization: "If you do little things and you're a woman, you're doomed to craft-world obscurity,"[4] she observed. But it was not only that: for Wilke, the great attraction of clay was its immediacy. She treated it as if it were an experimental material, an unstable compound which had to be handled delicately.

Wilke started out in ceramics in a high school art class and when she was just fifteen she worked at a local tile factory in her hometown of Great Neck, Long Island. It was on this job that she learned how to roll out perfectly even clay slabs, a process she would repeat countless times over the course of her career. She was put to work making tabletops from smashed tile—she remembered them as "awful-looking abstractions."[5] Soon after, she began her studies at Stella Elkins Tyler School of Fine Arts in Elkins Park, near Philadelphia, majoring in sculpture, but also taking classes with the potter Rudolf (Rudy) Staffel, who was beginning to experiment with porcelain for the first time (a material Wilke would later use in *Elective Affinities*). This was an unusual choice for an independent studio ceramist because at the time, this material was primarily associated with mass-produced dinnerware sets. He used the high-fired, white, translucent clay to make vessels that he eventually came to call *Light Gatherers*. They are built up in softly modeled layers; under direct illumination, a composition in light and shadow becomes visible within the thickness of the vessel wall (**FIG. 3**).

In detail, it is easy to see commonalities between Staffel's work and Wilke's mature work. They handled the material in a very similar way: thin membranes of clay layered in overlapping veils, the edges allowed to pucker and crease. In most other respects, though, they are totally antithetical. Staffel was going for transcendence, an abstract optical effect. Wilke, by contrast, seemed intent on

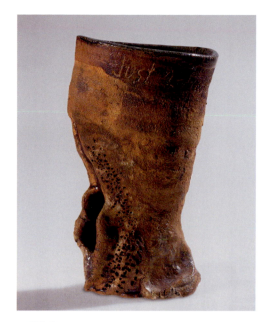

FIG. 4
Robert Arneson, *Just Two Fingers Please*, 1963
Glazed stoneware
5 ⅝ × 3 ⅛ × 3 ⅛ inches (14.3 × 8 × 8 cm)
Private collection

literalizing the term "clay body." Her gyno-morphism went far beyond the essential fact of vaginal imagery, probing the deeper sensual and psychological aspects of what it is to be a fleshly creature. This set her apart from some later feminists of the 1980s, who saw Wilke's embrace of the pleasure principle as "essentialist," and politically suspect. It also distanced her from other ceramists of the 1960s, who mostly pursued functional pottery (never an interest of hers) or macho expressionism, in the vein of the prodigious California sculptor Peter Voulkos. But Wilke's approach does bring to mind another figure working in clay, himself an apostate of sorts: the mischievous antihero of West Coast Funk, Robert Arneson.

Apart from Oldenburg, who was doubtless on Arneson's mind, there does not seem to have been any direct connection between him and Wilke. Even so, the juxtaposition is provocative. In 1963, just as Wilke was finishing her degree at Tyler and making her

first genital sculptures, Arneson created *Just Two Fingers Please*, a vessel form with a depiction of a vagina at its base; the title alludes both to drinking and sex (it could be a request made either at the bar or in bed) (FIG. 4). The work is crass in the extreme, typical of the rough-and-tumble humor prevalent at the University of California at Davis, where Arneson taught. It is nonetheless comparable to works by Wilke such as *It Was a Lovely Day* (1964), which is, if anything, even more explicit—she used Liquitex to represent the wetness brought on by arousal—and has a title that similarly evokes a sexual experience (FIG. 5). A few years later, we find another convergence, as Arneson and Wilke both directed their attention to the male genitals. Arneson's teapot *Blue Mountain Tea from the Sweet Golden Rod* (1969) is an unlikely conflation of body parts—an erect penis for a spout, nestled into a thatch of pubic hair atop a sizable pair of testicles, with a toothy mouth for a lid (FIG. 6). Around the same time Wilke made the work *Untitled (Phallus)*

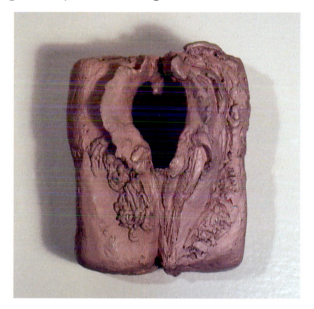

FIG. 5
It Was a Lovely Day, 1964
Terracotta with Liquitex
3 ¼ × 3 ¼ × 4 ½ inches (8.3 × 11.4 × 8.3 cm)
Ulrich Museum of Art, Wichita State University, Kansas

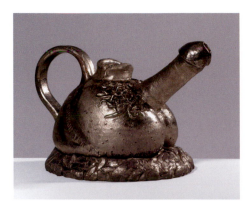

FIG. 6
Robert Arneson, *Blue Mountain Tea from the Sweet Golden Rod*, 1969
Stoneware, luster glaze
7 ½ × 11 × 8 ⅜ inches (19 × 28 × 21.2 cm)
Kamm Teapot Collection, 2016.142.1

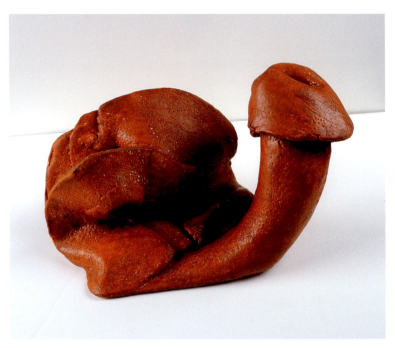

FIG. 7
Untitled (Phallus), ca. 1970
Latex and ceramic
6 × 5 × 10 inches (15.2 × 12.7 × 25.4 cm)
Collection of Donald and Helen Goddard

(ca. 1970) with its own curved member, and the overall contours of a snail (FIG. 7). Both objects are comical; Arneson's humor is once again broader, more obvious, while Wilke's communicates something less definite, perhaps gentle satire, perhaps fond affection.

What are we to make of these overlaps? Not—or not only—that Arneson and Wilke were like-minded souls, both aiming below the belt. Their separate investigations also reflect a shared interest in the affective qualities of their medium.[6] At times, Arneson positively wallowed in clay, in certain of his works, clearly taking pleasure in its infantile associations.[7] Saundra Goldman has suggested, similarly, that Wilke was "celebrating the part of ceramics that students often pass through quickly on their way to working in more refined techniques, [allowing] herself to stay in the reactive stage of working with clay."[8] Get past the sexual imagery, then, and we can see that while their aesthetic sensibilities moved in different directions, they were both participating in a much broader phenomenon, in which art's materiality and the body's subjectivity were analogous to one another, and brought into intimate contact. Here we might think of the felt works of Robert Morris, or the oeuvre of Eva Hesse—works that invite psychological readings, as if they were materialized states of mind. This is what Wilke found in clay: a primary order of experience, prone to emotive response. "Feel the folds," she wrote in 1975, "one fold, two folds, expressive precise gestural symbols. Multilayered metaphysics below the gut level, like laughter, making love, or shaking hands."[9]

Wilke's directly embodied aesthetics served her well. By repeating a few basic actions over and over, she was able to get to something extremely fertile. Indeed, she spoke of folding clay as a sort of immaculate conception: "It's the kind of art that's made in a second. One doesn't have to belabor it. We were all made in a second, too, a second of pleasure."[10] Her ceramic sculptures attest to this fecundity, as do her adaptions of this technique to other materials. Poured latex, laundry lint, chewing gum, kneaded eraser, marbled Play-Doh, raw bacon: she subjected them all to the same deft procedures of folding and pinching that she

had first developed in ceramic. In her 1974 video *Gestures*, she even applied them to her own face, "patting, massaging, caressing, pulling, pinching, slapping," as one early critic noted, just as if she were working on a slab of clay.[11] But it was arguably Wilke's ceramics that drew attention to the generative power of repetition most eloquently.

A breakthrough work in this regard was *176 Single-Fold Gestural Sculptures*, presented at her second solo show at Ronald Feldman Gallery in 1974 (FIG. 8).[12] Placed directly on the floor, the vaginal-form ceramics range in size from one to five inches across, but they are all made using the same basic vocabulary. One early critic and advocate, Edit deAk, saw their seriality like this: "By making hundreds of these little fuckers, she depersonalizes the very body part whose sensual quality depends so much on its individuality. She has made it into an asexual herd of repeated images."[13] In retrospect, we can see that this judgment was wrong—or at any rate, only half right. Wilke was certainly not interested in asexuality; and her intent was to create a dialectical situation in which repetition and individuality coexisted, bringing meaning and value to one another, compounds reacting. "I insist upon people making choices, like buying one piece of sculpture out of 176," she told Cindy Nemser in 1975. "One

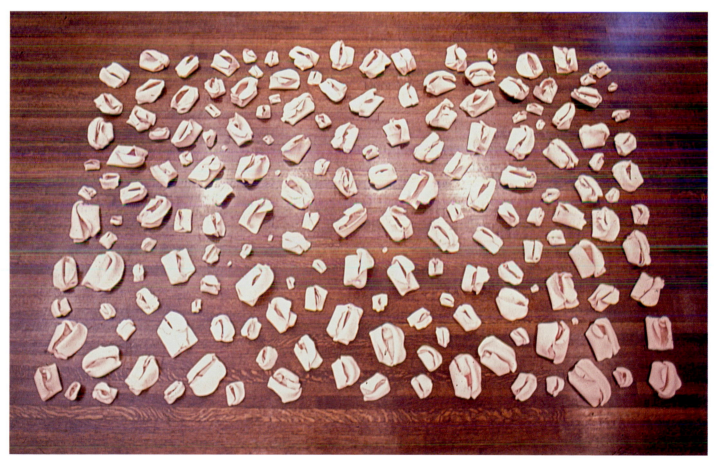

FIG. 8
176 Single-Fold Gestural Sculptures, installed at the Ronald Feldman Gallery, 1974
Liquitex on terracotta
Overall 72 × 96 × 4 inches (182.8 × 243.8 × 10.2 cm)
Collection of Donald and Helen Goddard

must look at my work, because there are differences."[14] She also brought an ethical interpretation to this idea, comparing it to social diversity: "my little ceramic pieces—there are hundreds of them, and all of these people, you know, have different forms, different shapes, different times, but they really exist— and I wonder, why doesn't it exist for man?"[15]

Again, we can find parallels here—for example, to Joel Shapiro's slightly earlier *One Hand Forming* (1971), in which he shaped a standardized quantity of clay over and over again (FIG. 9). When using one hand, the exercise produced a rough cylinder; with two, a sphere. These basic shapes seem to confirm the propensities of fingers and palm as a tooling system. As Shapiro has said, the work was "insistent about process and material and the haptic. I was trying to make irrefutable form!"[16] Yet there is also variation across each series—no two of the shaped clods are exactly alike, indexing the inherently irregular nature of all "handwork." Wilke's 176 sculptures obviously have some parallels with this rather austere thought experiment, but in comparison they are positively baroque. They are both serial and voluptuous, occupying a midpoint between Shapiro's Minimalism and, say, the undulating figural sculptures of Mary Frank (FIG. 10). One might also compare them to the contemporaneous ceramics of the British sculptor Anthony Caro, which stage an elemental contrast of the rigid and the pliant (FIG. 11).[17]

The range of Wilke's palette is another factor that distinguishes her ceramics even from these artists who were closest to her sensibility. Her very first

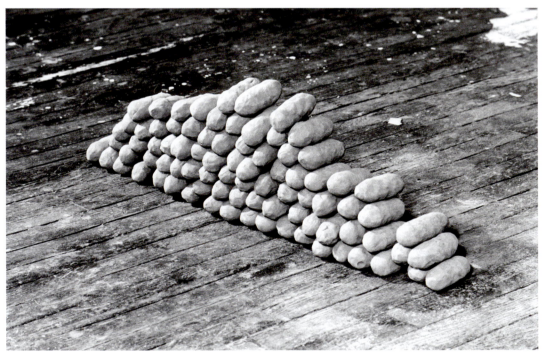

FIG. 9
Joel Shapiro, *One Hand Forming*, 1971
84 fired clay cylinders
Overall dimensions variable
Private collection

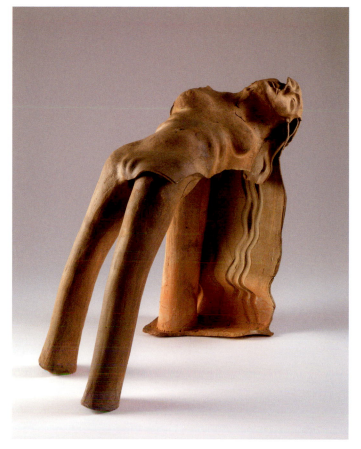

FIG. 10
Mary Frank, *Arching Woman*, ca. 1972
Ceramic
23 × 22 × 13 inches (58.4 × 55.9 × 33 cm)
Private collection

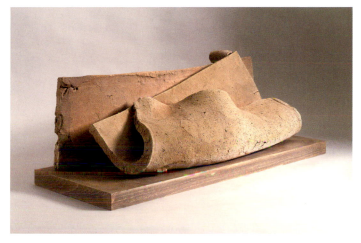

FIG. 11
Anthony Caro, *Can Company Rusty Nine*, 1975
Stoneware
11 × 11 × 29 inches (27.9 × 27.9 × 73.7 cm)
Private collection

works in the medium had been executed in simple terracotta, but already in the 1960s she was introducing color in various inventive ways—pink pigment mixed into the clay, green glaze, black slip. She also added gloss, using Liquitex acrylic medium and liquid latex, and textures imprinted from textiles—a common occurrence in pottery (as unfinished clay picks up the texture of whatever it is sitting on) but usually cleaned off prior to firing. Up until the mid-1970s, most of Wilke's surfaces were well within the standard vocabulary of ceramics, but that changed when she began to sheathe her work in acrylic paint (**FIGS. 12 AND 13**). This introduction of stronger color may have been influenced by her experiments with chewing gum. In 1978, she said,

> I was making grey sculptures made of kneaded erasers. When Edit deAk commented in a review about their anonymous grayness, I wondered how I could make them less depersonalized, and decided to buy some bubble gum. When I went to the store I saw that, God bless America, it's no longer just pink gum, but blue, purple, yellow, black, white, and green gum.[18]

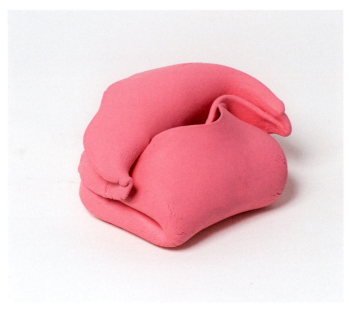

FIG. 12
Untitled, 1975
Painted ceramic
4 ½ × 4 × 2 ½ inches (11.4 × 10.2 × 6.3 cm)
Private collection, courtesy Alison Jacques, London

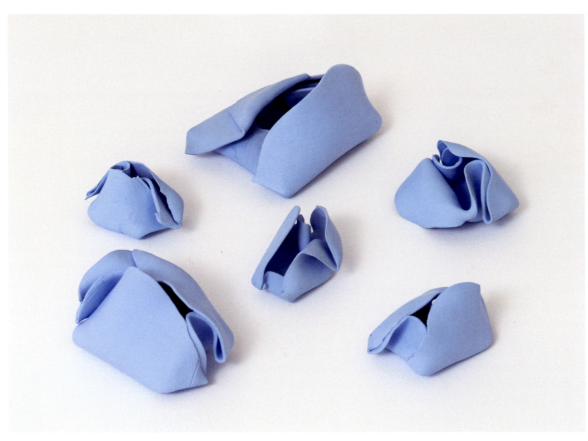

FIG. 13
Untitled, 1977
Painted ceramic (6 gestural fold sculptures)
11 ⅛ × 9 ½ × 2 ⅜ inches (28 × 24 × 6 cm)
Collection of Richard F. Grossman, courtesy
Alison Jacques, London

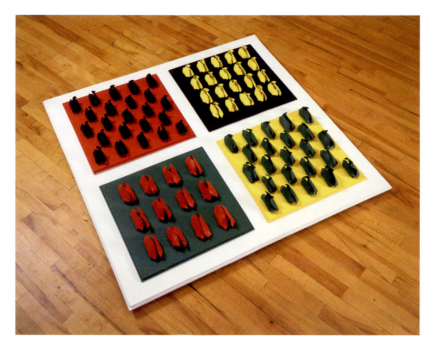

FIG. 14
Geo-Logic 4 to 1 from *Generation Process Series*, 1980–82
Painted ceramics on painted wood
3 × 48 × 48 inches (7.6 × 121.9 × 121.9 cm)
Collection of Donald and Helen Goddard

In the 1980s, Wilke's expanded palette positively exploded. No longer fleshy, her ceramics now were tricked out in bright primary colors, metallic lusters, brushed and spattered patterns (**FIG. 14**). The effect, as Nancy Princenthal has observed, was "more of a flag or a heraldic shield than of a field of sensuous blossoms."[19] At one level, this was simply a response to the decade's prevailing aesthetic, which tended toward saturated hues and extreme artificiality. It was the look of Memphis design, MTV, Neo-Geo painting. In 1979, Wilke had already hinted that such an approach might be more commercially viable: "if somebody made a piece that was very similar to one of my pieces from the 1950s [*sic*], that were less overtly sexual, that were less 'wet,' that were less translucent, that were maybe painted one side green and one side red, and very fancy looking, it could be more saleable, because they would deny the sexuality."[20] Despite the tone of dismissal here, this is exactly the direction her work would soon take.

Yet there was another, more significant reason for Wilke's bold embrace of color: it was a clever riposte to the charges of essentialism and narcissism which were beginning to be lodged against her.[21] Using paint quite literally put a barrier between the clay body and her own, transposing the sensuality that had long been a hallmark of her work into a more abstract key. It was a maneuver she pursued elsewhere in her work, too, as in *Venus Pareve* (1982–84), a series of miniature self-portraits executed in vibrantly polychromed plaster (**FIG. 15**). In Hebrew, "pareve" means neither meat nor dairy, a food that can be

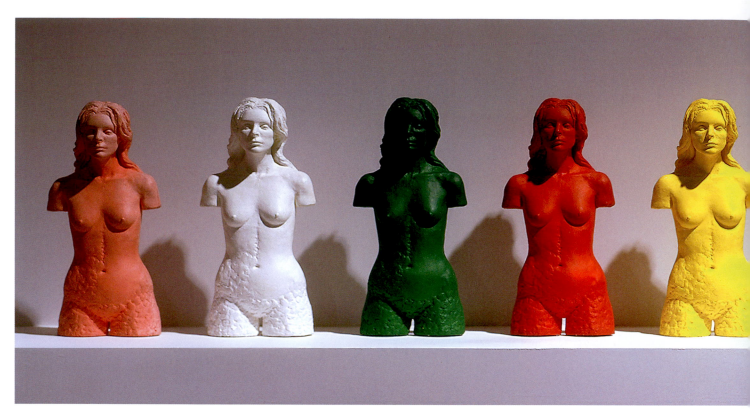

FIG. 15
Venus Pareve, 1982–84
Acrylic and plaster of Paris
Each 9 ⅞ × 5 ³/₁₆ × 3 ⁵/₁₆ inches (25.1 × 13.2 × 8.4 cm)
The Jewish Museum, New York, Purchase: Lillian Gordon Bequest, 2000-20a-i

eaten under any circumstances, and Wilke's title was meant to denote the idea of universality as well as her identity as a Jewish woman.[22] By rendering herself in unnatural hues, she distanced herself from the specifics of her own physical identity. This new posture reflected emerging ideas of gender as something performed, as in the writings of Judith Butler, and also anticipated more recent debates about the fluid relationship between the body and identity. Think, for example, of the controversy that circulated around the Pussyhat Project, a feminist protest against the Trump administration; the pink color of the knitted hats was critiqued for its insensitive exclusion of black and brown women's anatomy. Wilke was also considering issues of ethnicity when she used three Venus Pareve multiples in her *Venus Pareve: Monument to Replace the Statue of Liberty* (1982–86); the non-naturalistic palette she used in the 1980s did disrupt any easy equation between biological sex and the symbolism of gender identity.

In the context of ceramics, Wilke's swerve into plasticity positioned her once again as an outlier who nonetheless had serious business to conduct in clay. Ever a lover of wordplay, she titled one of her most important late ceramics *Geo-Logic 4 to I* (FIG. 14), implying that there was some mathematical

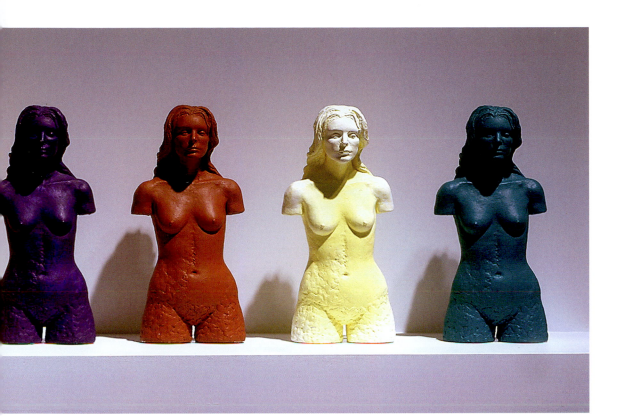

correlation between its spontaneous forms and its four-color gridded composition. Thus the painterly surfaces of her late work, while in some ways a repudiation of her earlier naturalism, were also a continuation. She thought of color much as she thought of clay—as a generative materiality. In her hands, this was a principle that crossed genres—decorative and fine art, craft and sculpture—and eluded stereotype. On one occasion, when discussing her 1984 exhibition *Support Foundation Comfort*, a memorial exhibition for her mother, Selma Butter, who had recently died, and which included many ceramic sculptures in memory of her as well as *Venus Pareve*, she commented, "I was never thought of as 'Earth Mother.' I was always thought of as 'Sex Goddess.' I think they are the same thing."[23] Her oeuvre in clay—always in touch with base materiality, yet assuming a beguiling array of different guises—bears out this thought. Goethe had it right: the most complicated cases are the most interesting.

NOTES

1 Saundra Goldman, "'Too Good Lookin' to Be Smart': Beauty, Performance, and the Art of Hannah Wilke" (PhD diss., University of Texas at Austin, 1999), 351.

2 This relationship was a theme running through the 1978 exhibition *So Help Me Hannah*, which included pointed allusions to the unacknowledged contributions Wilke had made to Oldenburg's work, particularly *Mouse Museum/Ray Gun Wing* (1969–77).

3 Wilke, quoted in Ruth Iskin, "Hannah Wilke in Conversation with Ruth Iskin," *Visual Dialog* 2, Summer 1977, 18. This limited-run periodical, unusually, presented Wilke's work in the context of other ceramic artists; the same issue featured an article on Peter Voulkos and another by the potter Erik Gronborg on the San Diego craft scene.

4 Wilke, "Hannah Wilke: A Very Female Thing," *New York*, February 1974, 58.

5 Wilke, quoted in Ernst Weber, "Artist Hannah Wilke Talks with Ernst, Part Two," *Oasis d'Neon* 1, no. 3 (1978) n.p. Wilke remembered that she got her then-boyfriend Francis Ford Coppola a job at the factory, but he was fired when the two were discovered kissing in the kiln room.

6 Though not strictly relevant here, Arneson and Wilke both created powerful bodies of late work addressing their own experiences of terminal illness. This connection was pointed out by Donald Kuspit in a review of Arneson's work in *Artforum*, September 1995, 91–92.

7 See Glenn Adamson, "Sloppy Seconds: The Strange Return of Clay," in Jenelle Porter and Ingrid Schaffner, eds., *Dirt on Delight: Impulses that Form Clay* (Philadelphia: Institute of Contemporary Art, 2009), 73–80.

8 Goldman, "'Too Good Lookin' to Be Smart'," 31.

9 Wilke, "Letter to Women Artists," in *Art: A Woman's Sensibility, Feminist Art Program* (Valencia: California Institute of the Arts, 1975), 76.

10 Wilke, interview with Robert McKaskell, [n.d.], quoted in Goldman, "'Too Good Lookin' to Be Smart'," 23.

11 Judith Tannenbaum, "Hannah Wilke," *Arts Magazine*, May 1974, 62. Saundra Goldman makes the same observation in "Gesture and the 'Regeneration of the Universe,'" in *Hannah Wilke: A Retrospective* (Copenhagen: Nikolaj, 1998), 20.

12 In this first presentation of the work, it was accompanied by *Laundry Lint (C.O.'s)* (1971–73), a row of sculptures of similar form, made from the lint of Claes Oldenburg's clothing.

13 Edit deAk, "Hannah Wilke at Feldman," *Art in America*, May/June 1974, 110.

14 Wilke, interview by Cindy Nemser, February 18, 1975, transcript (2013.M.21), Getty Research Institute, Los Angeles. A version edited by Donna Wingate with Marsie Scharlatt appears elsewhere in this publication, pp. 88–97.

15 Wilke, quoted in Weber, "Artist Hannah Wilke Talks with Ernst, Part Two."

16 Amanda Partridge, "Sculpting Scale: Interview with Joel Shapiro," *Sotheby's* (September 20, 2017), https://www.sothebys.com/en/articles/joel-shapiro-sculpting-scale.

17 Caro's ceramics were shown at the Everson Museum, Syracuse, in 1976. See Margie Hughto, *New Works in Clay by Contemporary Painters and Sculptors* (Syracuse, NY: Everson Museum of Art, 1976).

18 Wilke, quoted in Iskin, "Hannah Wilke in Conversation," 19.

19 Nancy Princenthal, *Hannah Wilke* (London: Prestel, 2010), 28.

20 "Artist Hannah Wilke Talks with Ernst, Part Two," n.p.

21 On Wilke and the question of essentialism, see Rachel Middleman, *Radical Eroticism: Women, Art, and Sex in the 1960s* (Oakland: University of California Press, 2018), 117–45.

22 This food-related theme is extended in another version of *Venus Pareve*, in which the figures are cast in chocolate—a wicked joke about Wilke as a consumable object. See Princenthal, *Hannah Wilke*, 136.

23 Wilke, quoted in Linda Montano, "Hannah Wilke Interview," in *Performance Artists Talking in the Eighties* (Berkeley: University of California Press, 2000), 140.

NEEDED ERASE HER? DON'T.

Hannah Wilke's Female Image

Connie Butler

Art history has chronically restricted women artists and artists of color from its canon, attendant with its narrow view of how such artists often flourished in the interstitial and politically contested spaces of its margins. Over the course of a career that ended with her death at fifty-two, Hannah Wilke worked in drawing, ceramics, sculpture, photography, video, and performance while traversing many of the major postwar art movements, including Pop, Conceptual, and feminist art with a range and ambition that always included an imagery of the female body, most often her own. In this essay, I use the term "female body" to refer to female-marked bodies, rather than to an inherent quality of the body itself. To Wilke, this distinction of understanding was not available. Her "female body" was one that presumed a cisgender and heterosexual male gaze.

Throughout the brief but prodigious arc of her project, Wilke crafted a radical feminist practice based on her particular bodily experience, with all of its attendant sexual stereotypes, misogyny, pleasure, and empowerment long associated with the female-gendered subject of art. Wilke used her body for evidence: as a tool of critique, as an object of our gaze, and as a spotlight on the problem of the subjugation of women's bodies throughout the history of art. The artist, while finding a material elasticity that matched the female body's own rhythms and mimicked its erotics, invented and used a sculptural language that could accommodate a multiplicity of forms, including abstraction, performance, and the construction of a conceptual self-image based on an idea of the female body as inhabited readymade. Prior to Wilke and feminism, art history's only use for the female body was as the object of the male gaze. With rare exceptions, it was only during the middle of the twentieth century that women artists began to make their inhabiting of the female body into a subject of art. Over and over—beginning with her ceramic forms; followed by the self-images she deployed to inhabit the guises of pinup, Madonna, and martyr; and finally in death when she recorded the transformation and

eventual demise of her own body from cancer (and with it the vacating of desire from within and without)—Wilke managed to deploy her body as material and image. Griselda Pollock, the feminist art historian whose groundbreaking work has suggested new ways of reimagining an art history to include practices that interrogate the very parameters of how a hegemonic art history is constructed, has suggested such a radical role for Wilke's work, asking:

> What happens…if you think that human condition through the particularities of the feminine body, the particularities of sexualities, of a different rhythm of time, the possibility of our own bodies to produce life, the decision perhaps not to produce life, the question of pleasure, the question of pain, and also the question of our very ambivalent relationships to beauty, to being seen. None of us can pretend that we are not traumatized by this particular problem in one way or the other.[1]

Wilke's lasting historical association with feminist art is clear, considering her inclusion in such important, early milestone exhibitions, both in the US and Europe, as *Anonymous was a Woman* in 1974 at California Institute of the Arts, two exhibitions at the Woman's Building in Los Angeles in 1977, and the artist-curated *Feministische Kunst International* (Women's Art International) in 1978.[2] These exhibitions—however marginal they may have seemed at the time—comprise a lineage within women's art history that is important to continue to note as evidence of a certain path that the artist sought from the beginning of her career.

Like many of her trailblazing feminist contemporaries, Wilke's artmaking began somewhat conventionally in 1957 when she entered the BFA program at Stella Elkins Tyler School of Fine Arts, to work in sculpture. Wilke's foundational training in ceramics provided an entry point to a sculptural language that was based on the human form, which allowed her to find, in the cul-de-sac of ceramics—formative for so many women in the postwar era—a way of both deploying her body and multiplying its image. This impulse toward seriality can be viewed as aligned with Pop art, and parallel to its sharp critique of commodification.

While at Tyler, Wilke studied with an influential ceramic artist named Rudolf Staffel, widely regarded as one of the innovators who reinvented the craft in the late twentieth century. It is this tutelage that seems to have solidified Wilke's roots in biomorphic abstraction, but also her notion and exploration of clay as a sculptural medium that could contain the subject, scale, and intimacy of the body. Wilke's gestural experiments in clay, the pinches and folds that describe her earliest forms, can be seen as an extended experimental practice and closely related to her later work in video and performance. The feminist art historian Jenni Sorkin has used the term "live form" to describe the ways in which the throwing of pots and the communal atmosphere and process of the pedagogy and studio environment of ceramic production impacted the formulation of social practices later in the 1970s, but also, as she says, "to understand

ceramics as a performative gesture made in real time and space...an object event."[3] But Sorkin also acknowledges that the liveness of ceramics and its direct relationship to the body, the responsiveness of the medium and its reliance on transformation, makes it a medium that was frequently allied with performance, especially for women artists. We can recall, for example, artists such as Lynda Benglis and her early use of porcelain. The bodiliness of Wilke's ceramic forms runs as a feminist counterpoint to the male-centric history of the medium's most experimental practitioners, whose forms remained resolutely within a modernist discourse.

Wilke's early drawings (once a little-known and rarely seen body of work) were similarly bodily focused biomorphic abstractions in which body parts, including sexual organs, are interwoven in beautiful, lyrical compositions with references to forms in nature, often nested in a grid structure or a webbing of parallel lines (FIG. 1). Not unlike her contemporary Eva Hesse, whose own move from colorful, surrealist-inspired drawings and paintings to gridded works in which the viscera of the body was contained and abstracted, Wilke, by the mid-1960s, deployed the geometry and serial impulse of Minimalism to order and structure her small units of clay, chewing gum, Play-Doh, terracotta, and porcelain.[4] By 1973 the clay forms were laid out in grids or orderly arrangements

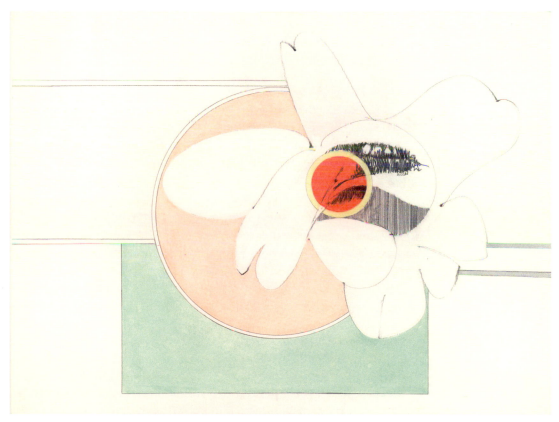

FIG. 1
Untitled, 1969
Colored pencil, graphite, and pastel on paper
18 × 24 inches (45.7 × 61 cm)
The Museum of Modern Art, New York, The Judith Rothschild Foundation
Contemporary Drawings Collection Gift

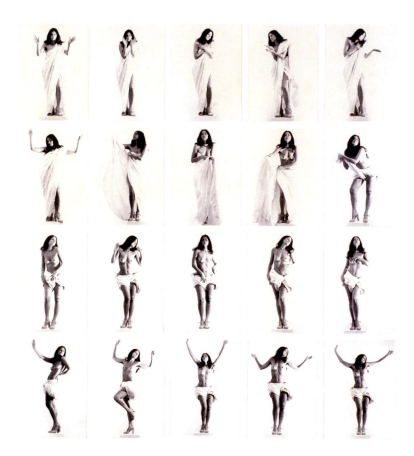

FIG. 2
Hannah Wilke Super-t-Art, 1974
20 black-and-white photographs
Each 6 ½ × 4 ½ inches (16.5 × 11.4 cm)
Overall 40 ¼ × 33 inches (102.2 × 83.8 cm)
Hannah Wilke Collection & Archive, Los Angeles
Courtesy Alison Jacques, London

directly on the gallery floor, for example, the pink units, varying in size, that populated the so-called *Floor Show* at Ronald Feldman gallery in 1974. Wilke's gendering of the space of the floor and the proliferation of her vaginal forms—and how these floor arrays were in dialogue with Minimalism's use of the floor as pedestal by artists such as Carl Andre, Donald Judd, and Barry Le Va—is notable, and worth further study. In the same year, *Needed-Erase-Her*, a series of kneaded eraser sculptures on painted boards in which rows and rows of the pinched forms march across painted wooden supports, threatened a kind of infinite multiplicity that borders on the monstrous.

Another way to situate Wilke's emerging interest in using the image of her own body as a medium, and as a living sculpture, parallel to the context of clay, and the role of crafts such as textiles and ceramic arts as a gateway for women artists into sculpture, is in the context of Pop art and the women artists in particular who reinvented it using their own bodies as eroticized, found objects. The emergence by 1974 of Wilke's performative photographic works such as *Hannah Wilke Super-t-Art* (1974), that develop alongside the abstractions in clay and latex, occurs through the trope of the goddess or pinup (FIG. 2).[5] This concurrence has always been jarring and apparently contradictory; and yet, taken together, they can be read as a meditation on the flesh as sculptural material and the female body as sculpture.

Perhaps the evolution of Wilke's female image in both her ceramics from the mid-1960s and her latex work from the 1970s, and the overtly feminist photographic and video works of the mid-1970s, is manifest through this trope, which we can view through a kind of art historical genealogy of the pinup. Its use by such artists as Willem de Kooning in his paintings and drawings of women, or proto-Pop images of the pinup by artists such as Mel Ramos or Richard Hamilton, offer potential corollaries. Wilke's contribution was to inhabit the pinup as living sculpture and, in doing so, to re-eroticize it. (De Kooning apparently owned one of Wilke's latex works from 1972, *Venus Cushion*, which is fascinating to consider against the backdrop of his Women paintings; the female subject and body dominated his work from 1950 to 1957

and lingered on in his drawings into the 1960s.) If one way to understand de Kooning's Women might be as a confrontation with the new image of "woman" that emerged in the 1950s and not as the violently cut, pasted, and painted bodies of misogyny, then his magnificent and muscular paintings become part of the cultural reckoning with the birth of the new woman and the women's movement. The image of the newly liberated woman is the point from which the Swiss artist Niki de Saint Phalle, the Belgian Evelyne Axell, and the lesser-known American artist Marjorie Strider, along with other women engaging with Pop art, initiated their critique. These powerful women artists began to articulate a proto-feminist position, a critique of the male gaze, by becoming authors of their own erotic visual language.

Another very obvious but not often charted nod that Wilke made to this male-dominated history of the female body-as-found-image and material is to Marcel Duchamp, whose legacy she explored in dialogue with the British artist Richard Hamilton, credited as the inventor of Pop art in Europe. Wilke met Hamilton in London in 1970 when she was there for the occasion of her then-partner Claes Oldenburg's retrospective at the Tate. She and Hamilton had an ongoing relationship that was intimate for a time in the mid-1970s through the early 1980s, and later evolved into a friendship and an ongoing conversation about their work, particularly their mutual interest in Duchamp.[6] Hamilton's own shape-shifting throughout his career from expressive painter to conceptual artist to manipulator of found objects has long made him an artist who is similarly difficult to categorize in the postmodern sense of stylistic experiment. First there is the uncanny resemblance of Wilke's anthropomorphic drawings of the late 1960s to Hamilton's early paintings in which what we assume to be a woman's body floats in and out of focus as a subject. I am thinking especially of his horizontal compositions such as *Hers Is a Lush Situation* (1961) or, one of his most famous early proto-Pop paintings, *Pin-up* (1961; FIG. 3). Wilke, too, made horizontal drawings that explored the body as landscape or abstract shapes.

Around the time the two artists met, Hamilton had just completed a series of twelve collages titled *Fashion Plates* (1969), which continued his ongoing interest in representation, but also in the fashion industry and its role in gender construction. Hamilton's work was a touchstone for Wilke at a number of points in her career, including perhaps her best-known video work, a striptease done in front of Duchamp's *The Bride Stripped Bare by Her Bachelors, Even (The Large Glass)* (1915–23) at the Philadelphia Museum of Art.[7] Organizing a retrospective of Duchamp after his

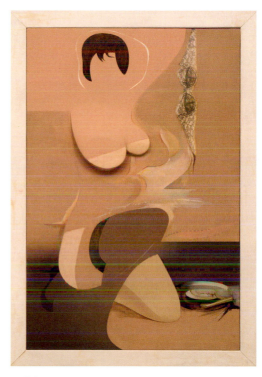

FIG. 3
Richard Hamilton, *Pin-up*, 1961
Oil, cellulose, and collage on panel
53 ¾ × 37 ¾ × 3 inches (136.5 × 95.8 × 7.6 cm), framed
The Museum of Modern Art, New York, Enid A. Haupt Fund and an anonymous fund

FIG. 4
Marxism and Art: Beware of Fascist Feminism, 1977
Silkscreen on Plexiglas
36 × 27 ½ inches (91.4 × 69.8 cm)
The Museum of Modern Art, New York, General Print Fund, Riva Castleman
Endowment Fund, Harrey S. Shipley Miller Fund, The Contemporary Arts
Council of The Museum of Modern Art, and partial gift of Marsie, Emanuelle,
Damon, and Andrew Scharlatt, Hannah Wilke Collection & Archive,
Los Angeles

death in 1968 for the Tate, Hamilton painstakingly recreated *The Large Glass* in homage to, and conceptual collaboration with, Duchamp. Wilke's playful action behind Duchamp's original work in *Hannah Wilke Through the Large Glass* (1976) resonates formally with her earlier abstractions, her body framed by the individual forms of Duchamp's chocolate grinder and the wires of the gridded glass. Wilke is both object and voyeur, a living sculpture, as she often was in her video works.

While this pantheon of male forerunners is one lineage that makes sense for Wilke, given her close, personal relationships with major artists associated with Pop art such as Oldenburg and Hamilton, it is important to also acknowledge Wilke's ties to her women colleagues whose use of self-image was striking and exceptional in the Pop context. Wilke is rarely included among Pop anthologies of women artists, of which there are very few. One excellent source is *Power Up: Female Pop Art* (2001), in which curator Kalliopi Minioudaki argues, "It is the redemption of the erotic pleasure of women's consumption of pop culture and the celebration of women's right to erotic pleasure per se that distinguish the proto-feminist drive of several of the women of Pop, whether they adapted or reinvented Pop vernaculars to speak of female desire(s)."[8]

While Wilke was always a self-proclaimed feminist and associated herself with a number of consciousness raising and women's groups, she also famously had a fraught relationship to what she would eventually call "fascist feminism," by which I take her meaning as the feminist art orthodoxy that is always, apocryphally, referred to by those who were part of second-wave feminism in New York, Los Angeles, and London, where organized movements existed adjacent to the art world. In 1977 Wilke made a poster, *Marxism and Art: Beware of Fascist Feminism,* in response to the question "What Is Feminist Art?" The small black-and-white print, later made into a large silkscreen (FIG. 4), was a provocation to Wilke's colleagues in the feminist orthodoxy, whose essentialist notions about women's identity didn't allow for such frank images of empowerment, self-representation, and pleasure. *Marxism and Art* is a direct response to then-feminist critic Lucy Lippard who, in spite of her conventional beginnings, was by the mid-1970s a champion of women's art but had publicly accused Wilke

FIG. 5
Evelyne Axell, *Valentine*, 1966
Oil paint, zip-fastener, and helmet on canvas
52 ¼ × 32 ½ inches (133 × 83 cm)
Tate, Purchased with funds provided by Tate
International Council 2016, T14349

FIG. 6
Marjorie Strider, *Green Triptych*, 1963
Acrylic paint, laminated pine on Masonite panels
77 ½ × 94 ¾ × 8 inches (196.8 × 240.6 × 20.3)
Private collection

of capitalizing on her body and her beauty. I have personally heard this reiterated by a number of Wilke's peers who grew tired of the artist disrupting various art events by performatively taking her clothes off. Wilke's performance of beauty—her modeling and foregrounding of the body she inhabited—was in fact a strategy. But there are a number of women artists whose work opened a category of Pop art that I would call erotic Pop, where a rethinking of Duchamp and the found object got reworked through the form and vehicle of the female body. De Saint Phalle, Axell (**FIG. 5**), and Strider (**FIG. 6**)—with whom Wilke taught for many years at the School of Visual Arts in New York—all invented a specifically female image in their individual practices of Pop art using the emblem of the so-called sexual revolution, the female body.

This focus on a visual language of the erotic has been little discussed in the literature on Wilke. I am interested in situating her within an erotic Pop art that emerged in the mid-1960s, adjacent to mainstream Pop art associated in the US with Andy Warhol alongside the women artists I have named, whose work was

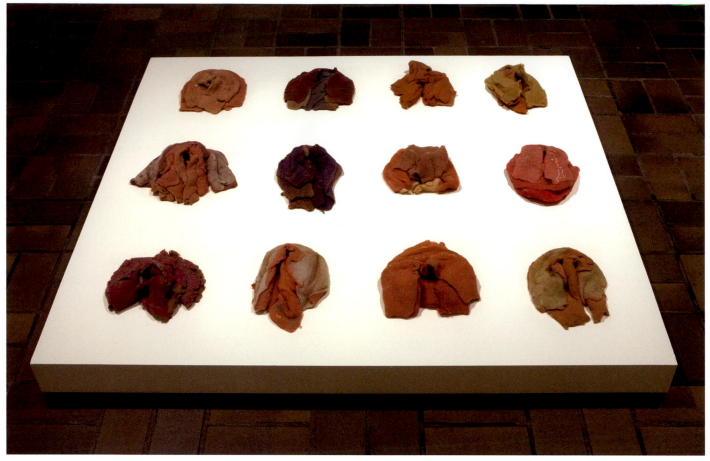

FIG. 7
Laundry Lint (C.O.'s), 1971–73
12 lint sculptures
Dimensions variable
Hannah Wilke Collection & Archive,
Los Angeles, courtesy Alison Jacques, London

equally unmoored from the conventional circulation of an art world that was beginning to consume American Pop. As her use of ceramics proliferated through the 1970s, even as her performance and photography became more conceptual, the forms took on a more obviously feminist iconography. Sculptures such as *Teasel Cushion* from 1967 (p. 130) and *Laundry Lint (C.O.'s)* (**FIG. 7**) both reference the body quite literally in color and material: the coarse, dark plastic nest that the pink ceramic form rests on resembling nothing if not pubic hair and the limp red, pinkish, and flesh-colored folds of laundry lint viscerally mapping the folds of vaginal and vulvic anatomy. In both cases the material was designated for its abstract qualities of color or tactility, and Wilke worked with these material choices to signify a certain domestic intimacy related to the female body. Scale also plays a role in these works, as the intimate and ephemeral is rendered enormous and static. The laundry lint is especially evocative, gathered by color into molded accretions reminiscent of the vagina and vulva and carefully laid on the floor in a row or in a grid (fifty specimens in its original incarnation) for the viewer to behold.[9] Vulnerable and humorous, these small heaps of flat lint sheets contain traces of inhabitance: hair, thread, and everyday dirt.

Even as she made these intimate, discrete gestures directly related to the domestic realm and the trace of the body within it, Wilke was thinking big. Her groupings of folded ceramic forms were multiplying, and she was imagining them at a monumental scale. It was at this same time that Wilke joined forces with an unlikely group of women artists in New York whose aggressive use of erotic imagery and overt sexuality from their perspective made them doubly controversial. In his essay "Hard Targets: Male Bodies, Feminist Art, and the Force of Censorship in the 1970s," art historian Richard Meyer writes about this overlooked and not otherwise associated group of women artists who came together in 1973 around a shared commitment to erotic imagery in their art, including founder Anita Steckel, Judith Bernstein, Louise Bourgeois, Martha Edelheit, Eunice Golden, Juanita McNeely, Barbara Nessim, Joan Semmel, Anne Sharpe, and Hannah Wilke. According to Meyer, Fight Censorship (FC) was a self-organized, feminist collective of women artists who, according to a press release on their activity, "have done, will do, or do some form of sexually explicit art, i.e., political, humorous, erotic, psychological....We women artists...demand that sexual subject matter—as it is part of life—no longer be prevented from being part of art!"[10]

As divergent as their practices were, according to this manifesto, what drew these artists together was a focus on the phallus and heterosexual pleasure. The image of Louise Bourgeois holding her sculpture *Fillette* (1968), a larger than life penis, as if she were cradling a child is perhaps the most indelible image from their activities. Others such as Judith Bernstein created an entire body of work that extended over many years based on the repeated drawing of a monumental and menacing phallus that surrounds the viewer like wallpaper. Anita Steckel's own imagery combined her naked body with the New York City skyline. Cavorting with the phallic buildings signifying the glory of American hegemony, Steckel suggested a world dominated by eroticism and sexual pleasure using her own body as urban monument. Figurative painters Sylvia Sleigh, Betty Tomkins, and Joan Semmel exploited sexual acts between men and women. Wilke herself incorporated phallic forms in her drawings, but she also incorporated the men in her life into photographic works that defied the critical rejection of an imagery that centers a woman's desire.

Wilke's clear interest in the reanimation of the forms of the body led to the first actual use of her own body in 1974 with the live performance at the Kitchen, where she first performed *Super-t-Art* as a three-minute series of performed gestures that became the source for the photographic work. The work was part of a Fluxus-style marathon evening of performances organized by artist Jean Dupuy and called "Soup and Tart," because the evening began with the sharing of a meal. Ever one to embrace a pun, as she frequently did in her own titles, Wilke's *Super-t-Art* riffed on the striptease and pinup as "tart." Writing in 1976, in the context of a Guggenheim fellowship application, Wilke articulated clearly her desire to create a woman's art using her own image:

Since 1960, I have been concerned with the creation of a formal imagery that is specifically female, a new language that fuses mind and body into erotic objects that are namable and at the same time quite abstract. Its content has always related to my own body and feelings reflecting pleasure as well as pain, the ambiguity and complexity of emotions. Human gestures, multilayered metaphysical symbols below the gut level translated into an art close to laughter, making love, shaking hands.... Eating fortune cookies instead of signing them, chewing gum into androgynous objects...Rearranging the touch of sensuality with a residual magic made from laundry lint or latex loosely laid out like love vulnerable exposed...continually exposing myself to whatever situation occurs...gamboling as well as gambling.[11]

In many ways Wilke's feminism was complicated by the mixed reception of her own art, by her now-infamous performances and photographs featuring her body and image that were rejected by some of the feminist orthodoxy in which she chose to engage in the 1970s. When she was young and beautiful it was as if those attributes disqualified her from participating in a critique of sexuality and the construction of gender. Once she was older and dying from a disease that ravaged her body, she was criticized for images (see her *Intra-Venus Series* [1991–93; pp. 190–95, 198–99]) that were too frank, too stark in their confrontation with illness and eventual death. An audience that once couldn't look at her because she was literally exposing her sex, couldn't look at the same body once it was no longer conventionally beautiful. "How can we link thought and bodies?" as Griselda Pollock has written about Wilke's deployment of her own body.[12] It is as if the artist knew there was no way out of this problem and therefore decided to ramp it up—to double down as we might say today—on her own ambition, inventing a female language of art by co-opting the conventionally hyper-feminine image and type. It was as if by using and even flaunting or at least teasing us with her nakedness, Wilke reinforced her commitment to the female image.

NOTES

1 Griselda Pollock in "Rethinking Hannah Wilke," Tracy Fitzpatrick in conversation with
 Saundra Goldman, Thomas H. Kochheiser, and Pollock, in *Hannah Wilke: Gestures*
 (Purchase, NY: Neuberger Museum of Art, 2009), 81.

2 See "Selected Chronology of All-Women Group Exhibitions, 1943–83," in *WACK! Art and
 the Feminist Revolution* (Los Angeles: The Museum of Contemporary Art; and Cambridge,
 MA: The MIT Press, 2007), 492. This timeline suggests an alternative geneology for
 women artists showing in the nascent context of feminist art during this period.

3 Jenni Sorkin, "Craft as Collective Practice," in *Live Form: Women, Ceramics and
 Community* (Chicago: The University of Chicago Press, 2016), 4.

4 *Elective Affinities* from 1978 is one such major work in porcelain, consisting of eighty-six
 white glazed porcelain ceramic sculptures arranged in four grids.

5 Tracy Fitzpatrick's essay in *Gestures* "Living Sculpture" discusses this at length.

6 This was related by Wilke's sister Marsie Scharlatt in an email to the author, October 18,
 2020.

7 According to Scharlatt, Wilke asked Hamilton to photograph her near Duchamp's home
 in Cadaqués, Spain, for her performalist self-portrait *I Object: Memoirs of a Sugargiver*,
 1977–78, and she made the Polaroid triptych *Venus Envy*, 1980, from a series of Polaroids
 they took together for Hamilton's books of portraits of himself by artist friends, in which
 Wilke is included.

8 Kalliopi Minioudaki, "Other(s') Pop: The Return of the Repressed of Two Discourses," in
 Power Up: Female Pop Art (Vienna: Kunsthalle Wien, 2011), 141.

9 See an image and description of the original work in *Gestures*, 23.

10 Richard Meyer, "Hard Targets: Male Bodies, Feminist Art, and the Force of Censorship in
 the 1970s," in *WACK!*, 366.

11 This quote was reused in the videotaped lecture performance "*Intercourse with…*" in 1977
 and published in *Re-View* 1, no. 1 (1977): 41–42 and back cover. See Wilke's excerpted
 writings on Hannah Wilke Collection & Archive, Los Angeles website: http://www
 .hannahwilke.com/id15.html.

12 Pollock in "Rethinking Hannah Wilke," 81.

Daughter / Mother

CATHERINE OPIE

Hannah Wilke began working on her *Portrait of the Artist with Her Mother, Selma Butter* in 1978, the same year Susan Sontag wrote the book *Illness as Metaphor*. Sontag's celebrated work argues that victim blaming as a form of language should be looked at, and that cancer is just a disease. Wilke's unflinching image of her mother is a stark portrayal of the devastation of cancer: the battle is etched in her skin.

Photography is capable of lying to us in different ways, but these photographs are about witnessing Wilke's own contemplation of what is private and public with regard to her mother's illness, her body/her mother's body. The seemingly simple act of making a photograph always amazes me and reflects the depths of photography as a visual language.

I need to tell readers that I began writing this during the COVID-19 pandemic, just before my mom called me with news that her routine colonoscopy showed a growth that could be cancer. It is now a week later, and she has had surgery. I am in Poway, California, taking care of her, and as I look at her eighty-four-year-old body, so visibly strong from her years of being an athlete—swimming and playing tennis, sports that are still a large part of her life—I am very aware of our bodies, her body and my body, the way we both share space.

The desire for me to document the fragility of the moment is present, but I resist the temptation of my lens. Our mother/daughter bond through our bodies is loaded with metaphors that are at times difficult to reckon with.

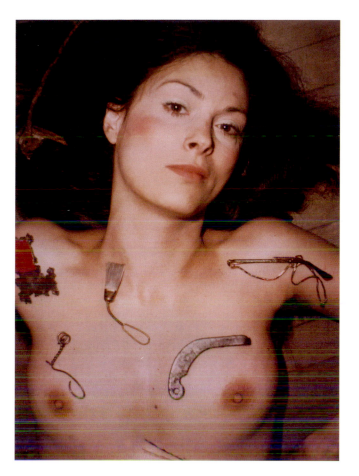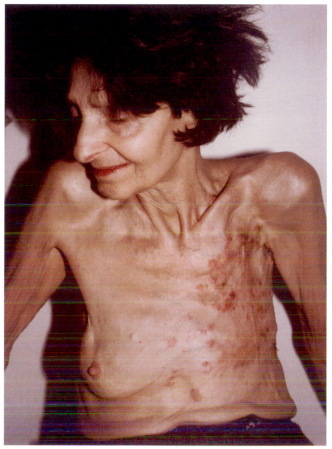

Portrait of the Artist with Her Mother, Selma Butter, 1978–81
Cibachrome diptych. Exhibition prints, 2003
Each 40 × 30 inches (101.6 × 76.2 cm)

Birth and death loom large as themes in literature and film (for example, as mammals we are all birthed). With a determined consistency through Wilke's years as an artist, working across a number of mediums, she explored a number of such big themes encompassing body and death.

The diptych of photographs consists of Wilke lying down with objects placed above her breast and shoulders—at first glance they seem like tattoos, but they are in fact talismans, reclaimed gifts to an ex-lover. The second photograph shows her mother, Selma Butter. Although Selma's eyes are closed, her head is positioned to gaze onto her daughter's body. In another moment from a different frame on the contact sheet her eyes might have been open, but Wilke chose to represent her mother in this image. Wilke's body is youthful, her breasts intact: the artwork and body that critics have commented on throughout the years, for not being a good enough feminist, and for objectifying her own beauty in the making of her work. This was always a problematic argument in my mind: that using one's relationship to their body and beauty as an object isn't being a good feminist. I think to myself, "What would Sontag say?"

Wilke stares at the camera, thus engaging directly with the viewer. Her mother is revealing the mastectomy scars, one breast gone, a body that has been damaged by cancer and exposed in the most vulnerable way. The camera's flash illuminates the details and maps the damage. Is she is wearing a bit of lipstick? The mark of femininity, lipstick. This compromised body of one's own mother is seen through that ambivalent lens, capturing the personal, making it public. Most women of this generation were taught not to talk about the body. We bleed, we maybe give birth, we go through menopause, and we die. Selma Butter was born in 1909 and died in 1982. Hannah Wilke was born in 1940, diagnosed with cancer in 1987, and died in 1993.

This work, these photographs, stop me in my tracks. Photography and its ability to gaze upon the history of these two bodies remind me of both the simplicity and difficulty in creating a language of bearing witness to one's own life. There is an enormous amount of failure in photography, but often the failure, in my mind, is in how viewers read photographs. It takes years for the act to reveal the complexities of image makers. It is at times an impossible task and undertaking to be an artist. Wilke was critiqued in her life and then mourned in her death. The art lives on for us to continue to grapple with the themes of life and death. I am grateful to be reminded again of her work in the time of my own mother's cancer, during COVID-19, in a world grappling with a disease that is challenging with regard to language and ideologies. Failure is present.

what does it mean for the mother's body to fail
for the disease to be present
on the body of the mother
the mother who gave birth through her vagina
a vagina that Wilke explores
a cunt
what is the mother
in 1978
a mother who once breastfed the artist
as a baby
(I presume)
a mother who looked away from the camera
while Wilke stares back

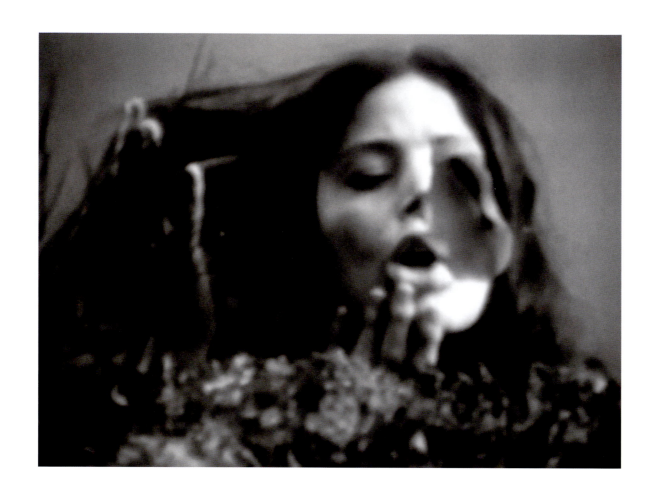

Still from *Hello Boys*, 1975
Black-and-white video with sound
12 min.

Ha-Ha-Hannah

JEANINE OLESON

Humor is a lot like good art: it can provide us with a jolt, just when the incongruities of life and known materials collide in unexpected ways. It's a state of suspension between what we think and what we experience—a kind of delight in the revealed potential of this jolt. I'm mostly thinking of something called the "benign violation theory," which suggests that humor occurs when there is a violation but the situation is benign—that is, the violation cannot cause us harm. We look at the harm and see it in a new way through a shocked response that makes us laugh.

Why am I talking about humor and violation with regard to Hannah Wilke? Because through her artmaking, she was really quite funny, possessing an ability to leverage and take on risks that consistently produced certain shocks and intellectual scramblings—as well as a plethora of terrific puns.

In particular, I'm thinking of her twelve-minute video piece *Hello Boys* (1975). It's one continuous shot of Wilke doing a slow languorous performance behind a fish tank, which provides a veil of fish and coral through which we see her upper body. It's recorded in that soft greyscale glow of the Sony Portapak, which was the first such system that allowed artists to work with long, cheap expanses of time on videotape.

In the shot, the camera zooms in and out to both reveal and abstract the entirety of the scene. *Quadrophenia* (1973), that other (cock) rock opera by the Who, provides the soundtrack. I'm imagining the album playing in some apartment in Paris with a fish tank, the art dealer Gerald Piltzer (who is

credited with shooting the piece), and the sound of waves crashing that opens the record, when it suddenly dawned on Wilke that this was the perfect stage to enter with an erotics of display. In this, as with many of her performances, Wilke used her own body as material—she moved in exaggerated undulations to lyrics like "Is it me, for a moment?" and then, "Can you see the real me, can you, can you?"

Casting herself as a mermaid possibly luring men to their ruin, and reminiscent of the campy soft-core titillation of a mid-century Florida Weeki Wachee mermaid show, Wilke was still simply a person with a fish tank and some music acting out an illusion of the underwater world. But mermaids signal death and destruction to those who desire them, which is based on some pretty deep patriarchal anxieties. What could this possibly be but some cultural trauma-laden humor?

The title also reminds me of that bawdy powerhouse of sexual camp, Mae West. West always managed to flip the script on gendered power, walking her way into so many cinematic scenes filled with men who were flattened by one of her madamesque "Hello, boys" greetings—thrown to assert a certain sexual power and knowledge in a world where women were often patronized and/or terrorized into inconsequential "girls." West was famously known for writing her own double entendre–laden scripts, to both claim credit for her comedic genius and maintain her iconoclastic standing. It would not surprise me one bit to learn that Wilke grew up on (and loved) Mae West's vaudevillian audacity and larger-than-life sexuality.

Humor has also been called an evolutionary tool, one that produces new understandings through shock and pleasure. I remember seeing *Hello Boys* as a young student at the Video Data Bank in Chicago and being so confused by it, due to my own limited ideas about what I even thought Wilke was allowed to do as an artist. My understanding of it was that it was actually funny and exciting, seeing her flaunt the conventions. There was something about having that critical distance from desire, while watching that same desire create another version of pleasure, pushed out into some new kind of space for my conception of art.

For some reason, I carried around an idea in my naive young mind that art wasn't—or couldn't be—funny, that is until my cousins laughed really hard at my "intense" foundation year art videos in a trauma-jolt of its own comedic reality. At about the same time, it dawned on me that popular culture

Still from *Belle of the Nineties*, 1934, with Mae West

and the many-faceted constructions of gender could actually be critiqued from a casual, arch-erotic performance staged behind a fish tank. This work, as well as my own experiences connected to my queer teen passion for John Waters's campy, trashy films as legitimate expression created in the face of the world's horridness, helped me realize that this was a valid form of art. While I didn't have an aptitude or interest in weaponizing heteronormative forms of gendered desire, I definitely appreciated the critique I saw being wrought. Studying with transgressive teachers such as Barbara DeGenevieve, whose work pushed the boundaries of what could be permitted in the context of art (or even culture) as desire, I came to see Wilke's work as a precursor in this lineage—a perverse, funny, sex positivity before the Culture Wars of the 1990s.

Wilke's work, always feminist, was more concerned with engaging the structural apparatus of misogyny and sexism as it existed in the framework of culture and cultural production, than in creating controlled virtuous representations. In rewatching her performances for the camera, it's clear to me that she understood how to deploy the "value" of her white, conventionally attractive, able—and, for a time, young—body as an object to mine the mechanisms of patriarchal view and control, a kind of mineshaft into the psyche of gendered power. I might even go so far as to say she embedded herself in that role in order to report back to us via her work—treacherous work—that gained her few ideological allies. Her performalist self-portraits became extended performances such as the later *So Help Me Hannah* (1982) at A.I.R. Gallery. Not unlike *Hello Boys*, this piece figured Wilke into a bizarre femme fatale in mock dramatic poses. Naked and in high heels, she held a handgun as multiple cameramen followed her every move, while the voiceover of statements and quotes indicates a desire to further control the direction of interpretation. Her comedy gets a little serious.

When I think of Hannah Wilke's legacy, I think of sexuality, pleasure, and humor—though they are often in conflict with the very movements with which she might have been aligned. Her artwork, also well known for its straightforward depictions of illness and the aging body, still engages in layers of humor and play. For Wilke, life, humor, and sexuality seemed closely related to death. As is said in the voiceover to *So Help Me Hannah*, "Beauty and ruin are not things in themselves. They are physical necessities necessarily interdependent." Humor is a form of embodied survival—in the case of Wilke surviving misogyny, a kind of conservative feminist ire, and a public engagement with death. Frank sexuality overlaps with the same ideas about illness. Death and subsequent loss loom within her work, but despite it all, life is also driven by libidinal impulse, desire, and pleasure—all of which can be metered through a certain humor. They're not mutually exclusive, and this is what remains for us to behold in Hannah Wilke's "body" of work.

Cycling through Gestures to Strike a Pose

NADIA MYRE

In repeated viewings of Hannah Wilke's *Gestures* (1974), what I see first and foremost is an artist studying herself in a liminal state, working with and through her body to make a connection to the world. The in-camera performances she enacted in this, her first work in video, and the reaction and debate they stirred in the art world and the larger community about feminism would influence and shape the rest of her career. Wilke recognized the unparalleled intimacy and honesty of performing on video: "That confrontation is so aboveboard that sometimes it is frightening."[1]

Gestures is a black-and-white, thirty-five-minute-long work of moments shot sequentially, in real time. Each segment was recorded in a single take and edited in-camera, becoming progressively shorter as the video plays on. Wilke set up the camera herself, anticipating how she would be framed. She recorded five "acts" that vary in states of dress, confrontation, and intimacy. Although some of the gestures point to intimacy, this is mostly conveyed by how her figure appears in the frame, moving from various close-ups (regular, loose, tight, and extreme), the slowness of her movements, the quality of the light as the day passes, and the ambient bustle of city sounds against the drum of the camera, in contrast to Wilke's silence.

Most of the writing I have come across on this work interprets the piece through the lens of her sculpture in clay, commenting on the pulling, kneading, and shaping of her face as a malleable material, while others view it critically for stirring a sexualized affect in the viewer, with her "sultry eyes, seductively parted lips, and naked breasts" to be "read as cultural signifiers of female sexual invitation and availability."[2]

Wilke herself described the impetus of this work as a compelling urgency to move into action after the sudden passing of her brother-in-law. "When my brother-in-law died, I set up the video camera in Claes's [Oldenberg] studio, and I touched myself, felt myself, molded my face, and stroked myself until I got back my body at a time when I felt emotionally lost."[3] As she labored to shift grief toward something else, the camera bore witness to a series of private acts of performative gestures.

In front of a black wall, wearing a black top, Wilke's hands and face float in darkness. We sense her performing to the camera for the first time. There are moments of hesitancy and uncertainty, mixed with duty and expectation. Her initial series of movements are tentative and stiff. Her expression is emotionally blank, as if observing from outside herself. Her fingers prod, massage, and pull at her face as if attempting to soften the emotional self.

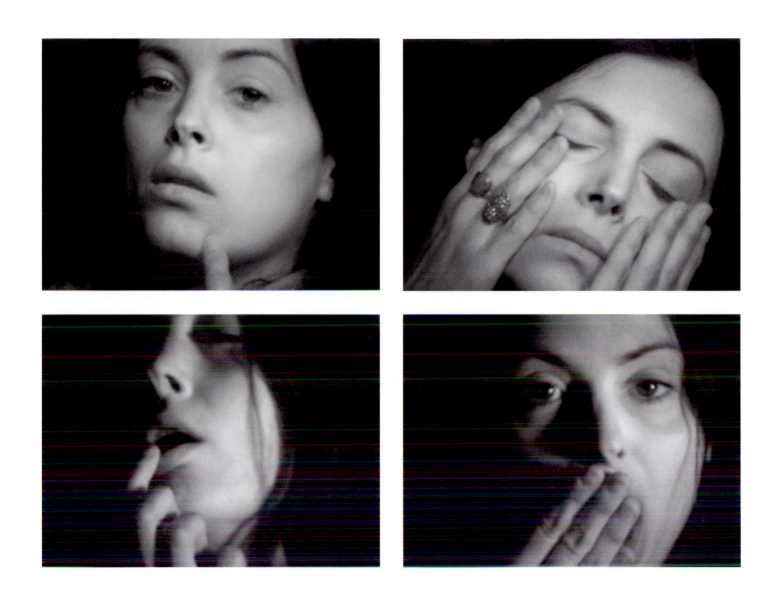

Stills from *Gestures*, 1974
Black-and-white video with sound
35:30 min.

At times her hands enact familiar gestures, moving in tandem to circle around her eyes and cheeks, as a woman might wash her face or apply cream, others more sensual, as she strokes her open lips with wetted fingers. Occasionally her hands appear to belong to someone else as they cycle through memories of how loved ones have touched her: playfully pinching and patting her face and head, affectionately brushing away wisps of hair, contrasted with more violent actions such as pushing the side of her cheek up, as if pinned against a wall or floor.

The first sequence is a warm-up exercise. It is raw and imbued with naïveté, expressing the inner private world of the artist. The second sequence wrestles with the outward-facing image. Enacted with precision and mindfulness, Wilke glides through a series of pantomimic poses to reveal a myriad of archetypes commonly associated with women: ingenue, coquette, diva, shy maiden, scorned queen, seductress/petulant lover, stoic huntress, gamine.

This sequence is especially important, as the impetus to "pose," to assume a certain attitude or character, will generate subsequent work (such as *S.O.S Starification Object Series* [1974], pp. 30–31), wherein Wilke toyed with the many roles women are meant to "play." Throughout, *Gestures* oscillates between an embodied and disembodied self, between inner private moments against outer social displays. To watch sensual gestures performed impersonally uncouples our expectation of pleasure, and the pathos of her performance confronts and unsettles our own desire.

In my own experience, working with gesture as an embodied practice is to engage in a moment of deep intuitive listening. Gestures, as I perceive them, emerge from an emotive condition to utter secrets revealed through movements that are driven by an instinctual (unconscious), deliberate (conscious), or intuitive (subconscious) action, reaction, or counteraction. As an artist, I must allow my body the time and space it needs to share what it knows and remembers.

Rooting into one's bones isn't a given. Awakening the senses to the kinesthetic self helps establish a feeling of embodiment: exerting varied pressure against one's flesh—a forceful or feather touch, temporal shifts between furtive and slowed movements, putting your fingers in your mouth, closing your eyes, repetition. There is also the way in which one carries her body. If heavy and weighted with lead, you might move through space like molasses, slowed by an interior burden. Movements are fleeting. The act of repeating them helps define the articulation of the gesture—where does it begin? where does it lead? where does it end?[4]—and recognize its significance.

However, the artist's gestures must keep changing. Continued repetition excites the brain to situate an experience. The thinking self is always searching to attach a story or narrative to what is happening. Vacillating between significance and insignificance, the artist must be a vigilant observer: present but not attached to what she is doing, how she is being, and what meaning she is making. An embodied practice is not unlike a drawing or ceramic practice—you must disable the thinking brain from dictating what it believes it sees and knows, and instead let the eyes, heart, and hand lead the work—or

like meditation, in which the objective products of the unconscious are spontaneously produced and emerge in consciousness.[5]

Sometimes the artist doesn't really know what she's doing when she sets out. Throughout *Gestures*, there is a sense of Wilke discovering herself, rewatching her own image in a recursive process, wherein each new sequence is guided by the previous exploration. As a painter might sketch her subject, studying the composition before applying pigment to canvas, Wilke—an artist who worked with her body as medium—captured her image with a video camera to register and catalogue movements, drawing out a vocabulary of poses and archetypes for a repertoire that she would revisit throughout her career. What begins as a need to reconnect to self becomes an understanding of the artificial persona, and the performative mask. As Amelia Jones writes, the driving force of Wilke's oeuvre is not about "a superficial-self isolated as a pretty picture, but about a female subject deeply absorbed in its own embodied self-reflection."[6] To my eyes, *Gestures* is a study from which the seeds of a "self," wherein Wilke was both the artist and the subject of her work, are unearthed. It is through *Gestures* that Wilke is awakened to using her body in a feminist act to subvert the expectation of an easy read. "I become my art; my art becomes me....My heart is hard to handle, my art is too."[7]

NOTES

1 Wilke, quoted in Ruth Iskin, "Hannah Wilke in Conversation with Ruth Iskin," *Visual Dialog* 2, Summer 1977, 20.

2 Jennifer Linton, "The Art of Hannah Wilke: 'Feminist Narcissism' and the Reclamation of the Erotic Body," *Lady Lazarus* (December 31, 2010), https://jenniferlinton.com/2010/12/31/the-art-of-hannah-wilke-feminist-narcissism-and-the-reclamation-of-the-erotic-body/.

3 Wilke, quoted in Linda Montano, "Hannah Wilke Interview," *Performance Artists Talking in the Eighties* (Berkeley: University of California Press, 2000), 139.

4 Although the notion of mapping out a movement's phrase is a common tool in embodied practices, I was introduced to thinking about these particular sets of questions (where does it begin? where does it lead?) by Diane Roberts through her Arrivals Legacy Project.

5 Carl Jung, *Mysterium Coniunctionis: An Inquiry into the Separation and Synthesis of Psychic Opposites in Alchemy*, vol. 14 of *Collected Works of C. G. Jung* (Princeton, NJ: Princeton University Press, 1970), 710.

6 Amelia Jones, "Everybody Dies...Even the Gorgeous: Resurrecting the Work of Hannah Wilke." First published in markzine.com, 2003. Reprinted in *The Rhetoric of the Pose: Rethinking Hannah Wilke* (Santa Cruz: Mary Porter Sesnon Art Gallery, University of California, 2005), 11.

7 Excerpts from Hannah Wilke, "Letter to Women Artists," in *Art: A Woman's Sensibility* (Valencia, CA: Feminist Art Program, California Institute of the Arts, 1975), 76.

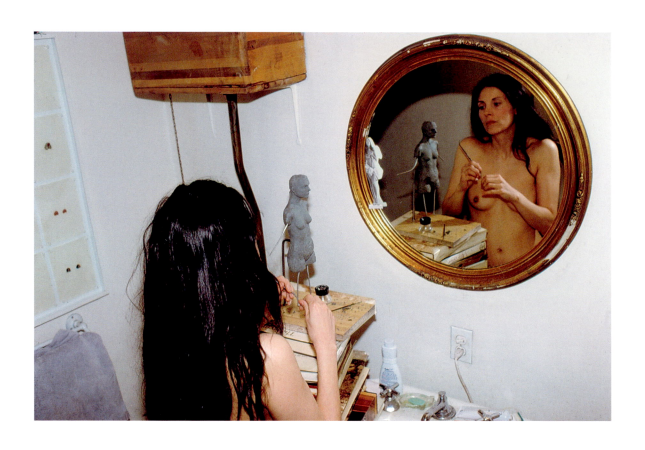

Hannah Wilke in her Greene Street
studio, New York, carving model for
Venus Pareve, 1982
Hannah Wilke Collection & Archive,
Los Angeles

Play and Care

HAYV KAHRAMAN

In one particular photograph of Hannah Wilke, her back is turned to the lens, her long black hair streaming out of the lower edge of the frame. A round mirror hanging on the wall reflects her face and nude body to us. She seems to be holding a sculptor's loop rake in her hands, her arms positioned to reveal one breast, while her eyes glance at the nude clay sculpture she is working on.

I'm reminded of Sandro Botticelli's protagonist in the *Birth of Venus* (ca. 1485), where she stands on a seashell reminiscent of a vulva, her head tilted, gaze indistinct, one arm across her chest in a vague attempt to conceal it. As a young adult, I came across this painting while walking through the Uffizi Gallery in Florence, and I remember feeling pulled in by some obscure, complicated seduction.

Western art is dominated by pictures like Botticelli's—made by men who appropriated women's naked bodies for the purpose of, among many other things, enticing the viewer into the frame. I think Wilke was interested in interrogating these reductive yet incredibly effective strategies.

Wilke's appearance conformed to the mainstream notions of beauty of her moment. Her impulse may have been to weaponize these attributes by reversing the gaze, aiming it right back at us. She knew that her image—this projection of her nude body as seen in *Hannah Wilke Through the Large Glass* (1976)—on one level functioned as a commodity to the masculine subject, one that was plagued by the patriarchal a priori image of man. Wilke was not afraid to call that out by turning the mirror back at us, as if to say, "I see you

Film stills from the performance *Hannah Wilke Through the Large Glass*, Philadelphia Museum of Art, 1976. Hannah Wilke Collection & Archive, Los Angeles

seeing me and here's what you look like!" It seems to me that she was reclaiming her own projection by conflating herself as both subject and object, carefully studying what "He"—the white, heteronormative man—desired, serving it back on a shiny plate, acting as both cake and the consumer of it.

Throughout her career, Wilke was at times critiqued for working with her body as medium and material. The critic Lucy Lippard wrote in 1976 that Wilke's "confusion of her roles as beautiful woman and artist, as flirt and feminist, has resulted at times in politically ambiguous manifestations that have exposed her to criticism on a personal as well as on an artistic level."[1]

Although critics such as Lippard seem to have misread Wilke's approach, her tactic of reversal is a familiar instrument to me; it is one that I use frequently in my work—albeit slightly differently than Wilke. At a young age, I fled the war in Iraq and became a refugee in Sweden, where I was taught to worship white European art history. The spell of coloniality was cast on my body, my thoughts, and my being, and I grew up feeling that the only way for me to speak about my status of being a minority, whether in relation to gender or race, is best expressed using the language of the oppressor. Throughout this process I learned the ins and outs of systemic oppression and its perpetrators, and I decided to adopt some of their modes of expression in order to flip the dynamic. European depictions of "beauty" are inserted in some of my paintings as decoys that serve to expose the corrosive fetishes placed on my body as an immigrant woman of color.

What particularly attracted me to this photograph of Wilke was what I perceive as her deliberate and defiant use of her beauty as a decoy. The mirror here suggests a palimpsest of multiple viewer/participant encounters, among them a private mirroring (part of the process of making, through looking at herself) and a public reflection. I can imagine Wilke in her studio, staring, watching, analyzing, and still discovering her body in the mirror, acutely aware

of implicating herself in acts of voyeurism as she playfully dissected what she saw and planed out how she could turn this projection into defiance. I wonder if a sense of self-care can be inferred in this intimate dialogue with her body. The internal process of artmaking for me starts with being profoundly aware of that deep wound, its origins, its trajectory, and then allowing myself to heal. I return to a quote by Audre Lorde: "Caring for myself is not self-indulgence, it is self-preservation, and that is an act of political warfare."[2]

Wilke often used repetition in her work, and I also wonder if, for her, there was redemption in that act, and if it became a praxis of care. To repeat something again and again is a way to repair, to reset, and to mend. For me, the practice of care can turn political in that it fuels the desire for transformation.

What I see reflected from this image, and more broadly throughout her work, is a clever manifestation of disobedience. Wilke seemed to be teasing us again and again, yet at the same time she was reclaiming and rectifying her agency. Her gaze was never passive, and her body served as a precision mechanism for questioning, subverting, and resisting.

In the 1980s, as Wilke's cancer surfaced, pain seemed to have left a mark. In looking at her later work, I am reminded of Elaine Scarry's work on pain that, as she states, debilitates—or rather unmakes—language.[3] How did Wilke approach pain, considering that her body was the device with which she spoke?

She continued to work prolifically throughout her illness, and it seems to me that the impetus for self-care became stronger and stronger. I believe that somatically working through trauma can enable transcendence. Maybe she did too?

There is something rather defiant about Wilke's later works. There seems to be a relentless desire to confront life, to repeatedly break, but not shatter, in a tireless effort to remake her own image in radical ways that formulate a new language of play and care. I have a feeling that if I were that mirror on her wall, I'd be entranced by her laconic resistance to all the shattered glass that came her way.

NOTES

1 Lucy Lippard, "The Pains and Pleasures of Rebirth: European and American Women's Body Art," in *From the Center: Feminist Essays on Women's Art* (New York: Dutton, 1976), 126. Essay originally published in *Art in America*, May/June 1976, 73–81.

2 Audre Lorde, *Burst of Light: Essays* (Ithaca, NY: Firebrand Books, 1988), 125.

3 Elaine Scarry, *The Body in Pain: The Making and Unmaking of the World* (Oxford, United Kingdom: Oxford University Press, 1987).

CONVERSATION
with
HANNAH WILKE, 1975

Cindy Nemser

On February 18, 1975, a conversation between Cindy Nemser and Hannah Wilke took place in the artist's SoHo studio at 62 Greene Street, in New York City. This previoulsy unpublished excerpt has been edited for brevity and clarity.

CINDY NEMSER Did you always want to be an artist?

HANNAH WILKE Yes, when I was a kid. But because I was a woman, I don't think I took it seriously until I was divorced. And then I knew. When people get married, it's very hard to be equal, and usually the woman suffers. Like in Ibsen's *A Doll's House*: she couldn't admit how fabulous she was; she had to leave. I was a school teacher to survive, but I was always making art. I didn't think I'd make money with my work, but I knew I had to take the risk. As a human being it was necessary, and I finally admitted that to myself. Women's Liberation helped me admit it.

In 1969 I started reading the Whitney Annual lists, and I saw that a lot of guys who were exhibiting were born in 1946, and I said, "What is this! They're six years younger than I am. Why is everybody telling me I have time to show my work?" I realized then that I'd better be responsible for myself.

NEMSER Do you have more of an affinity with the Abstract Expressionist sensibility than with 1960s art—the geometric, distanced, remote, or preconceived intellectualized ideas permeating the art world?

WILKE As an artist you take from everywhere and filter it through your body. Because I grew up in the fifties and sixties, I appreciated Abstract Expressionism, the de Koonings, the Pollock gestures, the enormous saturation that one feels through color. I feel sexual impulses from various colors; I think we even dream in color, have sexual experiences in color.

NEMSER You mention color. Your work has tended toward the pastels. What pulled you to that coloration?

WILKE Possibly because they were never used to any great extent. De Kooning was a colorist, but when I started making sculpture, I don't think I was informed enough to know what I was unconsciously taking or giving to this work. Now, at thirty-four, I might say that you can trace the iconography of my work through the gestures of Jackson Pollock—the idea of pouring latex rubber, capturing liquid movement, rolling out clay, bending it, having them both become frozen. In Pollock's work, you can see all his gestures, too. I can almost see the rigid structure of Frank Stella's work in my drawings, but making them in 1965, I probably hadn't seen Stella's work yet (**FIGS. 1 AND 2**). And Stella is not

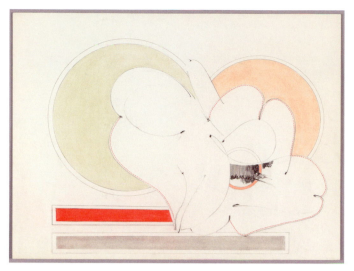

FIG. 1
Untitled, 1967
Colored pencil and graphite on paper
18 × 24 inches (45.7 × 61 cm)
The Museum of Modern Art, New York, The Judith Rothschild
Foundation Contemporary Drawings Collection Gift

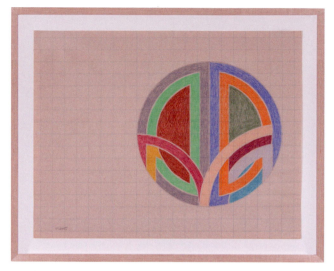

FIG. 2
Frank Stella, Untitled (Working Drawing), 1968
Colored pencil on paper
17 × 22 inches (43.1 × 55.8 cm)
Private collection

much older than me. The problem of women is not having the courage to push themselves like men. But, finally, I realized, "Ahem. Excuse me, I'd like to be in the Museum of Modern Art, also," and you respect what you're doing. You need help to get to that point, though, and that's what dealers and galleries are for; you need somebody to see what you're doing and say, "Your work is good, do ten more."

NEMSER How did your work evolve into the kind of vaginal form—the kind of characteristic form your art has now?

WILKE In 1960, I was working with fiberglass in Philadelphia, and I was interested in new material that suspended distances because I was concerned with gravity. By using a very lightweight type of fiberglass mesh, I could make large oval forms that were suspended on a thin leglike structure, similar to nature, such as plant life or birds that have very thin legs like the sandpiper, and my concern was structural. This basic structure, like flowers in the house, had a feeling of expansiveness or forms coming out of themselves, and this was what I considered erotic at the time (**FIG. 3**). I painted them black, which I wouldn't

do now as I think it was negative color—too massive and too heavy. Although it had these open forms, I admitted to very few people that they were sexual, but I was aware of their sexual iconography. Recently, I was pleased when a male student of mine said that the small grey kneaded eraser forms looked like the heads of penises—very androgynous. It was so intelligent.

NEMSER You said you were hesitant to acknowledge the sexual content of the work then. Why was that?

WILKE Well, I was just out of college, twenty years old. The Women's Movement didn't exist, and it was difficult for women to show. Also, I was too shy to believe, based on the history of two thousand years of men showing art, that I was a creative individual deserving of gallery exhibits. I think people who create art generally don't believe in themselves, or they wouldn't need to make objects.

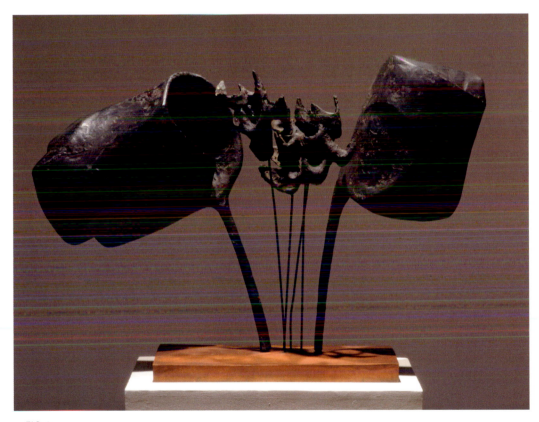

FIG. 3
Untitled, early ca. 1960s
Fiberglass and plaster
20 × 40 × 10 inches (50.8 × 101.6 × 25.4 cm)
Collection of Donald and Helen Goddard

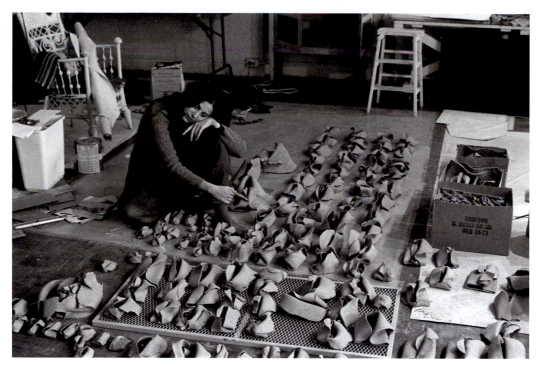

FIG. 4
Hannah Wilke in her Westbeth studio, New York, 1974
Hannah Wilke Collection & Archive, Los Angeles

NEMSER Exactly. I always think of it as an assertion of identity. One has to keep saying, "I'm here. I'm really here. I'm really here."

WILKE Probably those thousands of later pieces have to do with the idea of reinstating oneself. To make 300 pieces to find 176 that I liked, I had to be involved with a tiny form that kept repeating itself in a very singular aspect (**FIG. 4**).

NEMSER You're referring to the ceramic pieces?

WILKE The ceramics, the kneaded erasers, the lint fold sculptures, one-fold, two folds. I was involved with a simple process that repeated itself and was subtly different, so that I expressed the fact that all things are different, even if we're pushed together into anonymity.

NEMSER It's interesting, though, that you would take the sexual aspect, which evidently concerned you.

WILKE Well, a sexual aspect does exist, but I think what makes it art is that it's art, and I didn't know how to express that except by saying that if we look at it as a vagina it's one thing, but if we look at it as a very simple structure, the

basic idea of a flat painterly surface that is very quickly changed by a gestural motion, as soon as a human being—me, the artist—changes the sculpture, it becomes form. I'm going from a painterly two-dimensional form to a three-dimensional form in which you can see the entire structure. I've been concerned with going against traditional historical sculptural premises, because most sculpture until the twentieth century was concerned with solidity. Making a marble sculpture is destructive, always taking away so it still retains its solid structure, but the artist then wasn't concerned with showing *how* it was made. When you look at the layers of latex, you can still see each individual layer and become part of it. You can see the entire process.

NEMSER That ties in with certain concerns that we've seen in the past ten years about process.

WILKE But process art was only showing the process; I'm concerned with something becoming a different form from the same form, and that's different than just process. I'm concerned with the old-fashioned idea of it becoming art. You know, objects are like people. We're all individuals. We all have different faces, different forms, we gesture differently, move, laugh, cry, sing differently, which makes us special. I'm definitely not concerned with the sameness, the repetitiveness, the anal retentiveness of a singular concept. I think the artist, or any human being, is so complex that there's no reason to reiterate an idea. So, by calling it a cunt or a vagina, a lot of people dismiss it, just as they dismiss women, "Oh, it's one idea," but there are millions of forms within this one idea, and that's why it's interesting art.

NEMSER So in art school you began making these sculptural forms, and then you moved into painting?

WILKE I worked in painting, sculpture, drawing, and ceramics throughout the last fourteen years. I never gave up one for the other. The best artists I know work in every material. One is concerned with ideas and the material suits the idea. My idea is about movement, liquid movement.

NEMSER Well, there's a certain gestural quality, obviously, in your work.

WILKE That's more important than saying it's a cunt, because the idea of life is about movement. The essence of life and the most viable experience we have is making love. The most tangible experience you can have is when you really feel good, even though it's intangible and metaphysical. This feeling is so strong that to translate it sculpturally through the softest material that changes, that moves, is always different. Clay is soft, so taking it and moving it around is a fantastic experience. I'm really physically involved with my material.

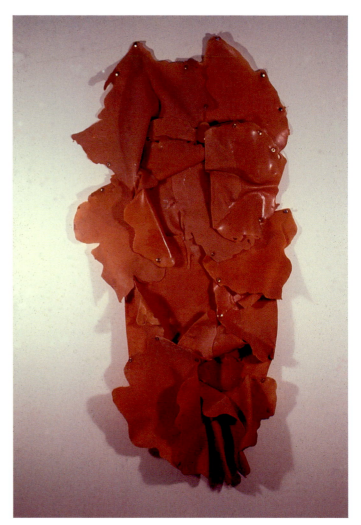

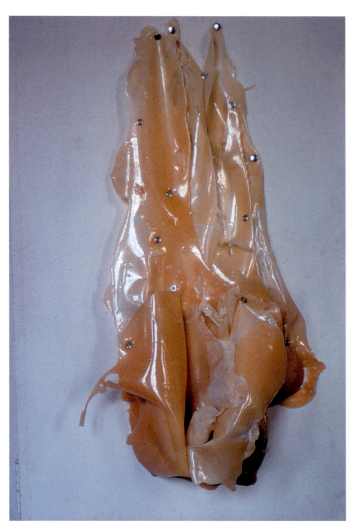

FIG. 6
Untitled, 1970
Latex
Artwork no longer extant
Image, Hannah Wilke Collection & Archive, Los Angeles

FIG. 5
Untitled, 1970
Latex
Artwork no longer extant
Image, Hannah Wilke Collection & Archive, Los Angeles

NEMSER Let's talk about some specific works while we're at it. We have some slides here.

WILKE This is probably the first latex piece I did. You can see the way I've folded it. You can see how I thought it out; it's not just the material (**FIG. 5**). I can show you another piece from about 1970, the first important latex piece I made which related closely to the ceramics (**FIG. 6**).

NEMSER You did the ceramics first?

WILKE Right. But the early ceramics (**FIG. 7**) had the same layered structure as this latex piece. The latex piece has many folds and layers, and I snapped it together to solve the structural problem of adhesion using metal snaps, an industrial material. I liked its shiny quality and snapping it together. And it's held together so tenuously and has that fragile quality, even more than clay has. It's thinner and just pinned to the wall, so it hangs, and I use gravity, essentially, to make sure it hangs together. Like, how do flowers stand up? It's really amazing. Funny that we can walk around without being attached to the earth.

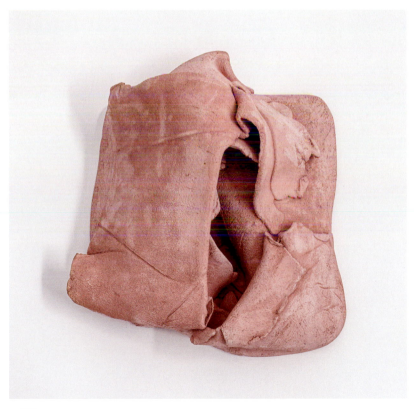

FIG. 7
Untitled, ca. late 1960s
Terracotta
3 ¾ × 7 ⅛ × 8 ¼ inches (9.5 × 18.1 × 21 cm)

This is a photo of a latex piece with me in it, a piece that de Kooning bought—natural latex rubber with a very slight pink latex tinge to it, and pink reminds me of flesh (FIG. 8).

NEMSER It has a very open quality about it, sort of vulnerable, you could say.

WILKE I like the photograph because my nude image is the same shape as the latex piece, but the opposite. Using my body is an intrinsic part of my work, which made it painful to be an artist. Because I look good, people didn't believe in me as an artist. But that's how the work might have evolved. I made

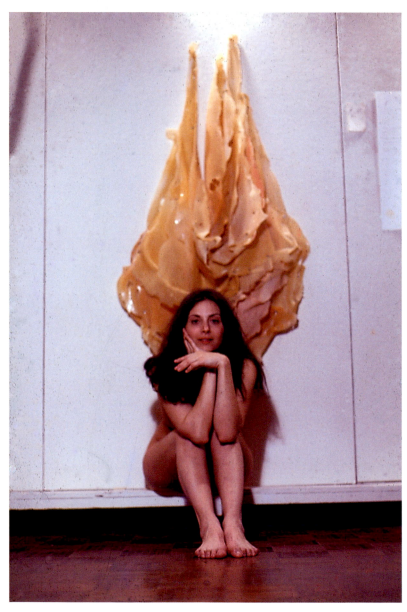

FIG. 8
Hannah Wilke with *Venus Cushion*, 1972
Artwork no longer extant
Image, Hannah Wilke Collection & Archive, Los Angeles

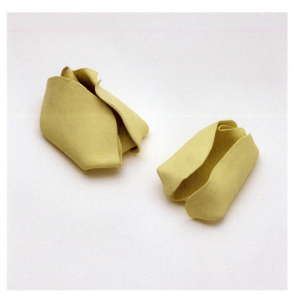

FIG. 9
Untitled, 1977
Unglazed painted ceramic
Left: 3 ¼ × 4 ½ × 7 ½ inches (8.3 × 11.4 × 19.1 cm)
Right: 2 ¼ × 4 ¼ × 6 ½ inches (5.7 × 10.8 × 16.5 cm)
Hannah Wilke Collection & Archive, Los Angeles
Courtesy Alison Jacques, London

art that was based on problems of identity and sexuality. I guess Marisol did, too, putting her face in the pictures, yet she didn't admit to it. Georgia O'Keeffe made sensual art, but she didn't say those flowers are vaginal. Maybe they weren't…for her. I admitted these things went past the flower image and were icons for females.

Just as phallic art existed for two thousand years, I felt we should make a more natural type of art that was more ephemeral, more delicate. You asked me about the pastel drawings. Pastel laundry rooms, women's rooms, children's rooms, and bathrooms: why don't they look good? Why should people be embarrassed by delicacy or lack of color (**FIG. 9**)? It's like the difference between rock and roll and Beethoven; you have to listen to it. You have to look at my art a little longer because it's fragile and delicate and you can't see the colors clearly. One must look at my work because there are differences. Maybe I'm more demanding. I insist on people making choices, like buying one piece out of 176. I make an object over and over again, and it's always different, as opposed to making the same object the same, which to me is frightening, regimented, fascist art.

> **NEMSER** Interesting, what you said about making art over and over, because you're almost saying, "Look at me really hard. This is serious and you have got to really pay attention." I never thought of it that way until you mentioned it.

WILKE Yes, pay attention. The sculptures have different personalities, like different seasons. Some gestures go out upon themselves; some turn in on themselves, some are totally flat. They're almost human.

NEMSER You've been working on the latex forms for a while now.

WILKE Yes, for about four years, but two years ago, they started to make sense. I really haven't explored the material enough, because I take so long to make them. I might need sixty sheets to make one sculpture, and I have to pour each section individually to build it up. Before I had a big a studio like I have now, I only had a six-by-eight-foot plaster floor.

NEMSER You actually pour the form?

WILKE Yes, but I pour it like you might a glass of water and then watch the way the shape flows. I might pour a series of semi-ovals, and if I pour 300 ovals, I look at each section. So instead of one solid mass, I make many, as with the ceramics.

NEMSER But when you pour it, it flows right into those kinds of forms?

WILKE I kick them around a little so it's preestablished, somewhat, but it's liquid, wet, like cream. I might use my hand to make the edge nicer, like in finger painting, but latex is thicker. The plaster floor soaks it up so you have this beautiful edge, and I can blow on it and push it, but I want it to look natural.

NEMSER And then you color it?

WILKE I'll color it before it's dry. You have to experiment with the colors, even though I sometimes don't want to know what's happening beforehand. It's hard to create the color, because the natural latex is beige, so you have to add a lot of color to it. I'd like to work with opaque white and have them become translucent somehow. Nobody was making pink sculpture, really, so making an eleven-foot-wide pink sculpture was a little more upsetting than your run-of-the-mill beige sculpture.

NEMSER When did you first show the latex pieces?

WILKE In 1972 at Ron Feldman Gallery.

NEMSER Yes. I think I remember hearing it was rather controversial. What was the reaction?

WILKE Oh, I had wonderful reactions! It was really terrific to see how happy people were that I made art. Until I was ready to show my work, I never asked

people to look at it, so a lot of people weren't aware of me as an artist. When they did see it, I think there was an element of shock. The nicest part about it was that the people who wrote about me weren't people who knew who I was, so I knew I was getting criticism that was based solely on the work.

This is the piece I had in the Whitney Annual that's about seven-and-a-half feet wide (FIG. 10). The concern with gravity is prominent. This one, eight or nine feet high, felt very large and very pink. It was quite an experience to have five in the gallery. One felt the tension. There's a nice poem, I think, by Robert Creeley [that goes something like] "Sometimes I feel tensions like flowers, like this one and that one and this one and that one."

NEMSER I remember, though, there was also some hostility to your exhibition because it was so overtly sexual, and people—I think, some women— were offended.

WILKE It's nice that I never really heard it. There's always competitiveness whenever anybody makes art.

NEMSER But I think you really touched a nerve, something that people were really concerned about. I wouldn't take it as an insult. I would take it as a compliment.

FIG. 10
In Memory of My Feelings, 1972
Latex
Artwork no longer extant
Image, Hannah Wilke Collection & Archive, Los Angeles

FIG. 11
Georgia O'Keefe, *Farmhouse Window and Door*, 1929
Oil on canvas
40 × 30 inches (101.6 × 76.2 cm)
The Museum of Modern Art, New York, acquired through the
Richard D. Brixey Bequest

WILKE I know. It's a problem that some women artists can't accept another woman artist's work just because it has to do with female sensibility. My sensibility has to be positive, not negative. I think a lot of women are making sexual art, but their art is negative. It's unconscious hostility toward their own being, and I find that painful. I try to elevate the status of women by making art with a very sexual, sensitive, open, free feeling.

NEMSER I would say beautiful.

WILKE Beautiful art, right. I'm sick of ugly.

NEMSER I've noticed, in some of the best of women's art, there is this real desire for beauty—to create a kind of celebrative art, rather than one that's negative and hostile. But many women artists are making art related to forms popular with male artists.

WILKE Well, even Barbara Hepworth. Just because it's a circle with a hole doesn't mean it's erotic. Just because Picasso draws a bull and a man and a woman fucking doesn't make it erotic. Eros has to do with affirming life.

NEMSER Oh, that's beautiful. I was thinking that, too. The sensual has to do with affirmation.

WILKE And it's also unconscious. You can't tell me how you feel when you make love; it's an unconscious feeling. Eros has to do with internal feeling. Georgia O'Keeffe's green door in the Museum of Modern Art, to me, is erotic, the way it all fits together like a perfect puzzle, like when someone touches you in just the right way (**FIG. 11**). I was turned on by Janet Fish, when she wrapped her tomatoes in Saran wrap (**FIG. 12**). She was talking about light. I'm talking about light, about gravity, about expansion. Like this piece: it changes ten inches, so I'm making something sag, come down—that subtle change of weight, the idea of movement, pushing, pulling, opening up, closing. That's what creates Eros, these movements.

NEMSER Because it's something that's alive. You know they used to call still lifes "morte." And it's interesting. In Audrey Flack's still lifes, she has set them up in such a way that they defy gravity.

FIG. 12
Janet Fish, *Four Tomatoes in a Clear Box*, 1974
Pastel on paper
22 ¾ × 24 ¾ inches (57.8 × 62.9 cm)
Private collection

WILKE When I exhibit the kneaded eraser sculptures on the ground, they don't defy gravity, they're just concerned with scale. When I hang them up or tilt them on the wall, they should fall off the wall, but they don't. They're defying gravity.

NEMSER You have these large pieces on the wall, here, with the rope coming from them. It's interesting that the rope form is kind of reinforcing the falling latex form.

WILKE Yes, I'm making a ribcage, in a way, with five pieces layered together. Just bending them creates that triangular form (FIG. 13). But they're soft triangles, and they're all different. I first made fourteen separate pieces that were vertical, and these strings made this riblike cage, and then I realized by 1974 that my work was more concerned with multilayers, which is much nicer.

NEMSER Some of the things you say relate to Eva Hesse's concerns. She was an influence for everybody, but I think you've taken your work further.

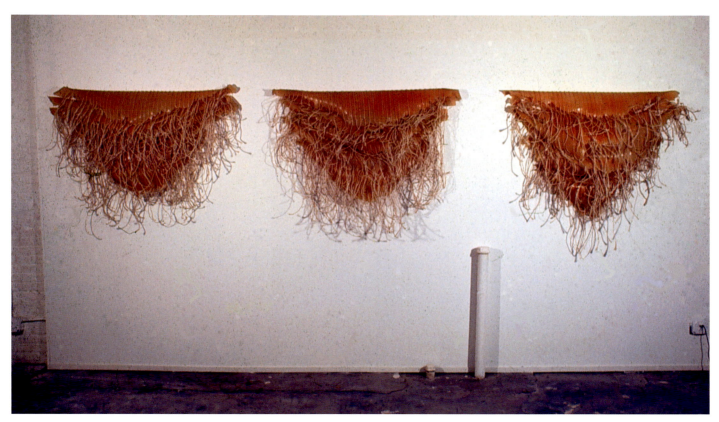

FIG. 13
Three Sisters, 1972
Installation view of three latex sculptures with twine
Artwork no longer extant
Image, Hannah Wilke Collection & Archive, Los Angeles

WILKE She was only four years older than I was. She had her shows in 1969, and I had mine in 1973. She carried her work much further than I might have done in 1969, but both our concerns were with materials. She made fantastic use of materials, but I think she denied the Eros I found in her work and she tried to make it much more methodical. She was good, though. And she did a lot, for the time she was doing it in. Eva Hesse also said that her work is indebted to Claes Oldenburg.

> **NEMSER** Yes, I think that was in the interview that I did with her. She admired Claes Oldenburg.

WILKE My work has to do with a lot of people, too. Maybe saying it's sexual is more important, like Duchamp saying a urinal is important. Maybe it's more important, historically, that I admitted that these were sexual objects rather than just saying they were one-fold, gestural, conceptual process pieces.

> **NEMSER** Right. It takes courage to say something which has been taboo.

WILKE And that's what's important in history: that a woman artist decided to say, "I make cunts and you better like them, because for two thousand years you've not liked them, and you still don't like them, no matter how intellectual you are. Will you put one in your collection?" "I really like it very much, but…" You know, it's art. It's not a cunt, it's an artwork.

NEMSER Well, the old fertility figures are. Because they're sanctified by time it's ok. But they were certainly about sex, and they're certainly art.

WILKE If it were a hundred years ago, I'd be a witch. I'd be burned at the stake. Eva Hesse was important, but people shouldn't make her into a deification figure. That's not fair, because she was our contemporary. She was even Oldenburg's contemporary, but what he did was more important, because he did create the whole soft sculpture movement. I think what I realized is that Claes made solid objects, the way marble sculpture is created. I destroyed the object when I made them in layers, so my work is about getting away from a solid object to the most intangible object possible. It's not solid like his soft typewriter or toaster, where every seam was sewn together. In my work you can see the inside and the outside of the layers. I think it's important that a lot of art isn't solid anymore. Like Dorothea Rockburne's thin pieces of paper—a different sensibility.

NEMSER That brings us to the idea of the eternal, the idea that sculpture should be solid because it's meant to last. Now people are exploring sculpture that will not last, or is ephemeral, almost. In a way, I thought of it as celebrating the present, rather than worrying about the future.

WILKE Maybe because I've experienced a lot of death in my family, I'm more involved with life, so I even accept the death of my sculpture. Some of the older latex pieces, just as Eva Hesse's pieces, are going to die. I wouldn't mind them living. I'm working with latex, now, that will have a longer life span. Our whole culture is concerned with planned obsolescence to resell products over and over again. Nobody had to make rubber last, because they knew tires wouldn't last.

NEMSER It was interesting when you mentioned contemporaries. Women have always been compared with Eva. It's unfair that men aren't. She told me that after she had made an early latex piece, Richard Serra admired what she was doing, and certainly was influenced by it. This hasn't been acknowledged.

WILKE Robert Morris, too. Nobody says, "Why, they look just like Joseph Beuys!" I mean, nobody does that to male artists to the extent they do to women.

NEMSER Oh, yes. Because the attitude is that women are always influenced by somebody. Half the time she's influenced by a man; she never influences a man, or they don't want to even make a comparison.

WILKE Because usually we're the muses, anyway.

NEMSER But you're now doing some work in prints, which I think are beautiful—the way you use drawing so that you're combining the geometric, organic, and your sculptural attitudes (**FIG. 14**).

WILKE Yes, I just finished my first print with Multiples, and it relates to the drawings, which have that very low-key color. I was concerned with using lines—the simplest line—to move form, so that one color will make the painting move back and forth just by subtle manipulation. I'm also using memorabilia—old postcards and 1930s decorative art. I like to rescue things that have been misused in our culture.

NEMSER Memorabilia is fascinating—the idea of going back to a past. Things that were discarded meant a great deal to people. You have the

FIG. 14
In the Doghouse, 1973
Screenprint with pencil
17 ⅞ × 24 inches (45.4 × 61 cm)
Published by Multiples, Inc., Marian Goodman Gallery, New York
Museum of Modern Art, New York. Gift of Marsie, Emanuelle,
Damon, and Andrew Scharlatt, Hannah Wilke Collection &
Archive, Los Angeles

postcards on which you placed your kneaded eraser sculptures and there are some interesting things happening with perspective and gravity. What brought you to this?

WILKE Somehow, I saw these postcards as landscapes (pp. 5, 178–79), and I thought it might be nice to incorporate the kneaded erasers on them, and because landscape is always concerned, in the painterly tradition, with perspective, I thought, "I could fuck up the perspective somehow." And I would be making something that changes, that would be phenomenal. This little object would become enormous because I'm putting it on top of a mountain. In the one of the sea and people on the sand, by randomly placing these small pieces, one might think of those on the land as flat and the pieces in the sky as floating. When I have things floating that shouldn't be floating, that's more important to me. That excites me.

NEMSER Also, I was just thinking that by doing that, you put women into everything, you know.

WILKE Yes, get her into the landscape!

NEMSER That makes me think of what it means to be a woman artist now. What would be your sense of the times? Have social conditions changed for women artists?

WILKE It's much easier. Having a bit of power has made me funnier and more secure, taking more risks with my art, as well. If someone says, "Where do you think the art world is going in SoHo," I can say, "To my house!" A lot of people are very serious. Why not bring back some humor. Bruegel's work was humorous, pathetic, painful, and about human feelings, emotions, and society.

NEMSER I've noticed that sometimes in public you're ultra-feminine. Do you need to do that?

WILKE No, it's probably insecurity, and it's also just being funny. If somebody says something aggressive or sexual, I finally have the courage to retort, a sort of female Groucho Marx. I realized, finally, that it's one-upmanship, so that if men are funny, I get funnier. It's a sense of humor more than femininity.

There is still chauvinism in the art world, but people see that women are doing things. The *Who's Who* in women. It might not be that big yet, but each year more women will take that chance. I think women will express something they might not have expressed before and maybe we have a better chance than men of making innovative statements. That's what art's about—innovation, invention, being an inventor.

NEMSER Yeah, people ask me, "What is women's art as opposed to men's?" There is great openness and a willingness to explore, because we've had this heavy emphasis on what's considered intellectuality and ultra-cerebral attitudes—which I don't think any artist can deny because no work is thoughtless—but personal emotions, feelings, experience have been excluded. Women are left with a kind of otherness.

WILKE Women do cry more easily than men, so we've been spared a lot of the anxiety and pain that men have repressed, and maybe my art is about not being repressed. My father died when I was twenty, and it made me grow up very quickly. We had many aunts and uncles in our family, and they all died. I saw so much tragedy that I had some kind of humility toward life. And I wanted to express that.

NEMSER I wanted to ask you, before we finish, about the videotape [*Gestures*, 1974] that you did.

WILKE The video was, essentially, part of my sculpture. Instead of using video-tape as a video artist, I tried to explain my sculpture using gestures—facial gestures, erotic gestures, sad gestures; again, the idea of showing movement and time so that if I played with my skin and tried to pull it, each time it was a different feeling, a different motion. I was also making a parody on serial imagery, so there were a lot of historical implications to a very sensual erotic idea.

I thought it was terrific the way James Collins documented it in *Artforum*. He picked one sculpture that he liked from *176* and asked to have a video still photographed, so he had a picture of me with my tongue out and a photograph of my sculpture, and there was a fantastic similarity of form (**FIG. 15**). Skin is layered form, and when I pulled my mouth over it was moving form. I was moving my tongue, so it was like a living sculpture, and doing things that are not societally done. Women aren't supposed to spit, or be vulgar, or erotic. Sticking one's fingers in one's mouth, sticking your tongue out—these are borderline erotic gestures, but I was photographing nice-looking skin, the light and shadow of the black-and-white film, the shadows moving my face. Nobody was photographing me. I had total control. I was manipulating film and making

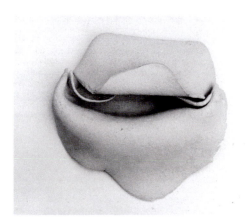

FIG. 15
Sculpture from *176 One-Fold Gestural Sculptures*, 1974, and still from *Gestures*, 1974, featured in a review by James Collins for *Artforum*, summer 1974
Left: © Donald Goddard, right: © Scharlatt/HWCALA

light move to show gesture and movement. By blocking the light, my head was floating in space the way my sculptures float. The camera can do wonderful things.

NEMSER So there's a link between the art that you make and the person you are which is very real, something one senses is a whole.

WILKE Yes, I think that's what's important. I don't want to deny who I am. I was told as a child, sometimes, not to look in the mirror. Maybe that made me more aware of the pain of being human.

When I got the art working, I showed that the whole thing had always gone together.

For my show at Feldman in 1972, we took out an ad in *Avalanche* magazine that featured a photograph of me sculpting in high boots and a leotard (**FIG. 16**). You can almost see my rear end. I had one leg up on the table and I was sculpting. I wasn't doing a fake cheesecake or showing myself nude for the sake of being nude. I was making my art being a sexy woman and it was funny to be in high boots. I gave Claes Oldenburg credit for it because I had been photographing him for years and, finally, I was the artist in his studio at the Chateau Marmont. This is what life is about: being a mistress, being a human being, a woman, being an artist. He recognized me as an artist, yet I was caught in a very vulnerable silly position, and he was turned on. One artist was turned on by another artist. That's a pretty marvelous thing that he took my photograph. Here was Hannah Wilke in her booties making her ceramic sculptures. I mean, it must have been shocking to see, but I don't look like Alexander Calder or somebody else. I look like Hannah Wilke and yet I still make art.

Untitled, early 1960s
Ink and paint on onion paper
19 × 25 inches (48.3 × 63.5 cm)

Untitled, ca. 1964–66
Pastel and graphite on card
6 ½ × 4 inches (16.5 × 10.2 cm)

Untitled, ca. 1964–66
Pastel and graphite on card
6 ½ × 4 ½ inches (16.5 × 11.4 cm)

Untitled, ca. 1964–66
Pastel and graphite on card
6 ½ × 4 ½ inches (16.5 × 11.4 cm)

Untitled, ca. mid-1960s
Pastel on paper
18 × 24 inches (45.7 × 61 cm)

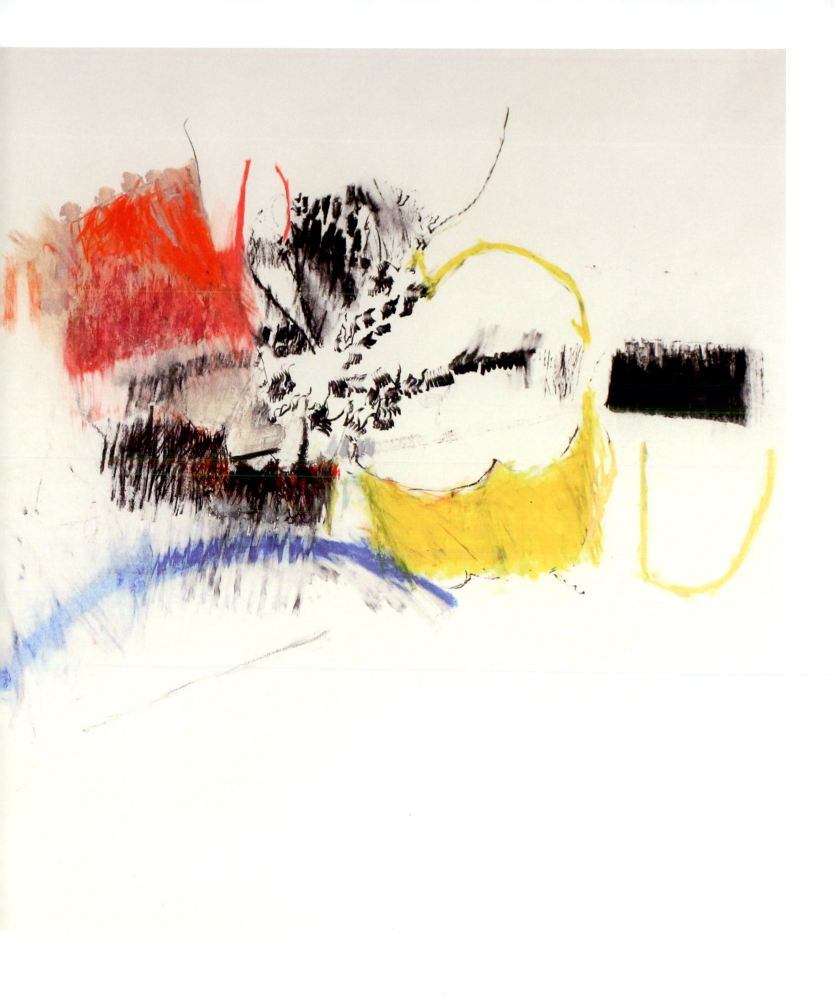

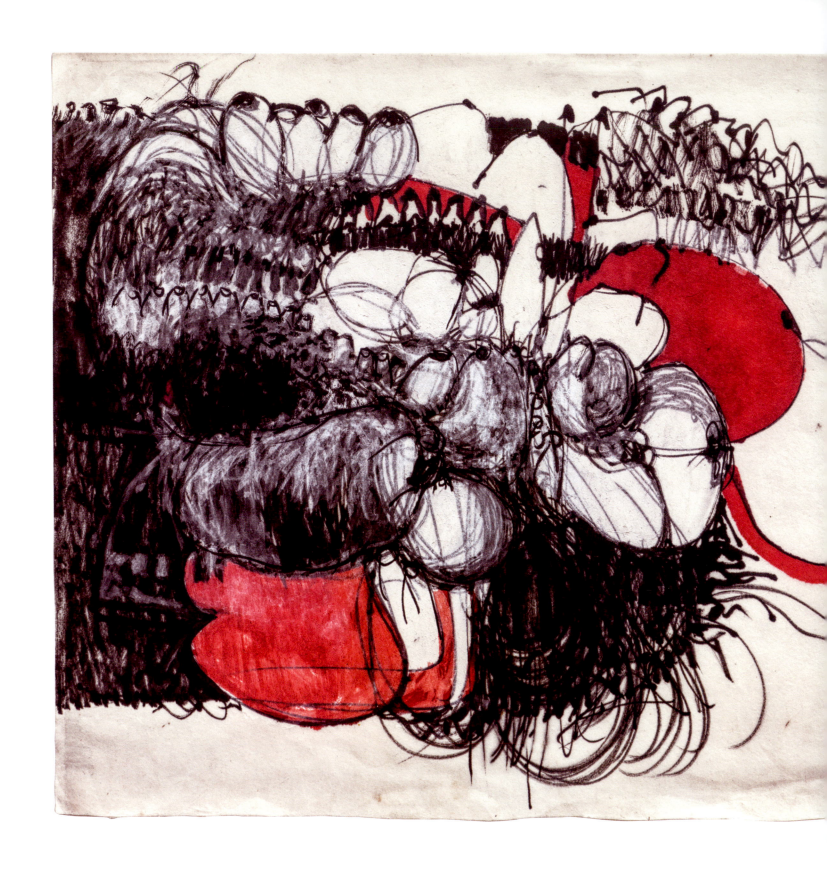

Untitled, 1965
Ink on rice paper
12 ¼ × 17 ⅝ inches (31.1 × 44.8 cm)

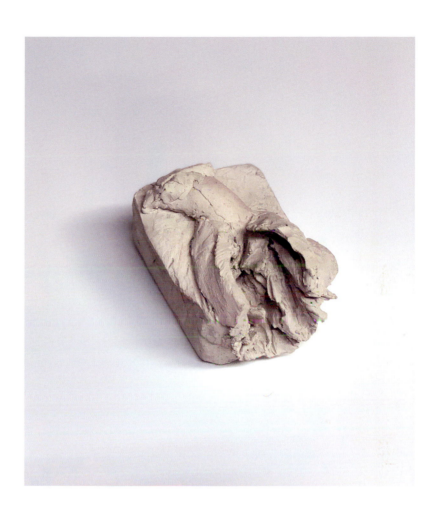

Untitled, 1960–63
Terracotta
3 ½ × 3 ⅜ × 4 ½ inches (8.9 × 8.6 × 11.4 cm)

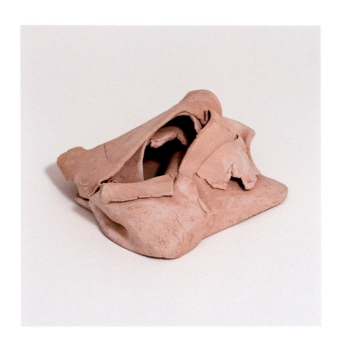

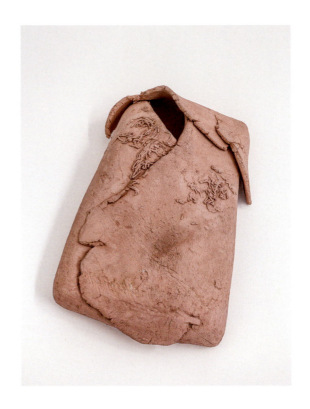

Untitled, ca. late 1960s
Terracotta
3 ¾ × 7 ⅛ × 8 ¼ inches (9.5 × 18.1 × 21 cm)

Motion Sensor, ca. 1966–67
Terracotta
3 × 10 ¼ × 6 ¾ inches (7.6 × 26 × 17.1 cm)

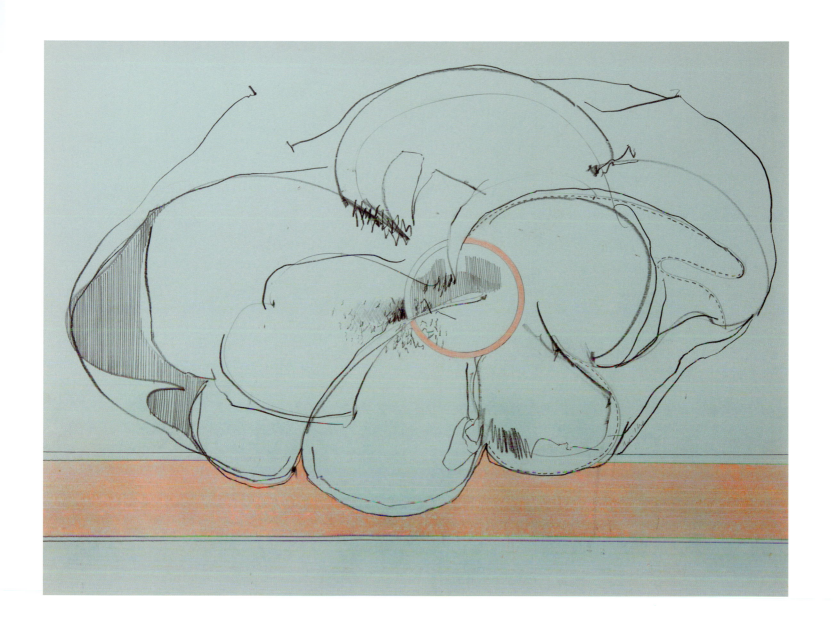

Untitled, ca. 1964–66
Pastel and pencil on paper
18 × 24 inches (45.7 × 61 cm)

Untitled, ca. 1960s
Pastel, chalk, and graphite on paper
18 × 24 inches (45.7 × 61 cm)

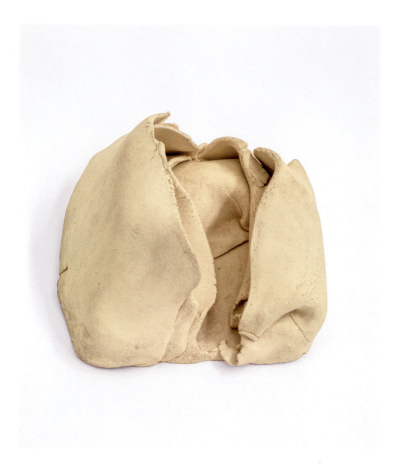
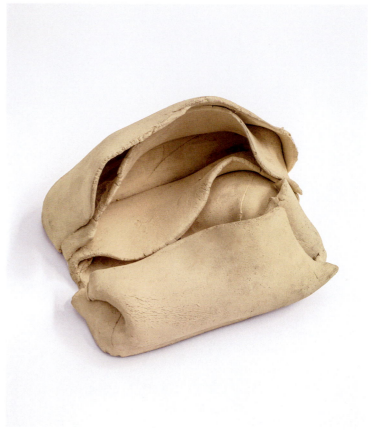

Untitled, ca. late 1960s
Terracotta
8 × 7 ¾ × 5 ¼ inches (20.3 × 19.7 × 13.3 cm)

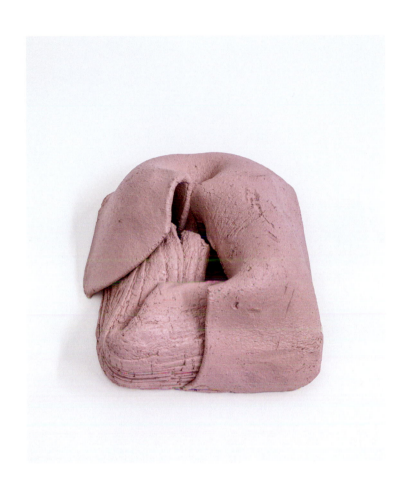

Untitled, ca. late 1960s
Terracotta
6 ¼ × 5 ¼ × 3 inches (15.9 × 13.3 × 7.6 cm)

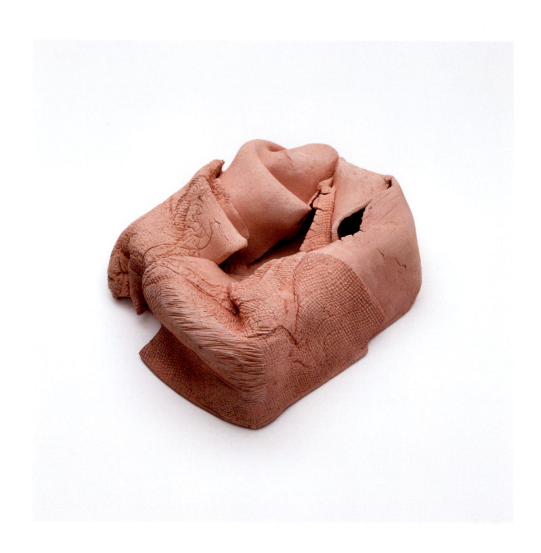

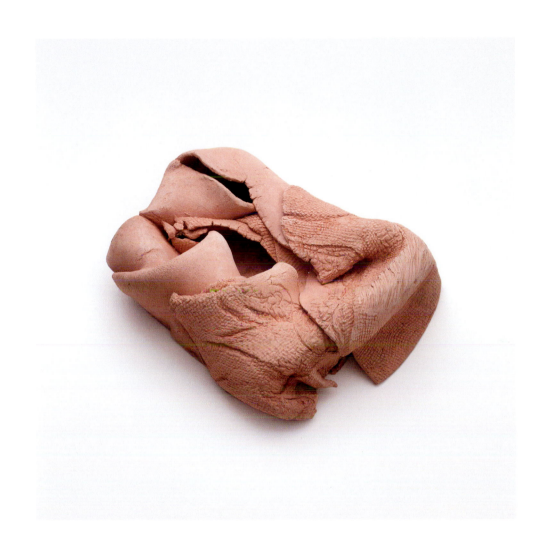

Opposite and above: Untitled, ca. late 1960s
Terracotta
3 ½ × 9 ¼ × 11 ¼ inches (8.9 × 23.5 × 28.6 cm)

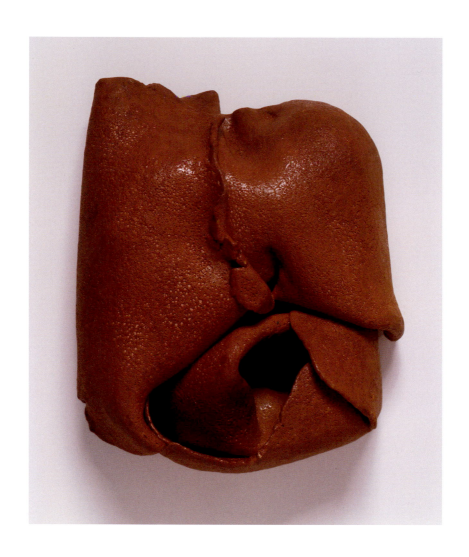

Untitled (Vaginal Box), ca. 1970
Latex and ceramic
6 ¾ × 10 ½ × 5 inches (17.1 × 26.7 × 12.7 cm)

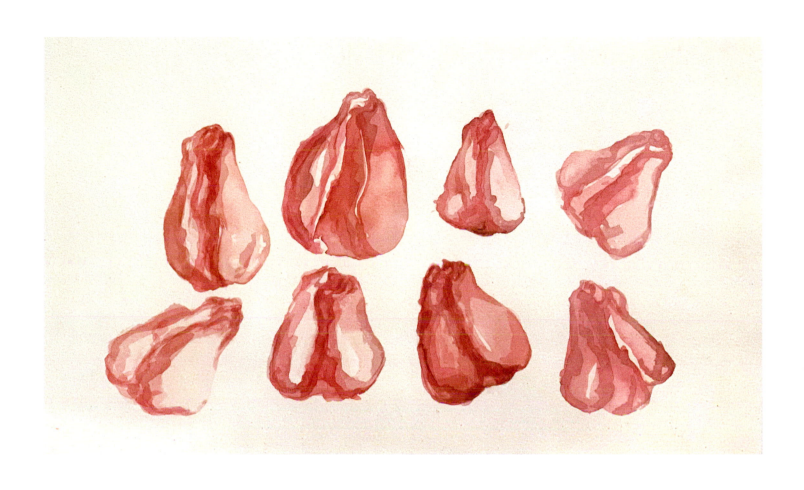

Untitled, ca. early 1970s
Watercolor on paper
10 ⅜ × 17 ⅜ inches (26.4 × 44.1 cm)

Untitled, ca. 1963–65
Acrylic on canvas
48 × 60 ⅛ inches (121.9 × 152.7 cm)

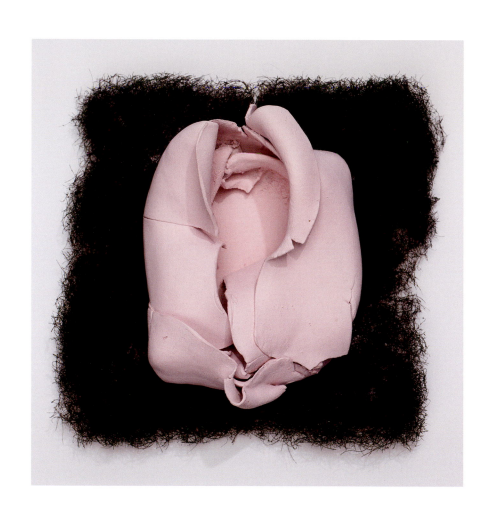

Teasel Cushion, 1967
Terracotta, acrylic, and plastic
4 × 12 × 12 inches (10.2 × 30.5 × 30.5 cm)

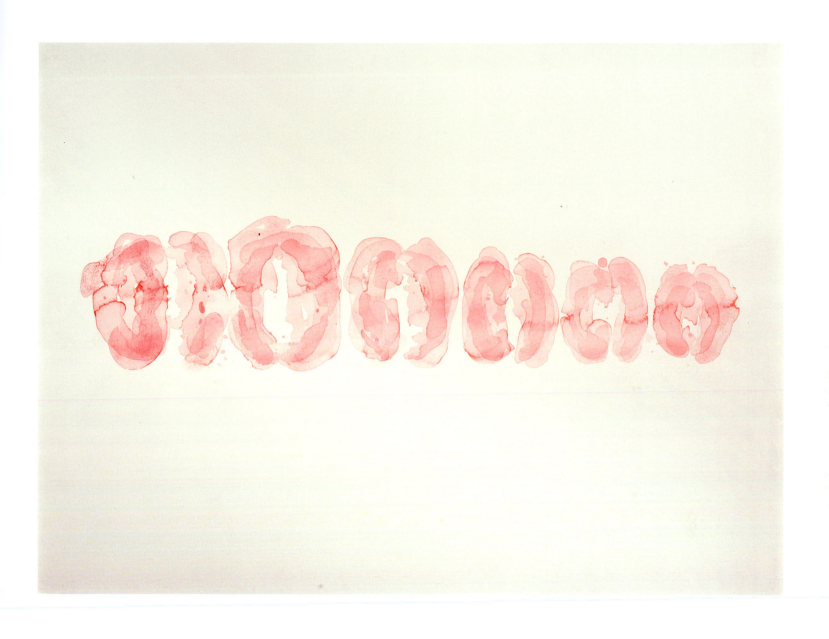

Untitled, ca. 1970s
Watercolor on paper
22 × 30 inches (55.9 × 76.2 cm)

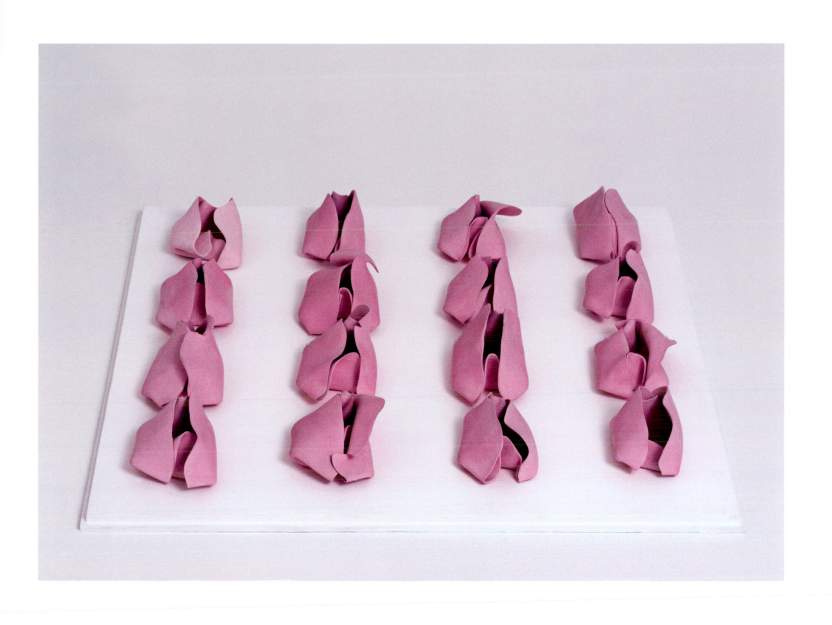

Sweet Sixteen, 1977
Painted ceramic on painted board
16 sculptures, each 3 ½ × 5 ½ × 2 ½ inches
(8.9 × 14 × 6.4 cm); board: 4 × 32 × 32 inches
(10.2 × 81.3 × 81.3 cm)

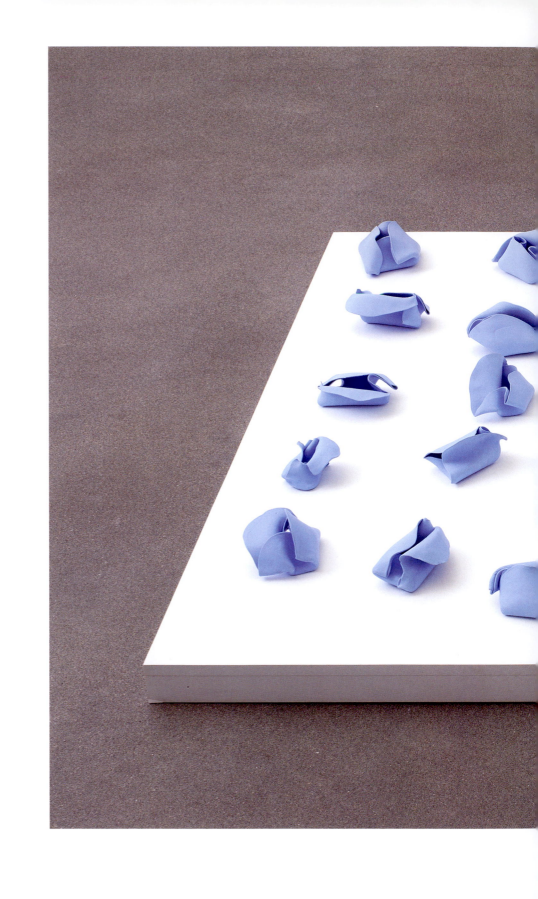

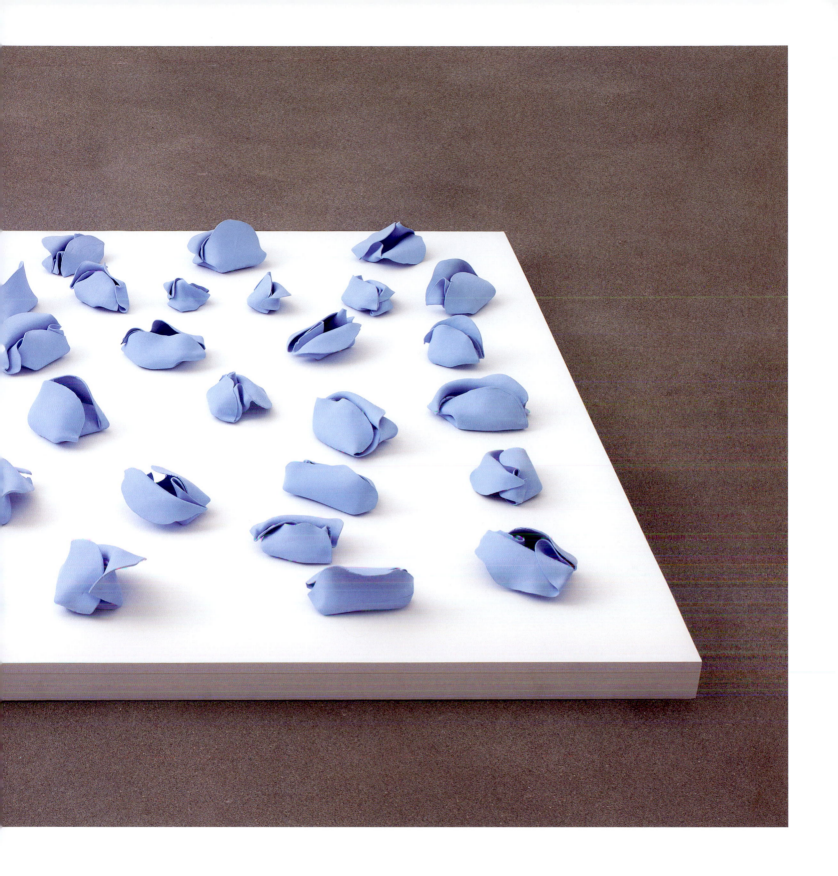

Baby Blue, 1977
Painted ceramic sculptures on board
36 sculptures, each 4–7 ⅛ inches (10.2–18.1 cm)
Board: 63 × 63 inches (160 × 160 cm)

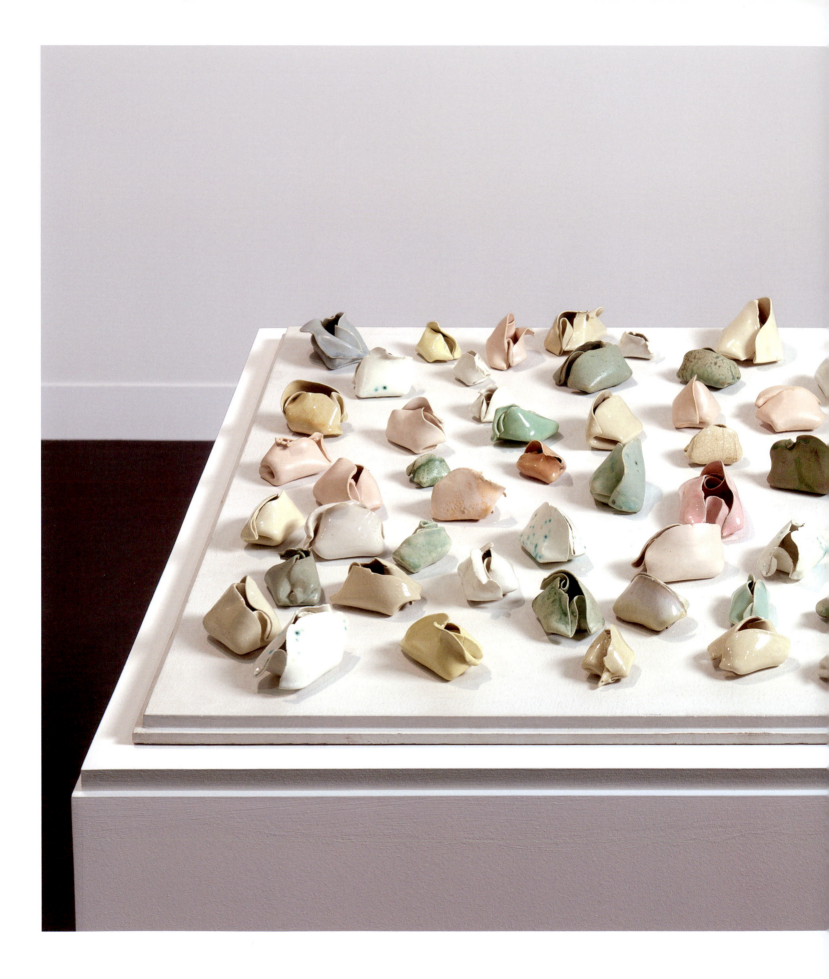

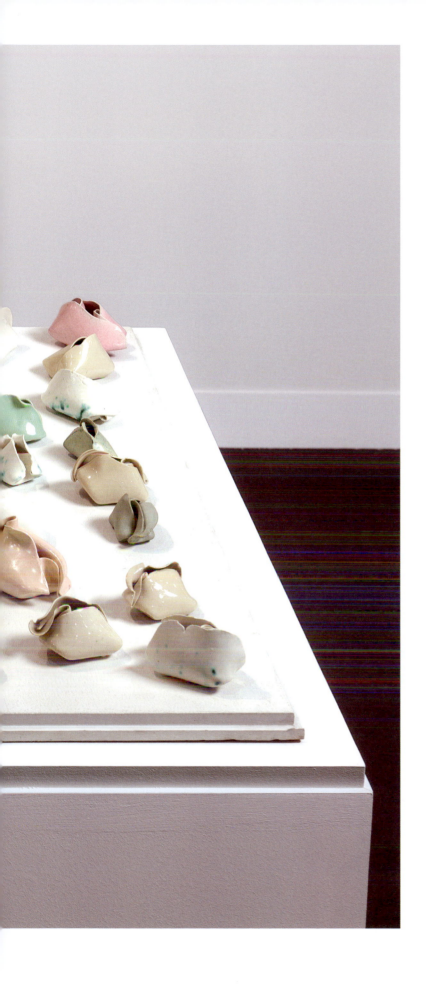

Untitled, 1975–78
Ceramic
60 sculptures, overall 32 × 32 inches (81.3 × 81.3 cm)

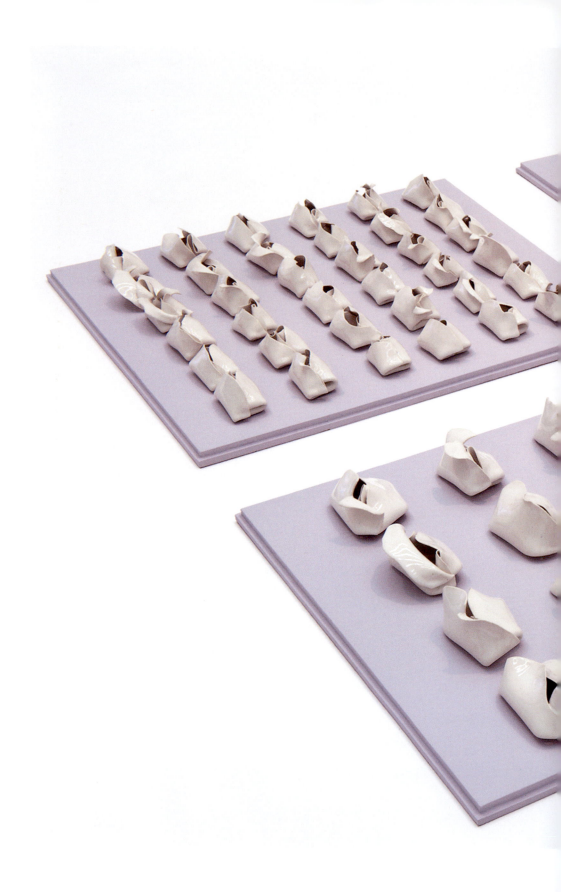

Elective Affinities, 1978
Porcelain and wood
Overall display dimensions variable

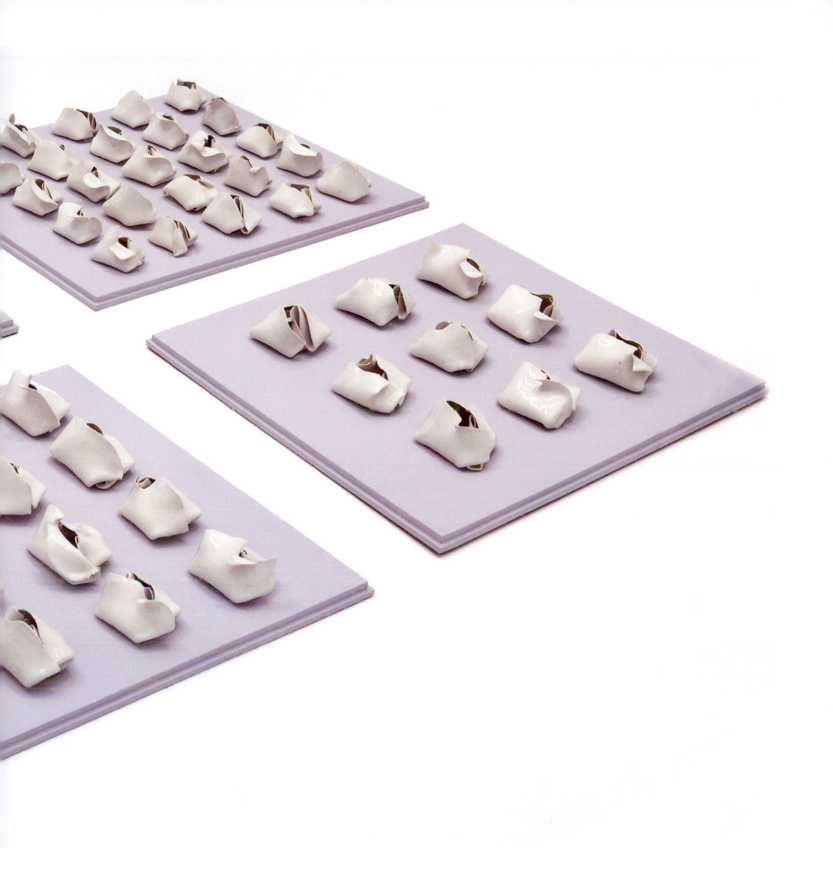

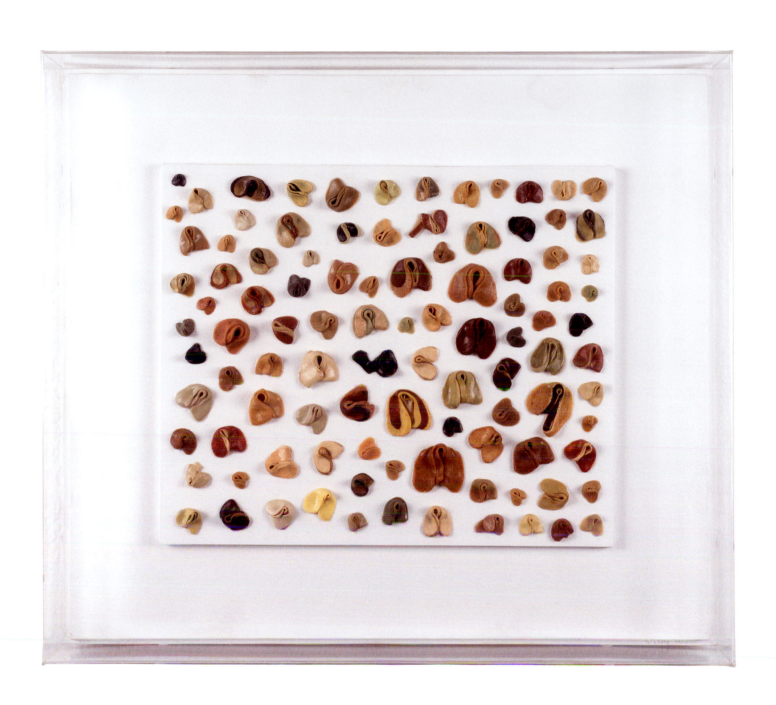

Gum Landscape, 1975
101 chewing gum sculptures on painted wood
15 ⅞ × 17 ¹⁵⁄₁₆ × 2 ⅝ inches
(40.3 × 45.6 × 6.7 cm)

The Forgotten Man, ca. 1970
Pastel, pencil, and collage on paper
23 × 29 ½ inches (58.4 × 74.9 cm)

to SISTER
on her Birthday

To Sister, 1973
Pastel and collage on paper
18 × 23 ⅞ inches (45.7 × 60.6 cm)

Untitled, 1967
Pastel, charcoal, and graphite on paper
17 ⅜ × 24 inches (44.1 × 61 cm)

Untitled, ca. late 1960s
Pastel and pencil on cut-out paper
16 ½ × 24 inches (41.9 × 61 cm)

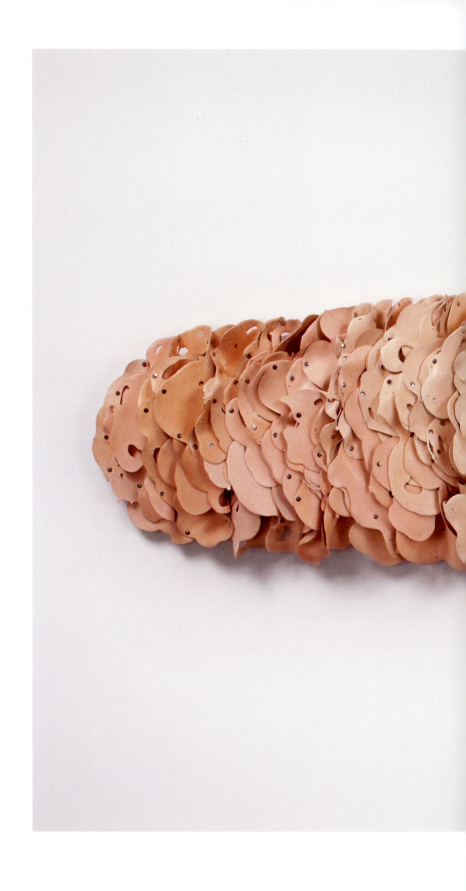

Rosebud, 1976
Latex, metal snaps, and push pins
24 × 92 × 8 inches (61 × 233.7 × 20.3 cm)

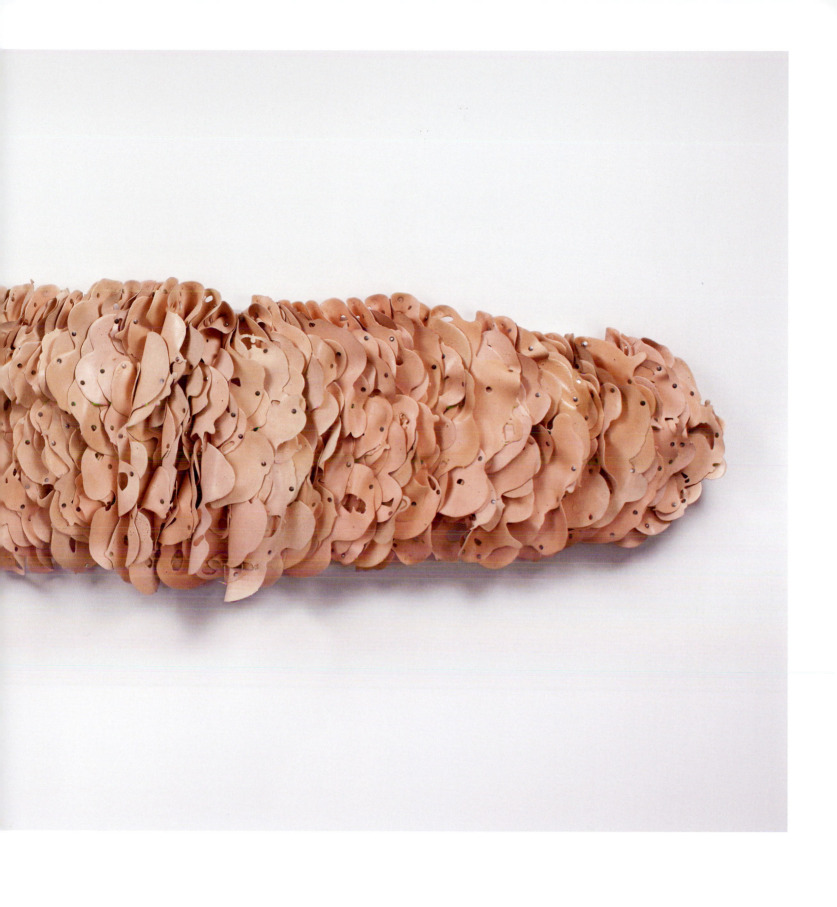

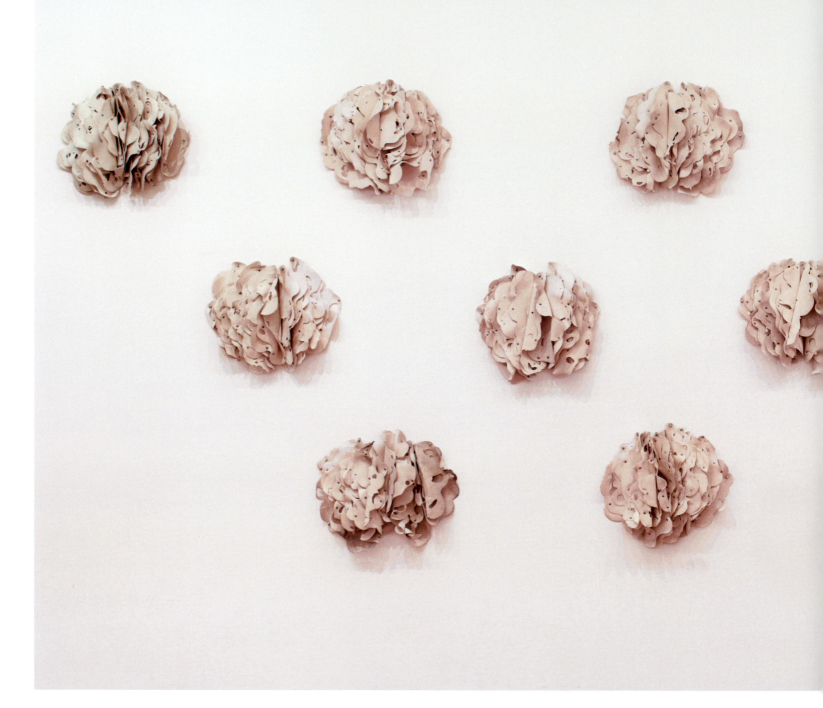

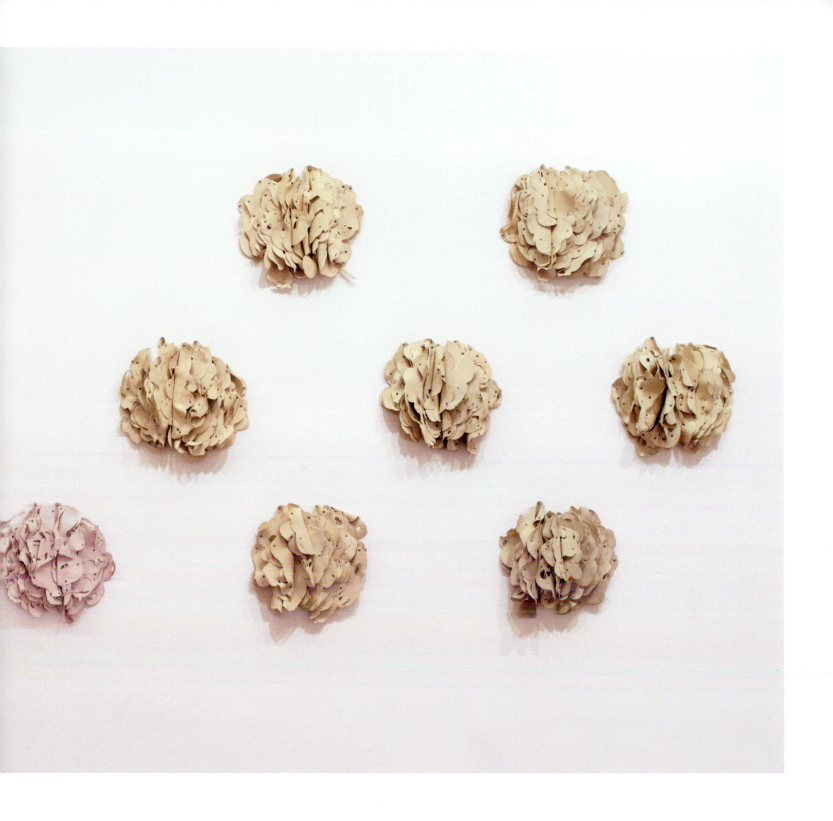

Ponder-r-rosa 4, White Plains, Yellow Rocks, 1975
Latex, metal snaps, and push pins
16 sculptures, each 17 × 26 × 5 ¾ inches (43.2 × 66 × 14.6 cm)
Overall 68 × 250 × 5 ¾ inches (172.7 × 635 × 14.6 cm)

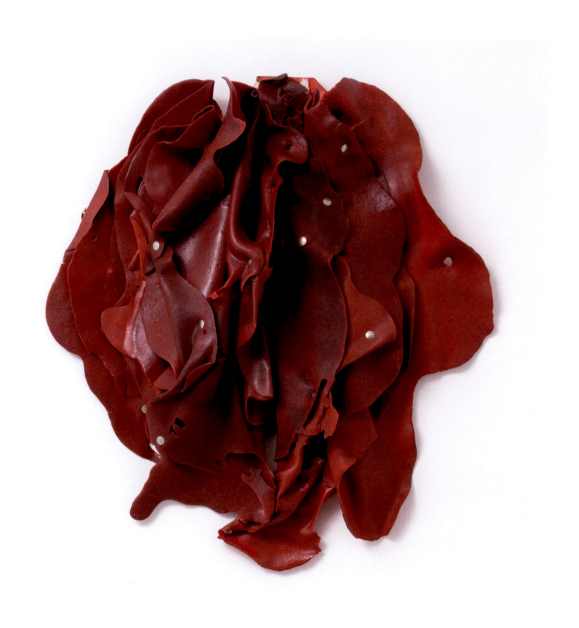

Untitled, ca. 1970
Latex, plywood, and metal push pins
20 ⅞ × 17 ¾ × 4 ¾ inches (53 × 45.1 × 12 cm)

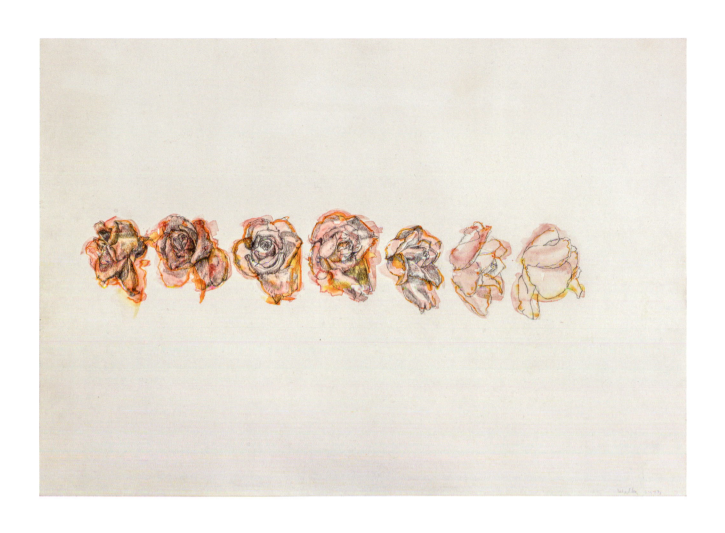

Roses, 1973
Watercolor and pencil on paper
18 × 24 inches (45.7 × 61 cm)

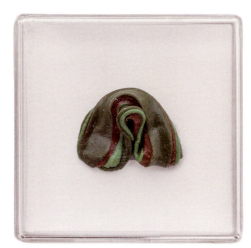

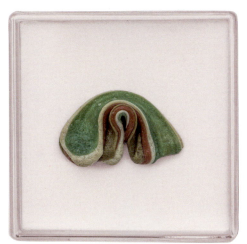
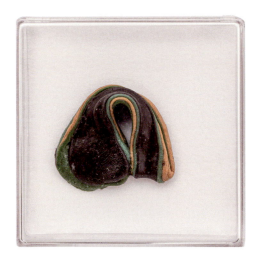
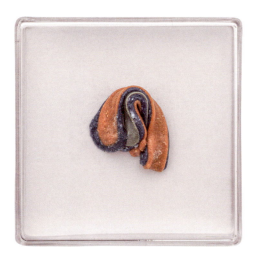

Untitled, 1979
Gum sculpture in Plexiglas box
2 ½ × 2 ½ × 1 inches (6.4 × 6.4 × 2.5 cm)

Untitled, ca. late 1970s
Gum sculpture in Plexiglas box
2 ½ × 2 ½ × 1 inches (6.4 × 6.4 × 2.5 cm)

Untitled, 1976
Gum sculpture in Plexiglas box
2 ½ × 2 ½ × 1 inches (6.4 × 6.4 × 2.5 cm)

Untitled, ca. late 1970s
Gum sculpture in Plexiglas box
2 ½ × 2 ½ × 1 inches (6.4 × 6.4 × 2.5 cm)

Untitled, ca. late 1970s
Gum sculpture in Plexiglas box
2 ½ × 2 ½ × 1 inches (6.4 × 6.4 × 2.5 cm)

Untitled, ca. late 1970s
Gum sculpture in Plexiglas box
2 ½ × 2 ½ × 1 inches (6.4 × 6.4 × 2.5 cm)

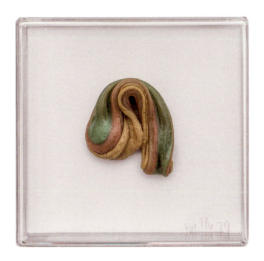

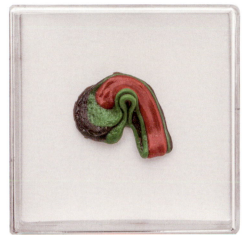

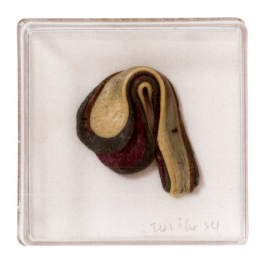

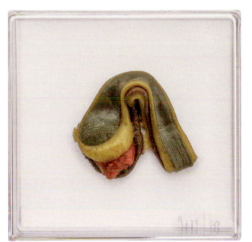

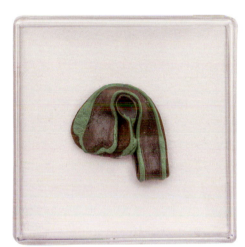

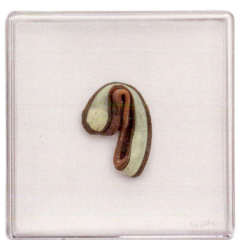

Untitled, 1979
Gum sculpture in Plexiglas box
2 ½ × 2 ½ × 1 inches (6.4 × 6.4 × 2.5 cm)

Untitled, ca. late 1970s
Gum sculpture in Plexiglas box
2 ½ × 2 ½ × 1 inches (6.4 × 6.4 × 2.5 cm)

Untitled, 1984
Gum sculpture in Plexiglas box
2 ½ × 2 ½ × 1 inches (6.4 × 6.4 × 2.5 cm)

Untitled, ca. late 1970s
Gum sculpture in Plexiglas box
2 ½ × 2 ½ × 1 inches (6.4 × 6.4 × 2.5 cm)

Untitled, ca. late 1970s
Gum sculpture in Plexiglas box
2 ½ × 2 ½ × 1 inches (6.4 × 6.4 × 2.5 cm)

Untitled, 1977
Gum sculpture in Plexiglas box
2 ½ × 2 ½ × 1 inches (6.4 × 6.4 × 2.5 cm)

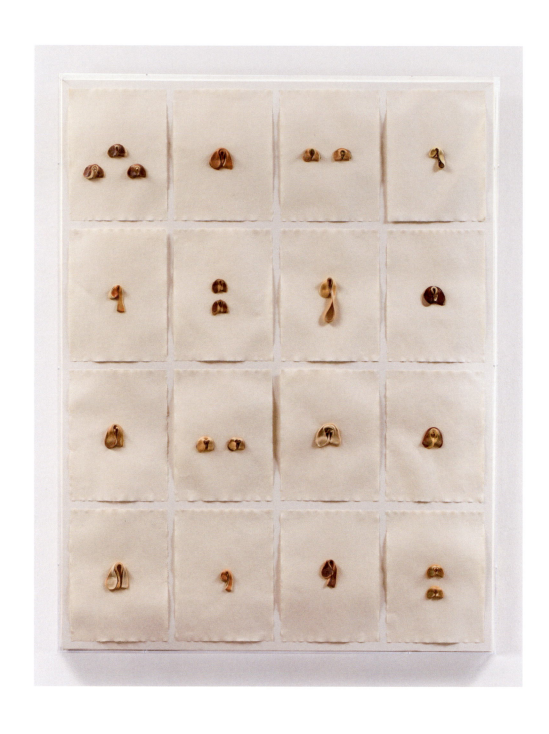

Untitled #4, 1976
Chewing gum on 16 sheets of rice paper framed
in Plexiglas
Overall 33 ⅞ × 25 ¾ inches (86 × 65.4 cm)

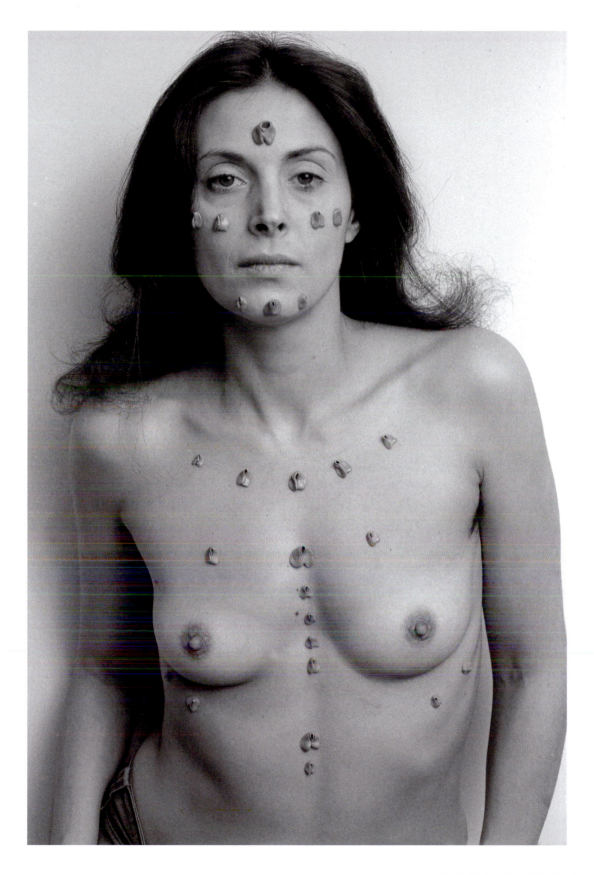

S.O.S. Starification Object Series, 1974
Gelatin silver print
40 × 27 inches (101.6 × 68.6 cm)

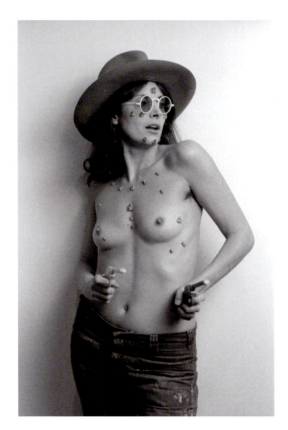
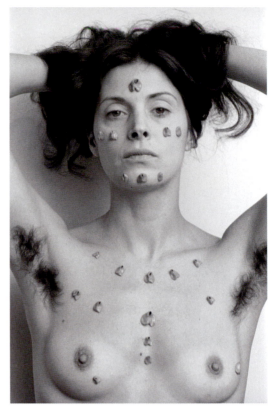
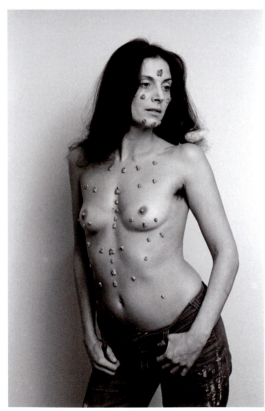
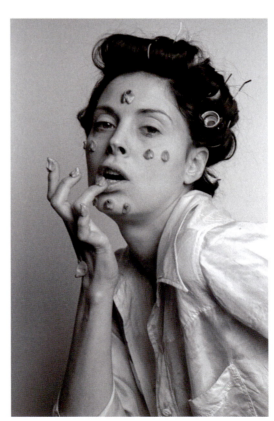

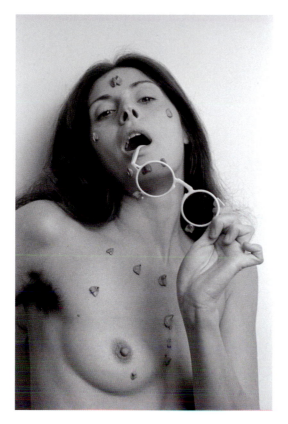
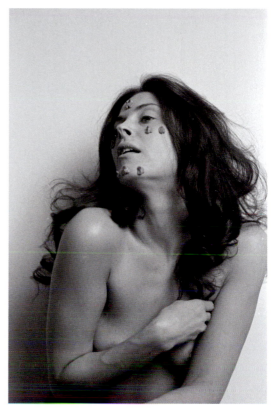
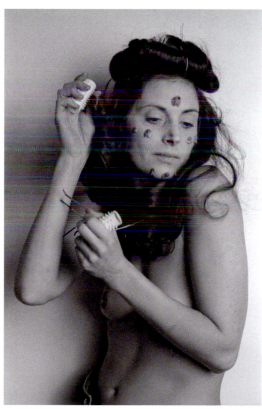
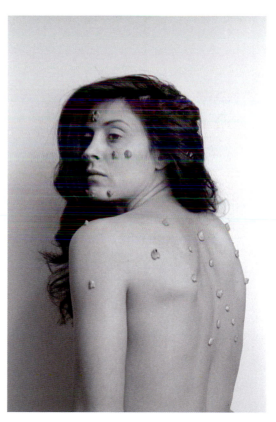

S.O.S. Starification Object Series, 1974
Gelatin silver prints
Each 7 × 5 inches (17.8 × 12.7 cm)

159

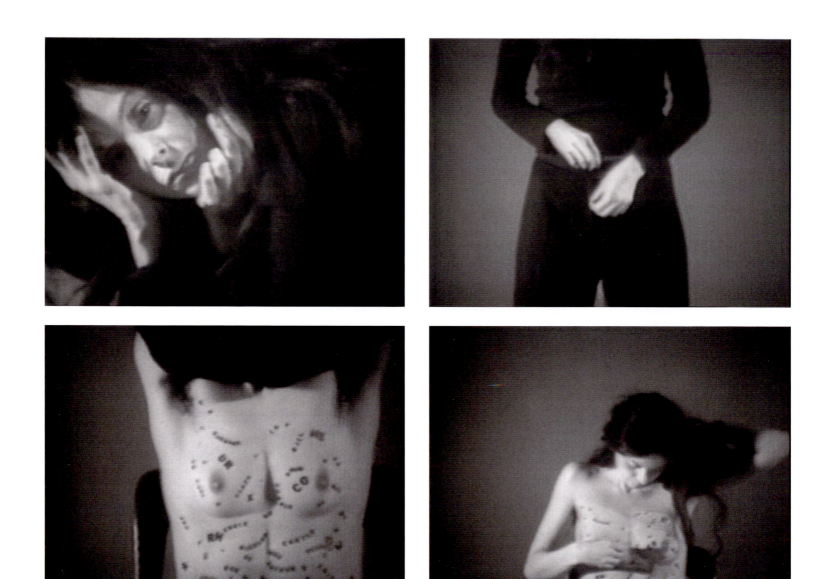

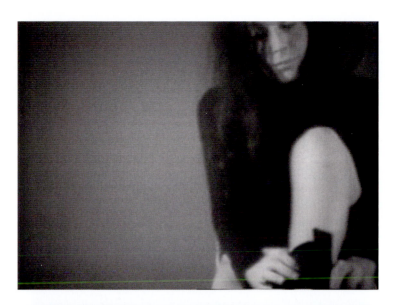

Stills from *Intercourse with...*, 1978
Black-and-white video with sound
27 min.

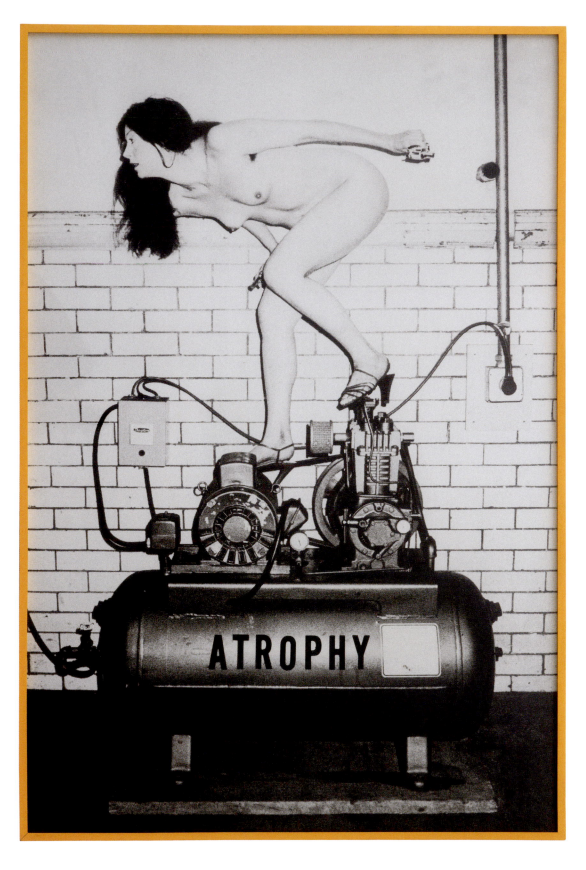

Atrophy from the *So Help Me Hannah* series, 1978–84
Vintage black-and-white photograph in yellow frame
60 × 40 inches (152.4 × 101.6 cm)

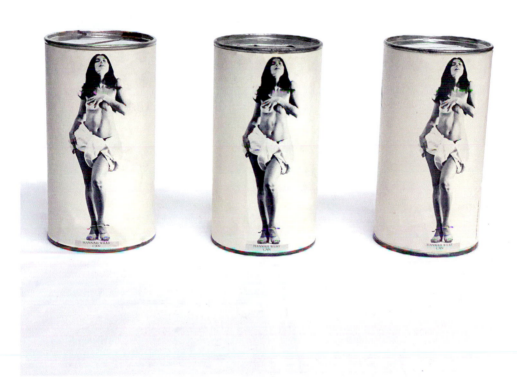

Hannah Wilke Can, 1978
Photo-reproduction on coin collection cans
Each 6 × 3 inches (15.2 × 7.6 cm)

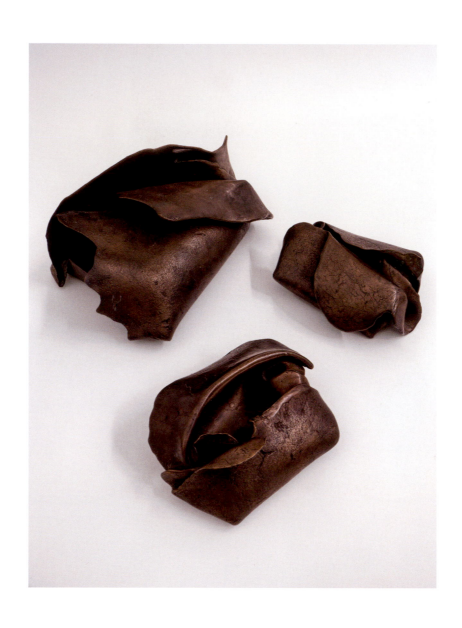

Ohio, 1979
3 matte patina bronze sculptures
5 × 6 × 9 inches (12.7 × 15.2 × 22.9 cm)
3 × 5 × 8 inches (7.6 × 12.7 × 20.3 cm)
3 × 5 × 9 inches (7.6 × 12.7 × 22.9 cm)

Untitled (Cityscape with Large Scale Sculpture), 1988
Ink and watercolor on cardboard with reverse image
8 ½ × 11 inches (21.6 × 27.9 cm)

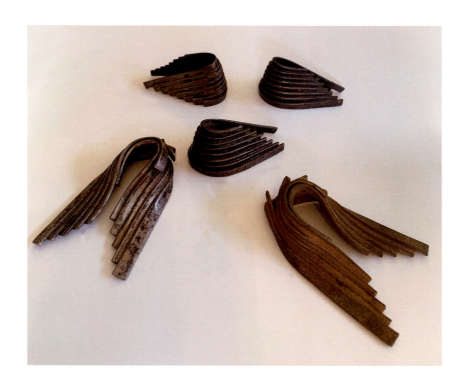

Pyramid Sculptures, Models for Large Scale Outdoor Sculptures, 1975–80
2 silver sculptures, each 2 × 2 ¼ × ¾ inches
(5.1 × 5.7 × 1.9 cm); 3 bronze sculptures, each
1 × 2 × 1 inches (2.5 × 5.1 × 2.5 cm)

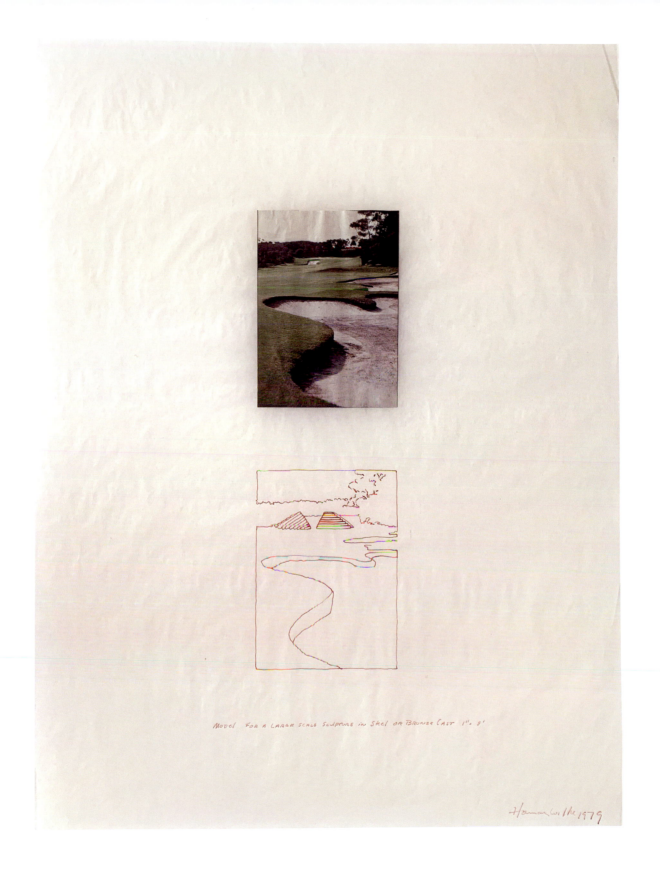

Model for Large Scale Sculpture in Steel or Bronze Cast, 1979
Magazine image and ink on paper
24 × 18 inches (61 × 45.7 cm)

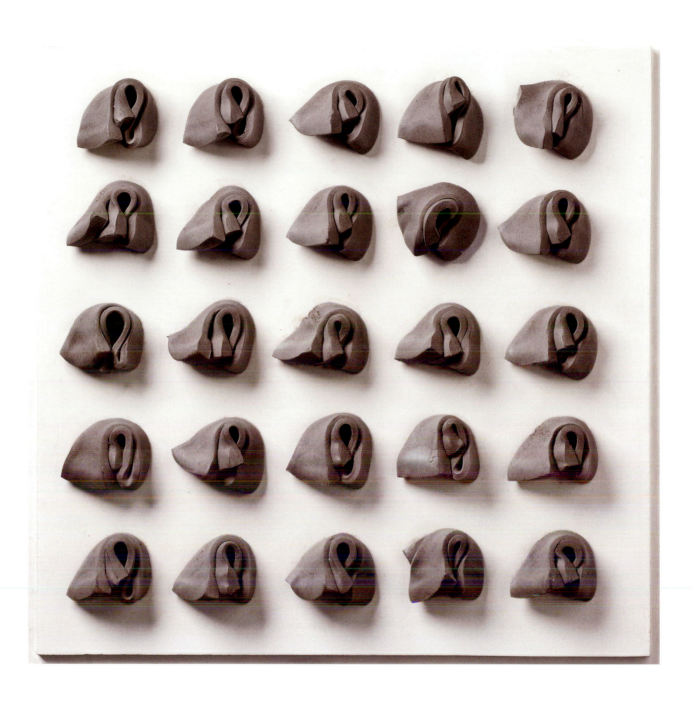

Needed-Erase-Her, No. 14, 1974
Kneaded erasers on painted board
2 × 13 × 13 inches (5.1 × 33 × 33 cm)

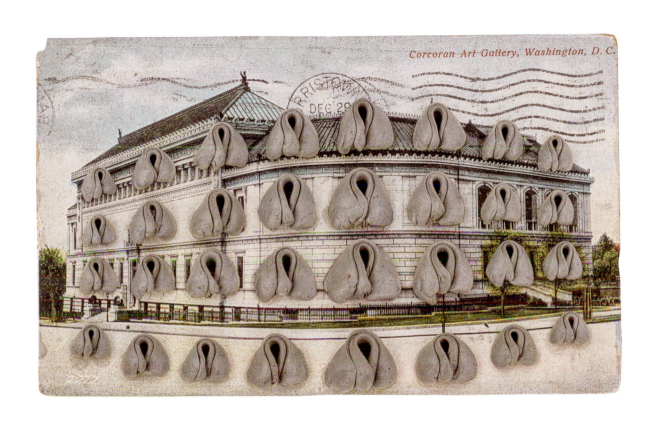

Corcoran Art Gallery (detail), 1976
Kneaded erasers on postcard and painted board in
Plexiglas box
Overall 15 ¾ × 17 ¾ inches (40 × 45.1 cm)

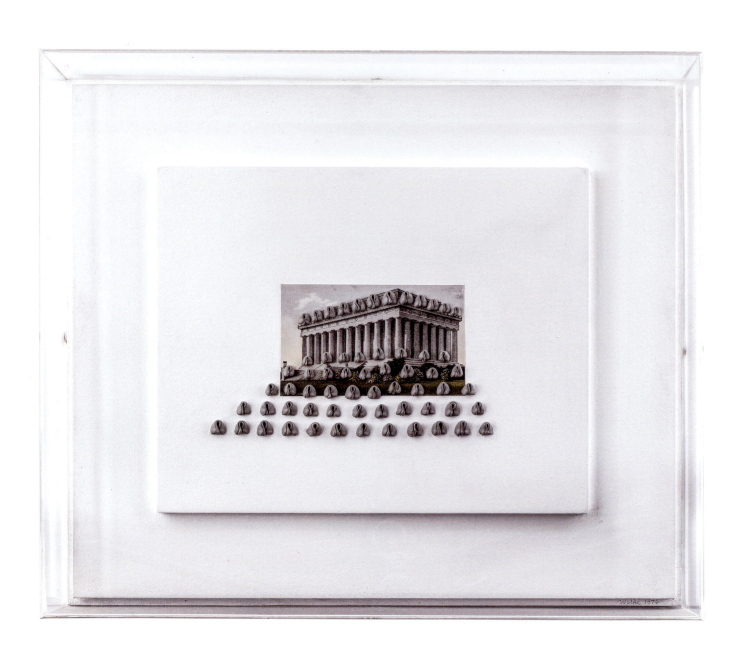

Lincoln Memorial, 1976
Kneaded erasers on postcard and painted board in
Plexiglas box
Overall 15 ⅞ × 17 ¹³⁄₁₆ inches (40.3 × 45.2 cm)

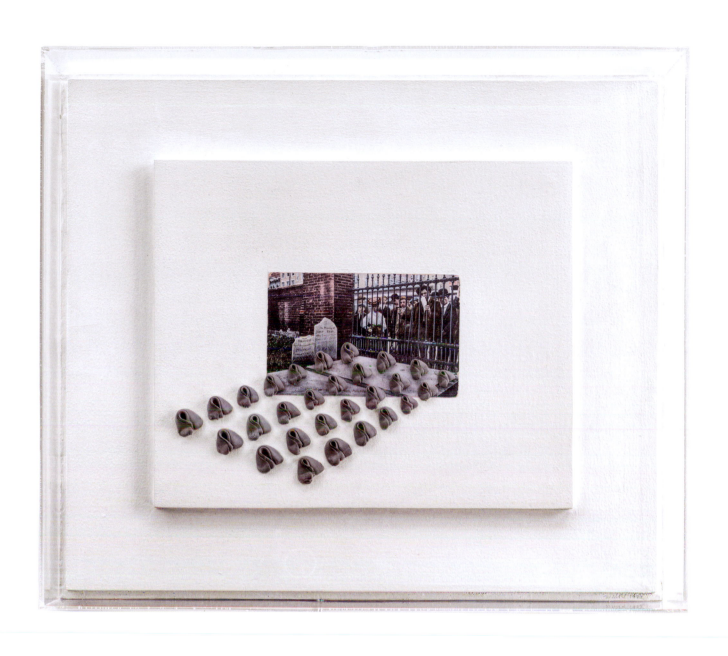

Franklin's Tomb, Philadelphia, 1977
Kneaded erasers on postcard and painted board in
Plexiglas box
Overall 16 × 18 × 2 ¾ inches (40.6 × 45.7 × 7 cm)

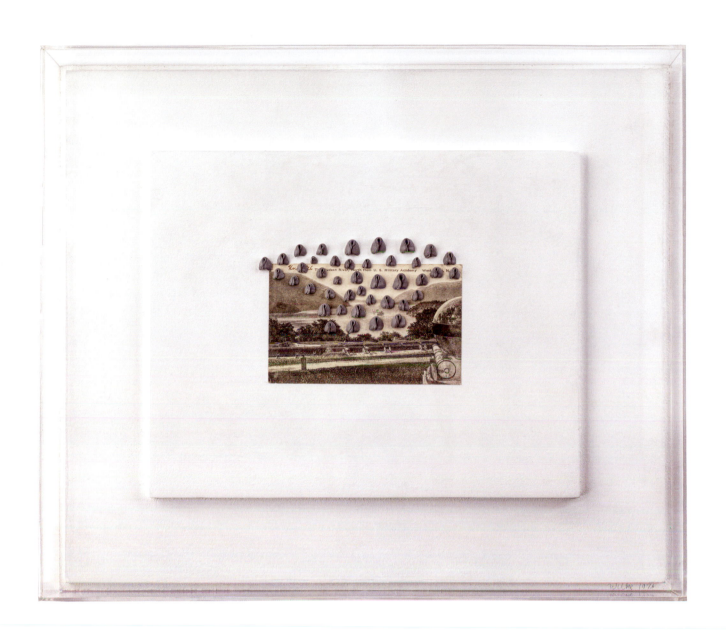

The Hudson River, West Point, NY, 1975
Kneaded erasers on vintage postcard and painted
board in Plexiglas box
Overall 15 ¾ × 17 ¾ × 1 ⅞ inches (40 × 45.1 × 4.8 cm)

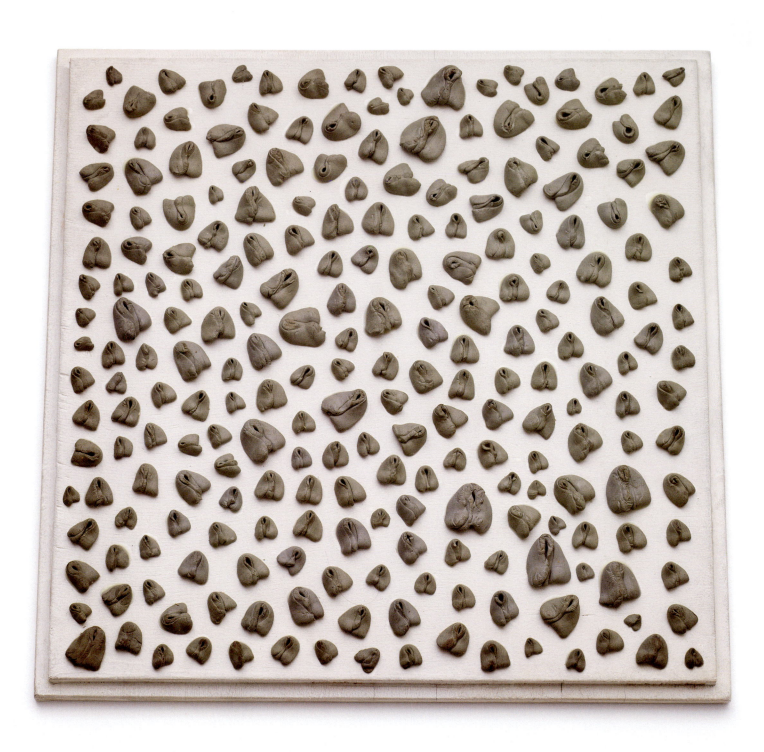

Needed-Erase-Her, No. 12, 1974
Kneaded erasers on painted board
2 × 13 ½ × 13 ½ inches (5.1 × 34.3 × 34.3 cm)

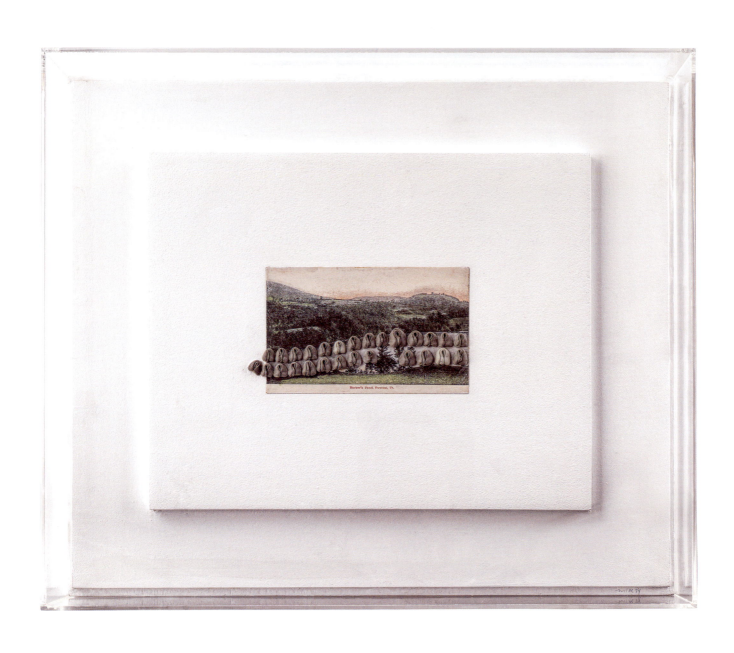

Barber's Pond, 1975
Kneaded erasers on postcard and painted board in
Plexiglas box
Overall 15 ⅜ × 17 ⅜ × 3 inches (39.1 × 44.1 × 7.6 cm)

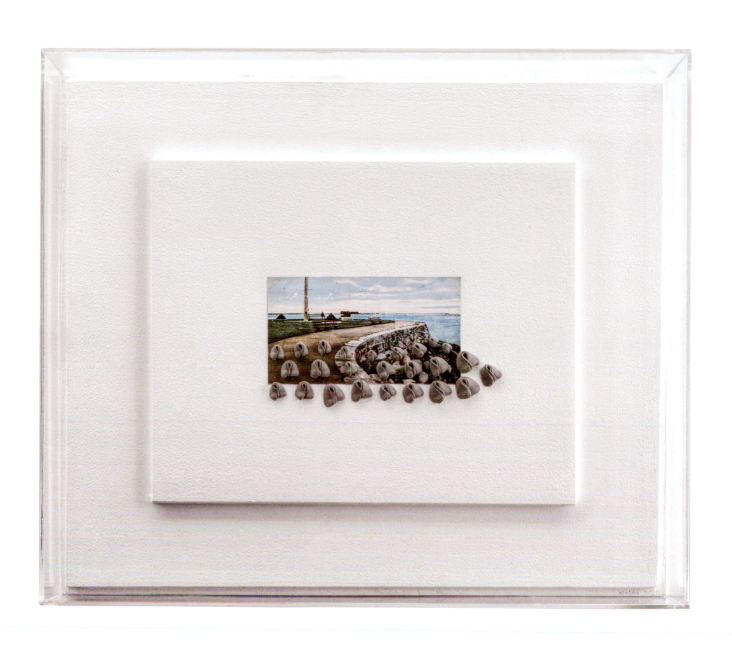

Sea Wall, 1975
Kneaded erasers on postcard and painted board
in Plexiglas box
Overall 15 ¾ × 17 ¾ × 2 ¾ inches (40 × 45.1 × 7 cm)

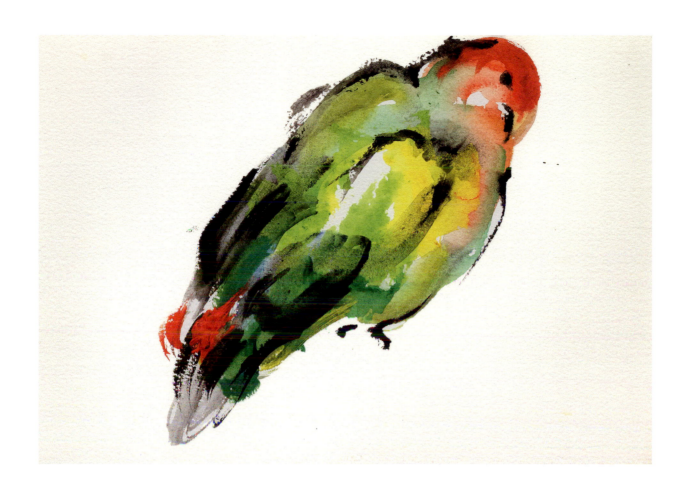

Untitled (Seura Chaya), 1983
Watercolor on paper
7 × 10 inches (17.7 × 25.4 cm)

In Memoriam: Selma Butter (Mommy), 1979–83
Photographic triptych with floor sculpture
Triptych: 3 groups of 6 gelatin silver prints,
with press type and paper, mounted on board
Each 41 × 61 inches (101.1 × 155 cm), framed
Sculpture: 3 groups of 2 acrylic painted ceramics
on acrylic painted Masonite board
Each 13 × 20 × 4 inches (33 × 50.8 × 10.2 cm)

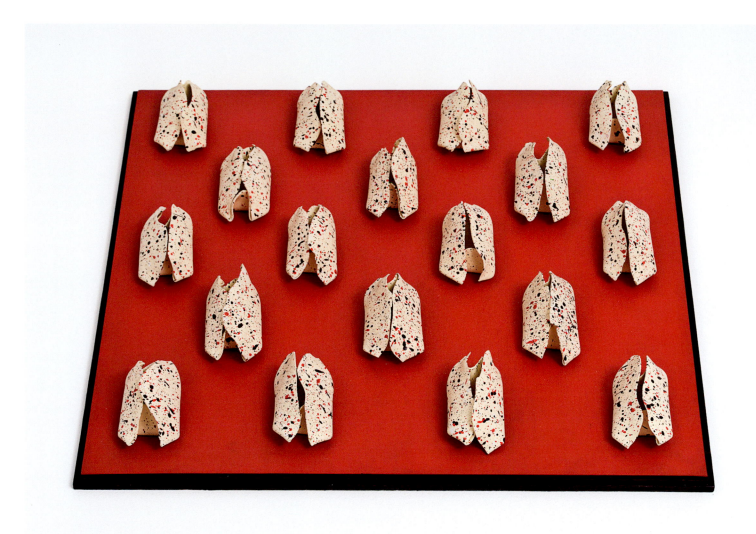

Generation Process Series #6, 1982
Acrylic on ceramic and wood
3 ½ × 19 ½ × 19 ½ inches (8.9 × 49.5 × 49.5 cm)

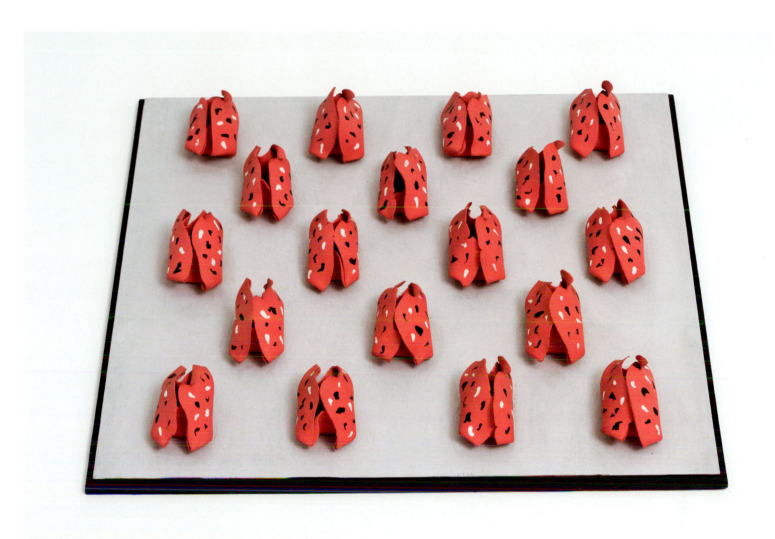

Generation Process Series #15, 1982
Acrylic on ceramic and wood
3 ½ × 19 ½ × 19 ½ inches (8.9 × 49.5 × 49.5 cm)

Untitled, 1983
Painted ceramic
4 ³⁄₁₆ × 10 ¼ × 5 inches (10.6 × 26 × 12.7 cm)

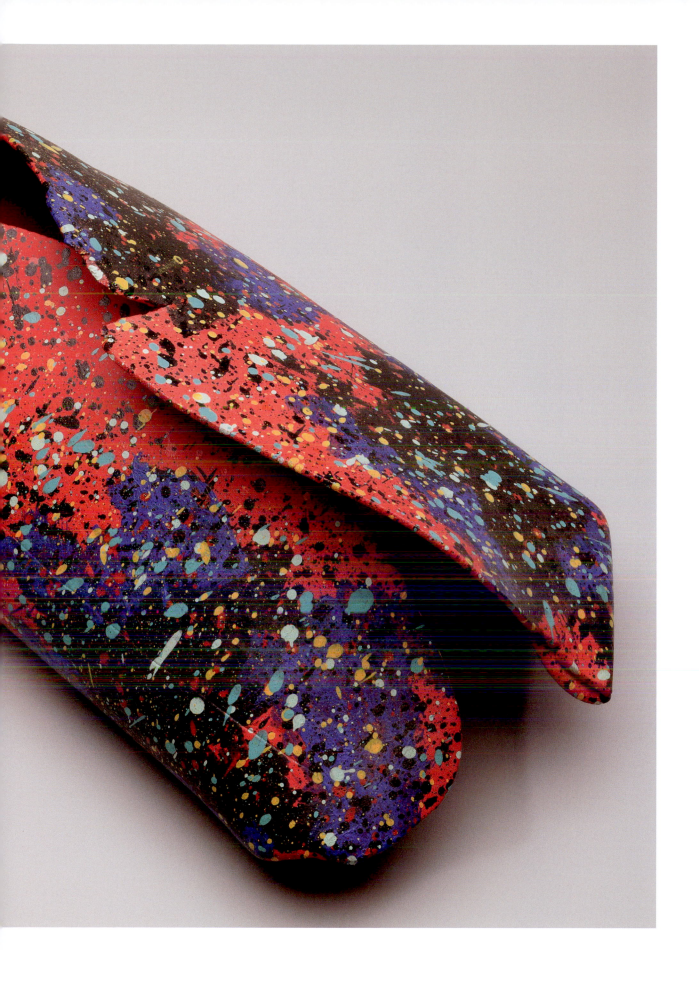

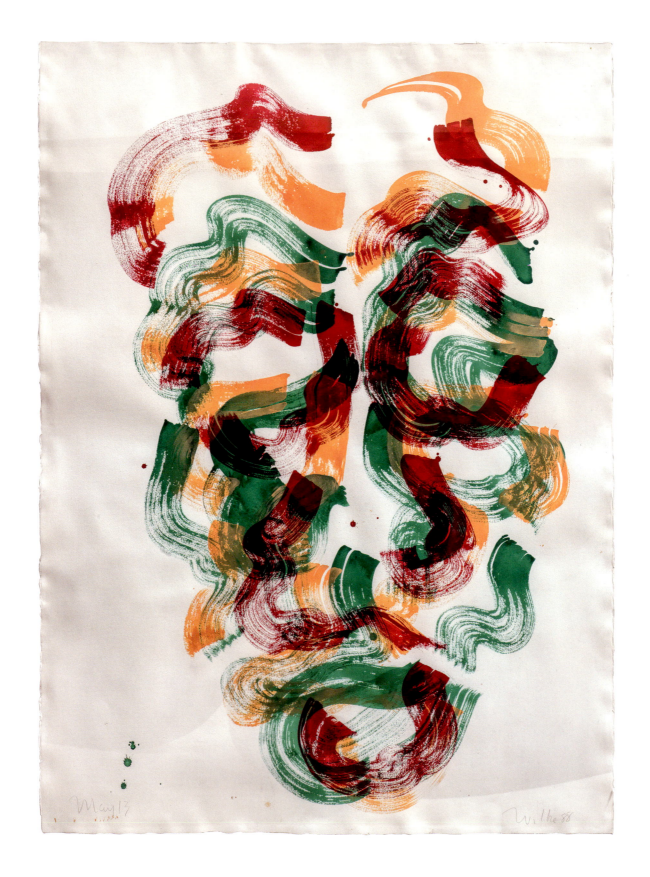

B.C. Series, Self-Portrait, May 13, 1988, 1988
Watercolor on Arches paper
71 ½ × 51 ½ inches (181.6 × 130.8 cm)

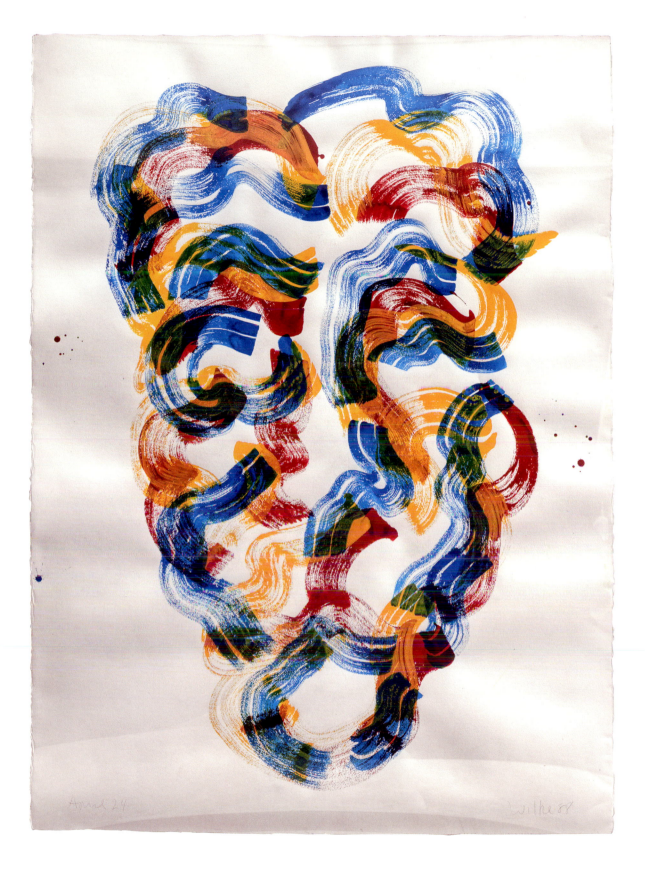

B.C. Series, Self-Portrait, April 24, 1988, 1988
Watercolor on Arches paper
71 ½ × 51 ½ inches (181.6 × 130.8 cm)

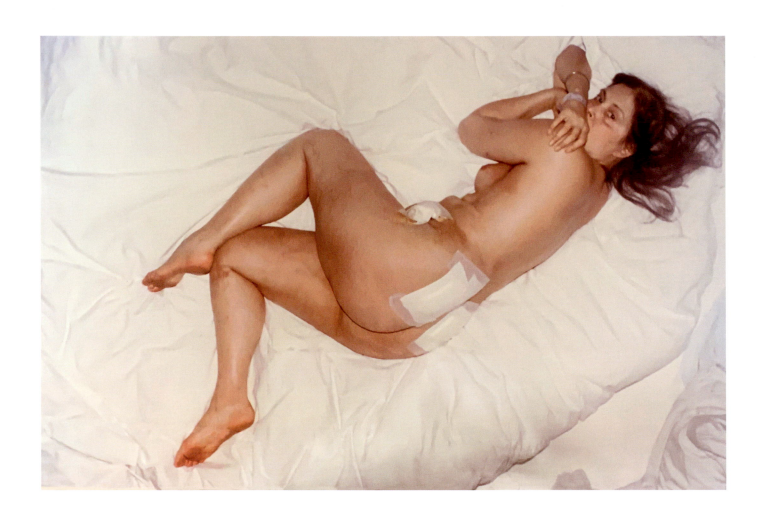

Intra-Venus Triptych, 1992–93
Chromogenic supergloss prints with overlaminate
Each 26 ¼ × 39 ½ inches (66.7 × 100.3 cm)

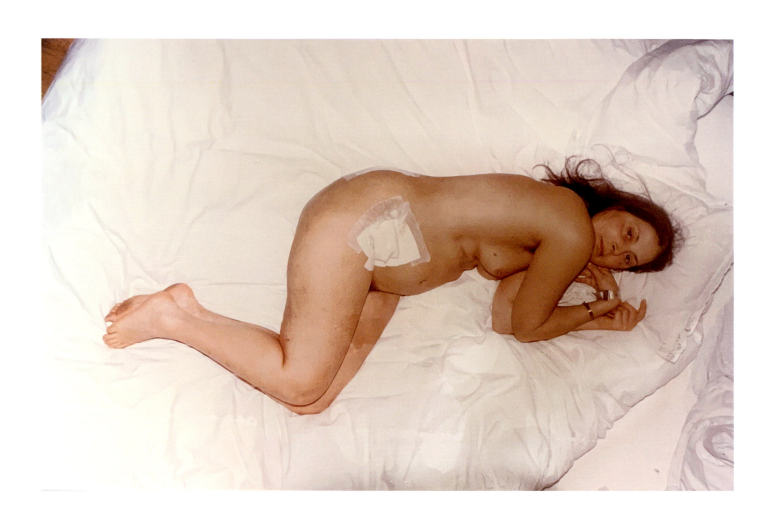

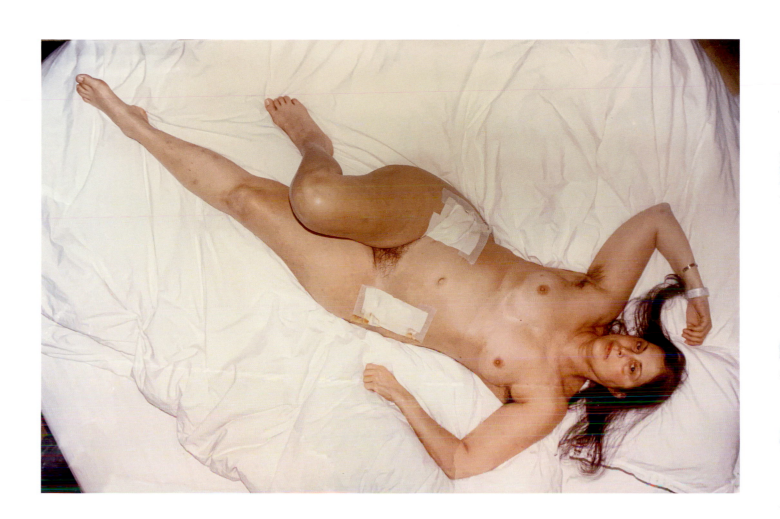

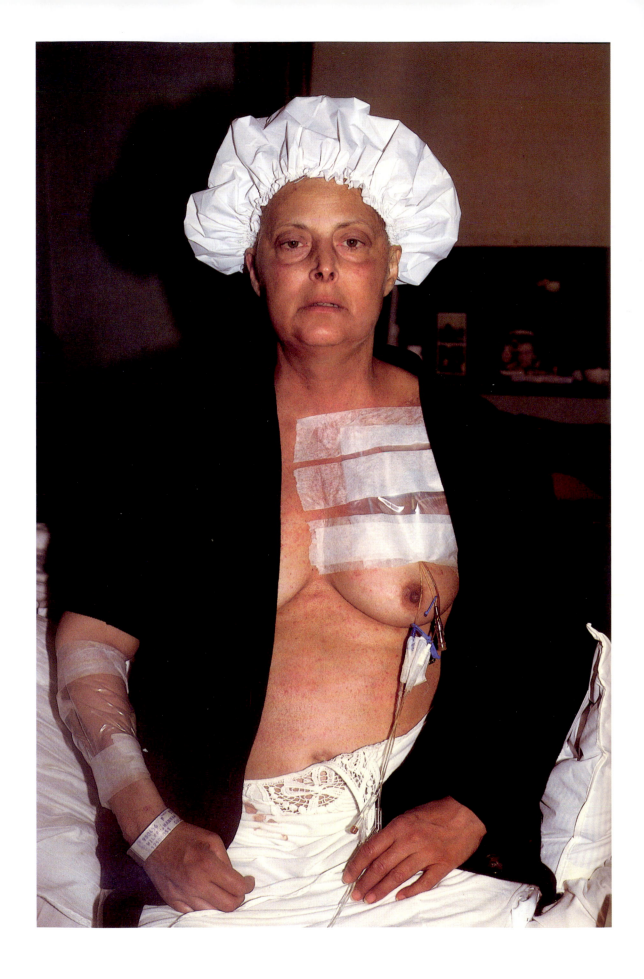

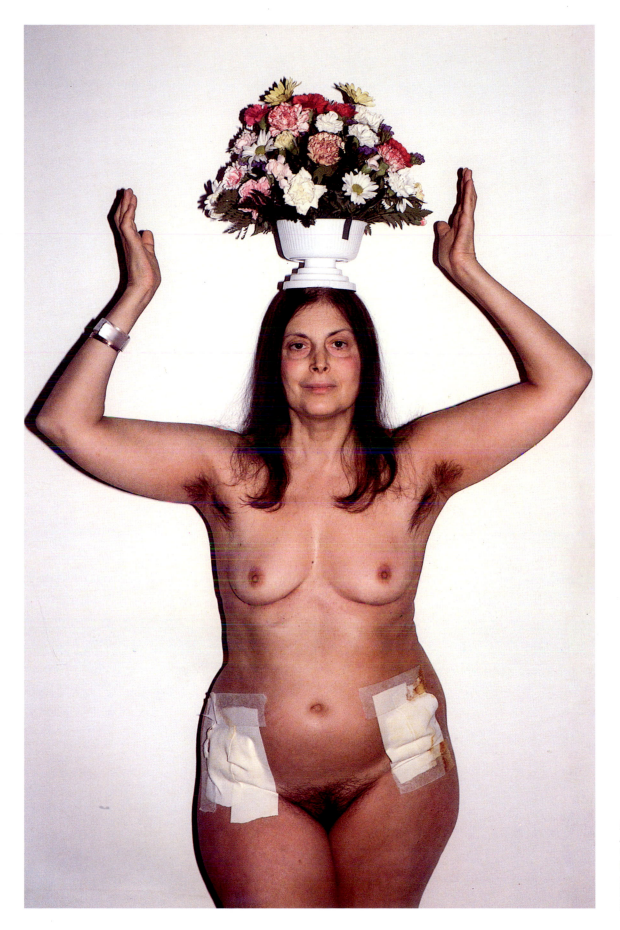

*Intra-Venus Series No. 1,
June 15 and January 30, 1992*,
1992
Chromogenic supergloss
prints with overlaminate
Each 71 ½ × 47 ½ inches
(181.6 × 120.7 cm)

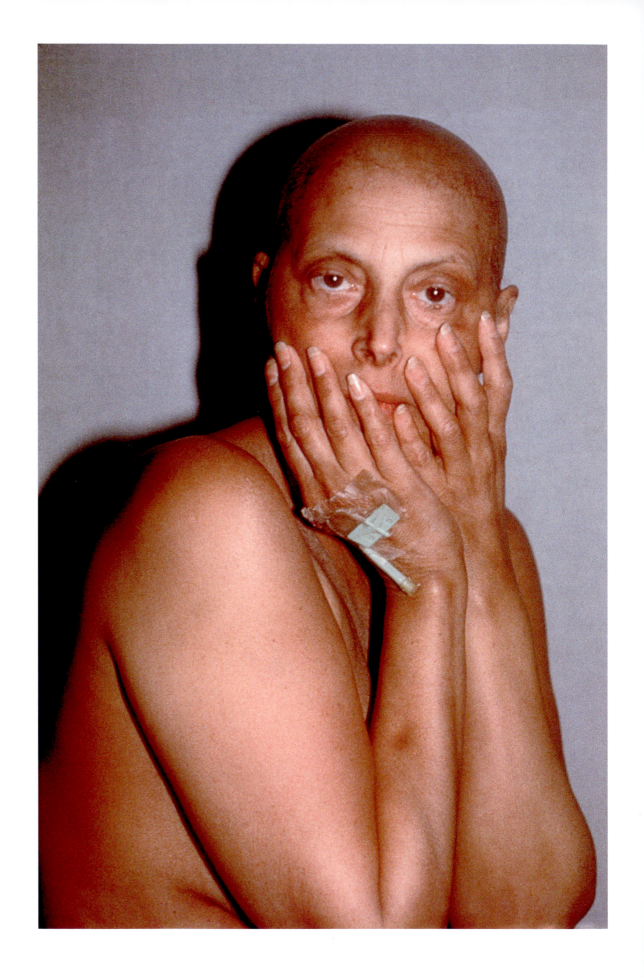

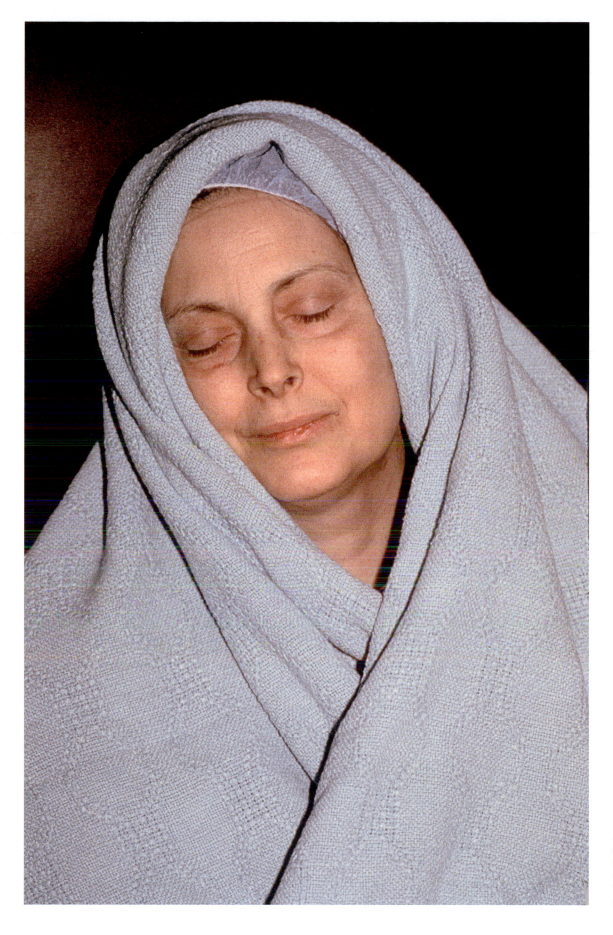

Intra-Venus Series No. 4, July 26
and February 19, 1992, 1992
Chromogenic supergloss prints
with overlaminate
Each 72 ¼ × 48 ¼ inches
(183.6 × 122.6 cm)

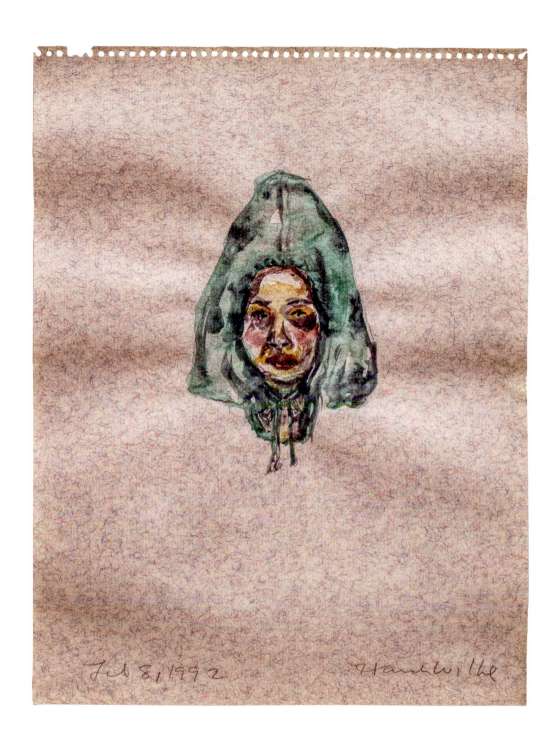

Intra-Venus Face No. 10, February 8, 1992, 1992
Watercolor on paper
12 ½ × 9 ½ inches (31.8 × 24.1 cm)

Intra-Venus Series No. 6, February 19, 1992, 1992
Chromogenic supergloss print with overlaminate
47 ½ × 71 ½ inches (120.7 × 181.6 cm)

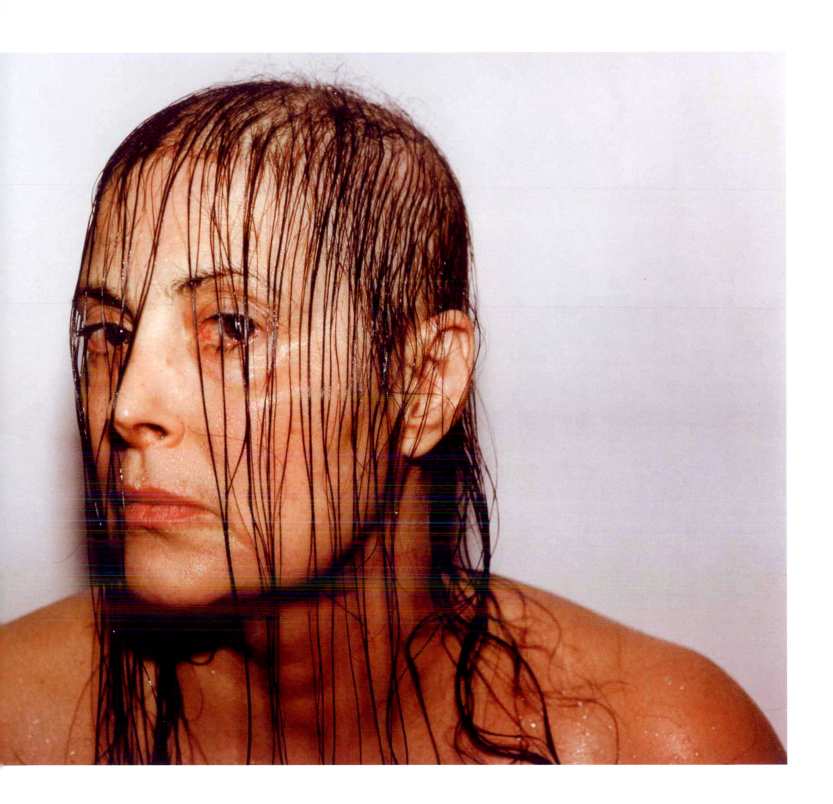

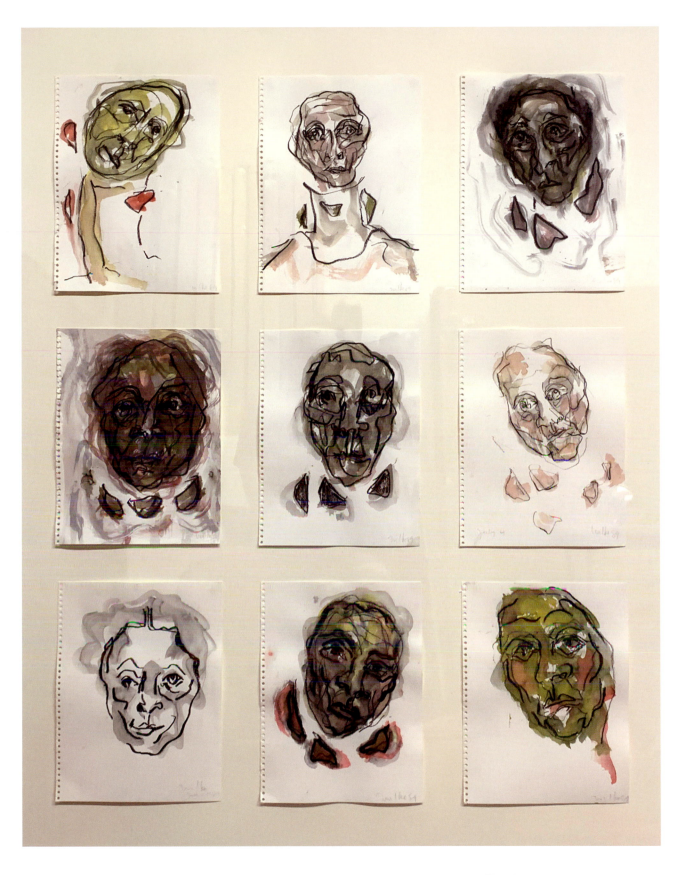

About Face #4, 1989
9 watercolors on paper
49 ¼ × 40 ¼ inches (125.1 × 102.2 cm), framed

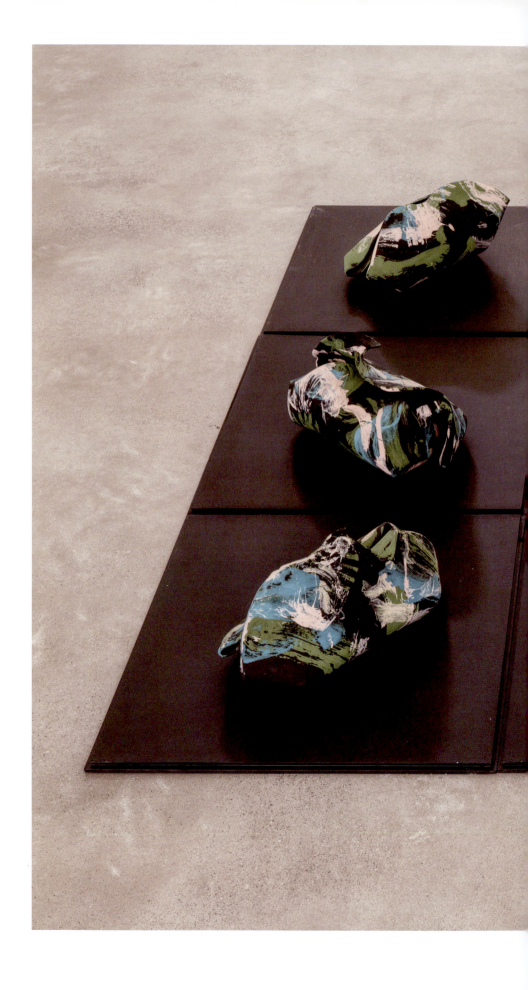

Blue Skies, 1987–92
Acrylic on ceramic and wood
7 × 59 × 59 inches (17.8 × 149.9 × 149.9 cm)

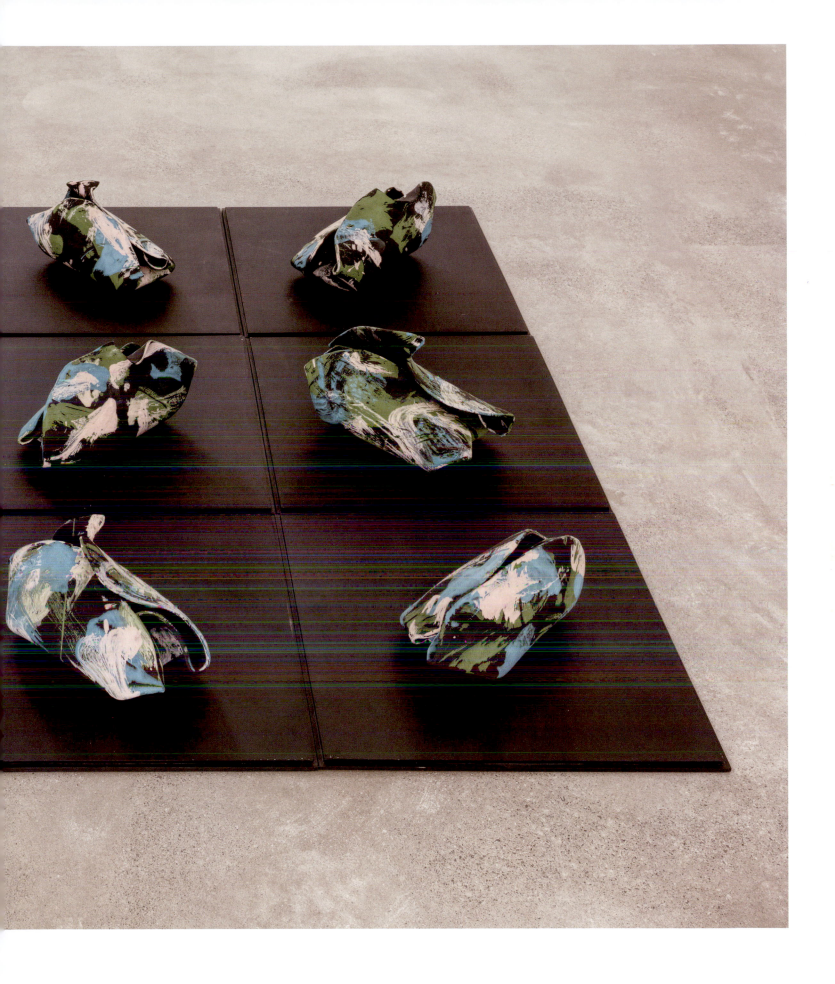

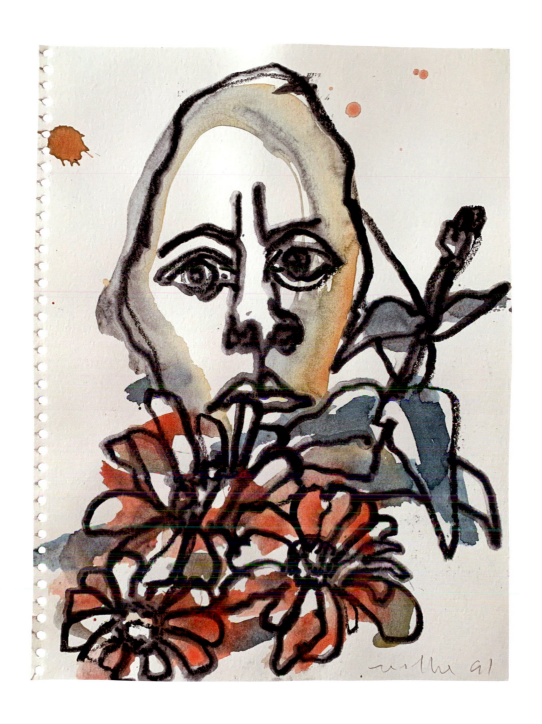

Untitled, 1991
Watercolor on paper
12 × 9 inches (30.5 × 22.9 cm)

205

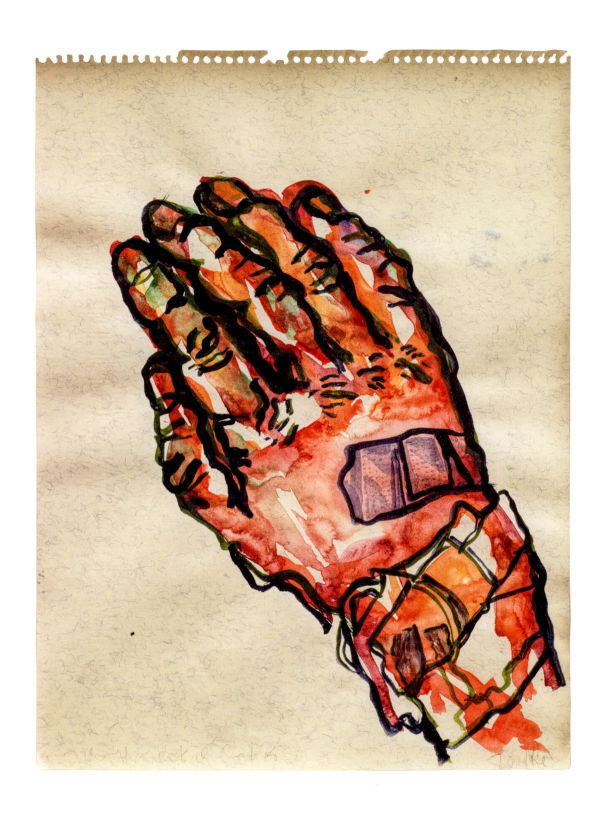

Intra-Venus Hand (NYC Hospital), October 18, 1991, 1991
Watercolor on paper
12 ½ × 9 ¼ inches (31.8 × 23.5 cm)

Untitled, 1990
Ink on paper
22 ¼ × 30 inches (56.5 × 76.2 cm)

Untitled, 1978
Sepia ink on paper
22 ¼ × 30 inches (56.5 × 76.2 cm)

Untitled, ca. 1978
Sepia ink on paper
17 × 22 ¾ inches (43.2 × 57.8 cm)

Untitled (*Gum with Berries*) from the
California Series, 1976
Archival pigment print, 2019
24 × 36 inches (61 × 91.4 cm)

Untitled (*Gum on Red Flower, Los Angeles*)
from the *Gum in Landscape* series, 1976
Archival pigment print, 2019
24 × 36 inches (61 × 91.4 cm)

Untitled (*Gum in Grass, Princeton NJ*) from the
Gum in Landscape series, 1977
Archival pigment print, 2019
24 × 36 inches (61 × 91.4 cm)

Untitled (*Gum on Palm Fronds, Los Angeles*) from
the *Gum in Landscape* series, 1976
Archival pigment print, 2019
24 × 36 inches (61 × 91.4 cm)

Untitled (*Gum on Rocks*) from the *Gum in Landscape* series, 1976
Archival pigment print, 2019
24 × 36 inches (61 × 91.4 cm)

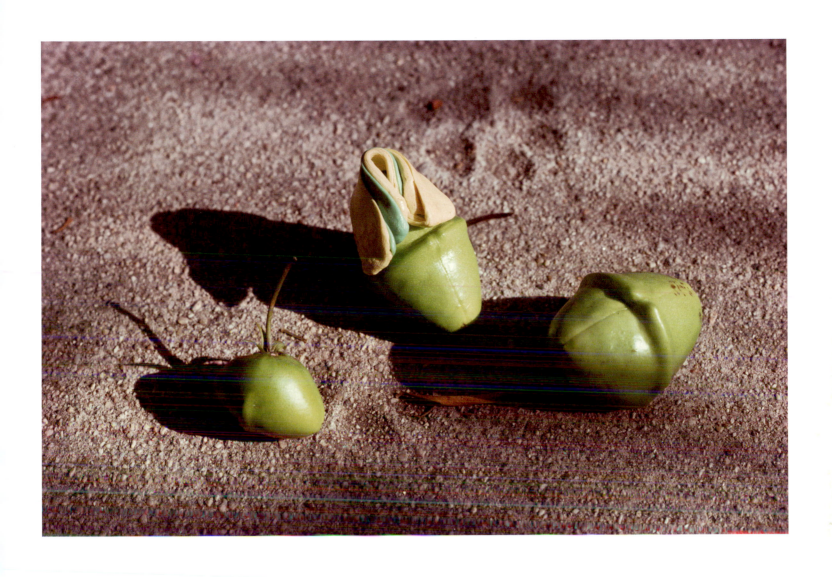

Untitled (*Gum on Acorn, Los Angeles*) from the
Gum in Landscape series, ca. 1976
Archival pigment print, 2019
24 × 36 inches (61 × 91.4 cm)

Hannah Manna. (Hebrew Hannah, grace. Japanese Hana, flower. Chaldean Ana, heaven. Sanskrit Ana, mother. Assyrian Anu, all-father. Hebrew Manhu, What is it?). Womblike blossoms resembling Venus mounds, a centerfold evolving from a circular plane, universally existing in both primary and secondary colors. Food from heaven, hence spiritual nourishment. Called angels' food.

Hannah Manna, 1985–86
77 painted sculptures with hand-typed, signed wall plaque
under glass
Dimensions variable

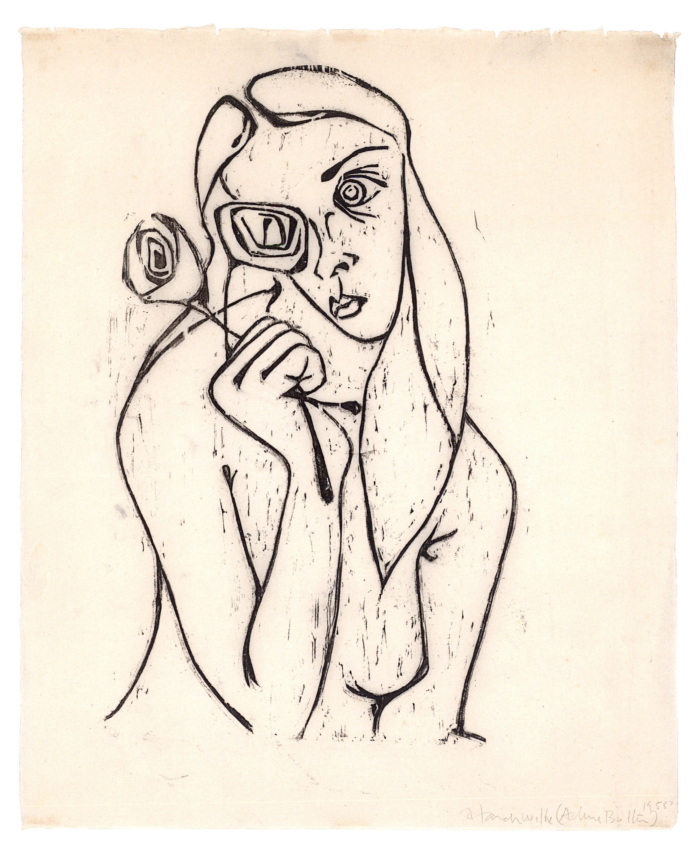

Self-Portrait with Flowers, ca. 1958
Unique woodcut on rice paper. Archival
pigment print, 2021
20 ⅝ × 16 ¾ inches (52.4 × 42.5 cm)

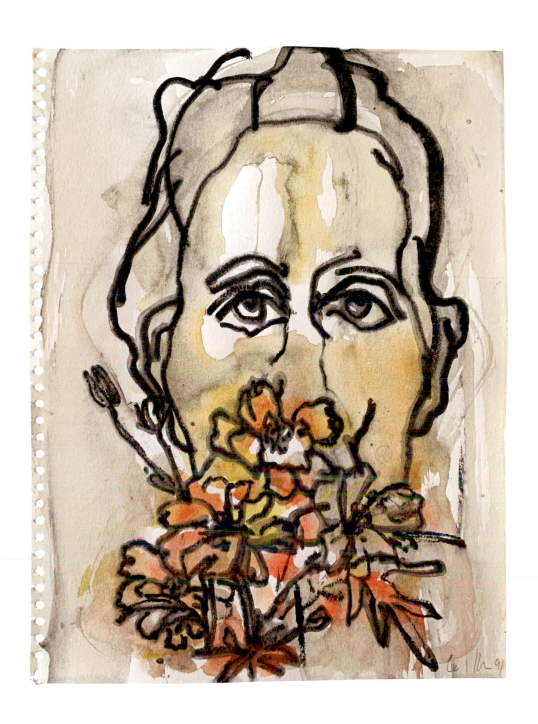

Untitled, 1991
Watercolor on paper
12 × 9 inches (30.5 × 22.9 cm)

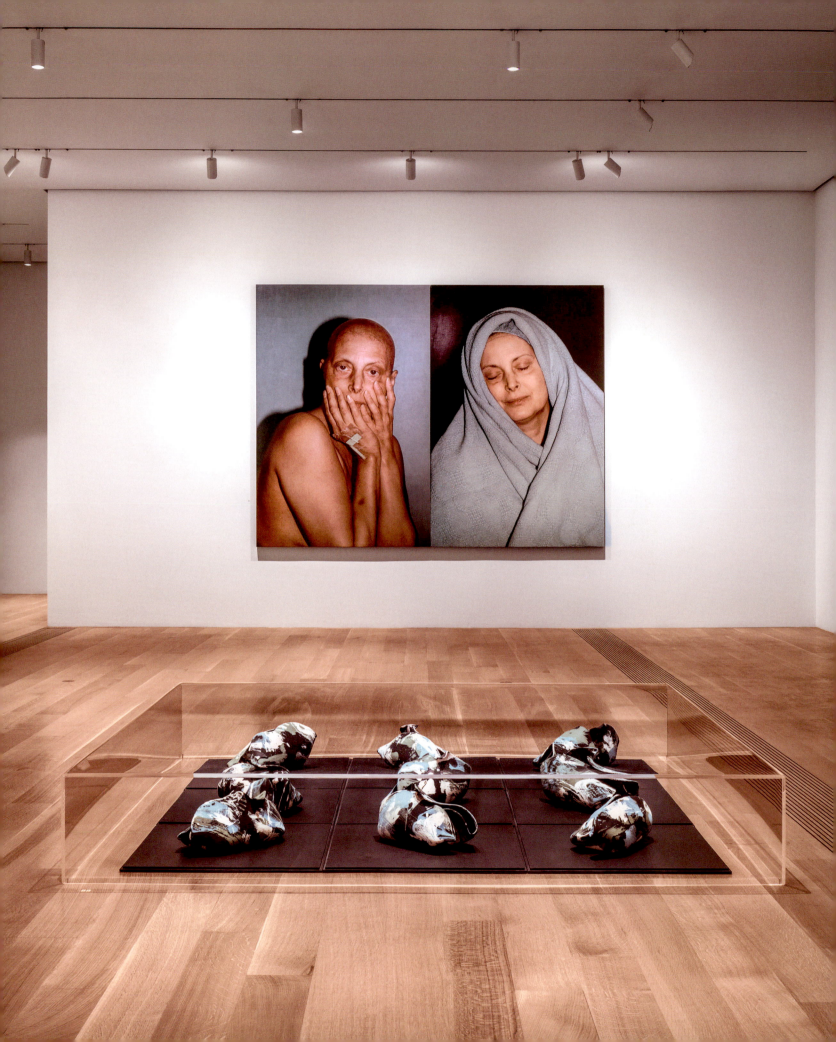

Chronology

KATHERINE B. HARNISH
AND MARSIE SCHARLATT

Arlene Butter, right, with family in Patterson, NY, 1946

1940–43

Hannah Wilke (née Arlene Hannah Butter) is born in lower Manhattan on March 7, 1940, to Selma Fabian and Emanuel (Manny) Butter. Selma's parents emigrated to New York from Hungary in the late nineteenth century. She worked as an egg candler as a child and a stenographer before her marriage. Manny's parents escaped to New York from Russian-held Poland in 1906. He practices law in his own firm and works for the National Labor Relations Board. Arlene and her sister, Marsie Scharlatt (née Marsha Lesley Butter), born fifteen months earlier, grow up in a large, close-knit, Jewish family.

1943–52

In 1943, the Butter family moves to Jackson Heights, Queens, a diverse community marred at times by anti-Semitism. During World War II, Manny is an air-raid warden, Selma rations food, and they plant a victory garden. They're concerned about relatives in combat in the Armed Forces, and, as news of the Holocaust reaches them, they become fearful for relatives still in Europe.

At P.S.2, Arlene is identified as gifted. She takes ballet lessons and draws, paints, and makes crafts with her sister. Their mother sings songs of the 1930s and shows them how to fold pastry dough. Their father reads them poetry and plays them children's records of classical music. At their maternal grandmother's apartment, they look at paintings on the wall. In her sixth-grade graduation book, Arlene writes "Artist" as her future profession.

The death of her paternal grandfather is the first of many losses Arlene experiences. She later connects the early loss of loved ones to the focus on life in her work.

1952–57

In 1952, the Butter family moves to Great Neck, Long Island. Arlene and her sister receive a Polaroid camera from their father. (In 1977 she would use a photograph of herself, taken by her sister in 1954, in the diptych *Arlene Hannah Butter*, 1954, and *Cover of Appearances*, 1977.)

Arlene performs in high school dance recitals, pursuing an interest in movement that carries through to her later work. She works after school with her boyfriend Francis Ford Coppola at a local tile store, rolling out clay and glazing tiles. In art class, she sculpts a bust of her paternal grandmother and creates her first self-portrait by drawing *Self-Portrait on a Tricycle*, ca. 1956, from an early photograph. Her teacher encourages her to go to art school. Arlene graduates from Great Neck High School in June 1957.

Polaroid photograph of Arlene Butter posing in her mother's mink stole, 1954

Arlene Butter, right, dancing in Great Neck High School Modern Dance Club recital, 1957

Assembling an art display in the main corridor of the Plymouth-Whitemarsh Junior-Senior High School's fine arts wing are students (left to right) Karl Howard and Anne Todd with their teacher, Mrs. Arlene Wilke. Howard and Miss Todd are advanced students.

Arlene Wilke, right, with students at Plymouth Whitemarsh High School, 1964

Arlene Wilke, lower right, looking at student art in Professor Sabatini's senior sculpture studio, Tyler School of Fine Arts, ca. 1961–62

1957–61
In fall 1957, Arlene enters Stella Elkins Tyler School of Fine Arts, Temple University, Elkins Park, Pennsylvania, majoring in sculpture. She studies with ceramist Rudolf Staffel, working in terracotta. In Raphael Sabatini's class she makes organic forms in fiberglass, and begins to paint and draw organic imagery. She learns printmaking with artist Romas Viesulas, creating the woodcut *Self-Portrait with Flowers*, ca. 1958 (p. 220).

Arlene marries industrial designer Barry Wilke in July 1960, and they travel to Greece. She takes his family name and begins to sign her work "Arlene Wilke."

Wilke's prints are shown in 1961 in her first group exhibition, *Annual Graphics Show*, at the Philadelphia Print Club. She receives awards for her sculpture, *The*

Groves of Academe, from both Allen's Lane Art Center and Cheltenham Township Arts Centre, where she teaches in a summer art program.

In February 1961, Emanuel Butter dies suddenly of a heart attack at age fifty-two, leaving his family bereft.

1962–65
Wilke graduates from Temple University in spring 1962, with a Bachelor of Fine Arts and a Bachelor of Science in Education. Wilke later recalls that her father's death prompted her to teach so she could support herself. She draws and makes sculpture while teaching art at Plymouth Whitemarsh High School, Plymouth Meeting, Pennsylvania, and becomes aware that the vulvar nature of her sculpture could jeopardize her job.

In 1965, Wilke and her husband move from Philadelphia to Riverdale, New York. She teaches art at White Plains High School until 1970.

In December 1965, Wilke moves into her own apartment in Manhattan and obtains a divorce in Mexico, although she continues to use her married name.

1966
Wilke shows her terracotta boxes in *Three-Dimensional Art* at Castagno Gallery. She studies at New York University Institute of Fine Arts with art historian Irving Sandler and artist Robert Kaupelis. Painter Knox Martin suggests that she use her middle name Hannah instead of Arlene. *Comment*, an Australian arts magazine, publishes her first interview.[1]

As Hannah Wilke, she exhibits a terracotta sculpture in *Hetero Is…*, a show of erotic art at NYCATA Gallery. In Lucy Lippard's review, an image of Wilke's untitled sculpture is placed near that of Giacometti's *Disagreeable Object*, 1931.[2] Later, Wilke recalls: "The concept of the disagreeable object had offended me, and I decided to make 'agreeable objects.' I don't feel happy on any level with disagreeable forms—I love beautiful things."[3]

1967
In the summer, Wilke travels to France, Italy, Holland, and England, and returns from London with a Rembrandt etching and a Cranach woodcut that inspire her future work.

1968
In November, Wilke moves in with her mother in Greenwich Village, awaiting the completion of Westbeth, affordable live/work housing for artists in the West Village.

1969
Wilke begins an eight-year relationship with Claes Oldenburg, and they travel throughout the United States, Japan, England, and Europe. In Los Angeles,

Wilke is featured by Oldenburg in his film *Erasers and Snails and a Couple of Towels*, and they visit her sister Marsie, who moved there with her children Emmy, Damon, and Andrew after her divorce.

Wilke and Oldenburg live together in New Haven, Connecticut, for five months. As Wilke observes the installation of his outdoor sculpture for Yale, she becomes interested in creating her own public sculpture.

1970
In January, Wilke and Oldenburg move into Westbeth together, and she begins to use latex, experimenting with layers that are snapped together. In June, she leaves her teaching job to work at Oldenburg's studio Store Days Inc, taking photographs and consulting on projects.

In March, Selma Butter is diagnosed with breast cancer and has a mastectomy on Wilke's birthday.

In June, Wilke and Oldenburg rent a house in Los Angeles for five months. There, she draws, sculpts, and takes a photograph of Oldenburg she later uses in the diptych *Walk on By*, 1970–82, named for a song that expresses her feelings about the end of their relationship. They

move to the Chateau Marmont, where Oldenburg takes a photograph of Wilke that becomes *The Artist in Her Studio at the Chateau Marmont*. She begins mining photographs in her archive, including early images of herself, which becomes an important part of her practice.

Wilke is featured in *The Great Ice Cream Robbery*, James Scott's documentary about Oldenburg, shot in London. The film is shown in 1971 at the Pasadena Art Museum during Oldenburg's exhibition *Object into Monument*. Wilke is credited for photographs used in the catalogue, including its cover image.

1971
Gallery Director Michael Findlay includes Wilke in two group shows in New York: *Americans* at Richard Feigen Gallery, and, at Feigen Downtown, *10 Painters and 1 Sculptor*. (Wilke is the sculptor.) A large selection of her terracotta work is shown.

Oldenburg buys a building on Broome Street in SoHo, New York, where they live together. Wilke has a studio there and maintains her studio at Westbeth.

Hannah Wilke photographing her untitled sculpture, 1966, in *Hetero Is…*, NYCATA Gallery, New York, 1966

Lucas Cranach the Elder, *The Virgin and Child*, original woodcut from *Wittenberger Heiligthumsbuch* (Wittenberg Reliquaries), Germany, 1510

1972

Wilke teaches sculpture at the School of Visual Arts in New York until 1991. In her ceramics courses, as in her own career, Wilke emphasizes clay as a sculptural material, as art rather than craft.

Madonna Magritte, a small pink latex rosette, appears in Herbert Distel's *Museum of Drawers*, Documenta V, Kassel, West Germany. Her latex wall sculptures are exhibited for the first time in *Painting or Sculpture?*, Newark Museum of Art, and *American Women Artists*, GEDOK, Kunsthaus, Hamburg. Wilke is in several shows including one at Galerie Neuendorf, Cologne, and *Artists' Benefit for Civil Liberties*, Leo Castelli Gallery, New York.

In September, *Hannah Wilke*, her first solo exhibition, is presented at Ronald Feldman Fine Arts, New York, where her latex sculpture is shown. In November, her first solo show in Los Angeles is held at Margo Leavin Gallery. Wilke is also in the Leavin group show *Drawings by Sculptors*, with Oldenburg, Nancy Graves, Donald Judd, Sol LeWitt, Robert Smithson, and others.

1973

Wilke joins Anita Steckel's Fight Censorship group. Other members include Judith Bernstein, Louise Bourgeois, Martha Edelheit, Joan Gluckman, Eunice Golden, and Joan Semmel. Fight Censorship seeks to end the double standard for women artists who use sexual subject matter in their work.

In January, Wilke's latex sculpture *In Memory of My Feelings*, 1972 (p. 99), is exhibited in the Whitney Biennial. Wilke contributes another latex sculpture, *Of Radishes and Flowers*, to *Women Choose Women* at the New York Cultural Center.

Wilke's work is shown in *Recent Sculpture and Painting* at Lo Guidice Gallery, New York, with artists Richard Serra, Frank Stella, Mark di Suvero, Andy Warhol, and others.

1974

Needing more studio space, Wilke buys her own loft on Greene Street, SoHo, and moves into it in March. She has a plaster floor built to pour latex and acquires her own kiln to fire sculpture.

Margo Leavin exhibits *Drawings from the Flower* series, 1967–73, Wilke's solo show of pastel drawings with collage. *Hannah Wilke*, her second solo exhibition at Ronald Feldman, commonly referred to as the *Floor Show*, features *176 One-Fold Gestural Sculptures* (p. 51), one of her first groupings of multiple clay sculptures; the *Needed-Erase-Her* series, her first use of kneaded erasers (pp. 169, 176); *Gestures*, her first video (p. 81); and *Laundry Lint (C.O.'s)*, 1971–73 (p. 68), her only work in lint.

Wilke receives a C.A.P.S. (Creative Artists Public Service Program) grant for sculpture. She makes assemblages of kneaded eraser sculptures on postcards.

Wilke is commissioned by Carl Solway Gallery, Cincinnati, to create a work for the Ponderosa Art Collection, Dayton, Ohio. Referencing Marcel Duchamp, she

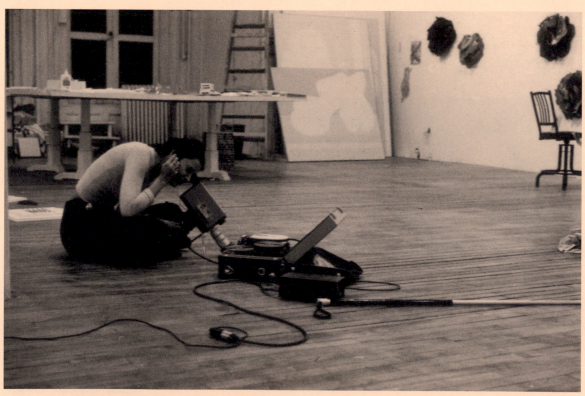

Hannah Wilke in her Greene Street studio, New York, mid-1970s

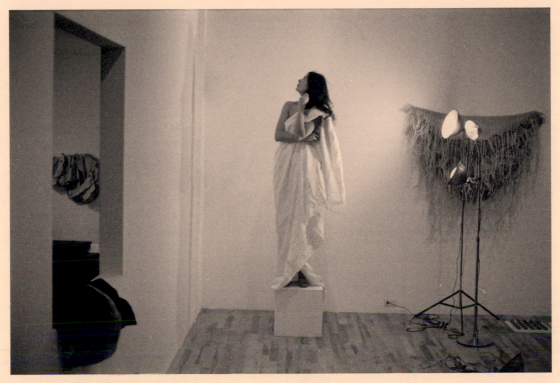

Hannah Wilke posing for *Hannah Wilke Super-t-Art* photographs in her Greene Street studio, New York, 1974

makes *Ponder-r-rosa #1*, an installation of nine black latex sculptures, and three other large installations in the *Ponder-r-rosa* series (pp. 26, 150–51).

Wilke contributes to two publications of the Feminist Art Program, California Institute of the Arts (CalArts), Valencia: *Anonymous Was a Woman* and *Art: A Woman's Sensibility*, for which she writes a "Letter to Women Artists." The letter is quoted widely.

The artist's first live performance, *Hannah Wilke Super-t-Art*, is presented in "Soup and Tart" at The Kitchen, New York, organized by artist Jean Dupuy, with performers Philip Glass, Joan Jonas, Gordon Matta-Clark, Yvonne Rainer, and others. She has herself photographed in her studio for the multipart photographic work, *Hannah Wilke Super-t-Art* (p. 64).

Artists Make Toys, 1975, exhibition poster featuring a photograph of Hannah Wilke and Claes Oldenburg also used on the cover of the exhibition catalogue, The Clocktower, Institute for Art and Urban Resources, New York, 1975

1975

After much research, Wilke discovers that by adding Liquitex acrylic paint to liquid latex, she achieves a more stable formula that slows deterioration of her latex works.

In *Artists Make Toys*, at The Clocktower, Institute of Art and Urban Resources, New York, Wilke debuts the installation *S.O.S. Starification Object Series: An Adult Game of Mastication*, 1974–75, in which

she shows photographs and chewing gum sculptures for the first time (p. 31). Oldenburg also contributes work to *Artists Make Toys*, and a photograph of them together in bed is used for the exhibition poster and catalogue cover.

During an interactive performance in *5 Américaines à Paris*, Galerie Gerald Piltzer, Paris, she asks the audience to chew gum and makes it into sculpture. Her video

Hello Boys, in which she performs behind a fish tank, is filmed in Paris (p. 76).

Hannah Wilke is her third solo show at Feldman. At the Fine Arts Building, New York, Wilke shows her intimate photographs of Oldenburg, whose work is also shown, in *Photography Not Photography*, and in *Lives* she unveils *Intercourse with…*, an audio installation of her answering machine messages from 1973 to 1975.

Wilke performs as Venus in Lil Picard's *White Sheets and Quiet Dots* at the Max Hutchinson Gallery, New York. At a Lynda Benglis opening at Paula Cooper Gallery, New York, Wilke removes her shirt and poses for the camera in *Invasion Performance*, her response to the notorious Benglis *Artforum* ad.

1976

Hannah Wilke: Starification at UC Irvine is the artist's first solo exhibition at a public institution. Curated by art historian Melinda Wortz, the show brings together Wilke's photographic, video, and audio work.

Hannah Wilke: Drawings and Sculpture, Wilke's third solo exhibition at Margo Leavin, features a large group of latex sculpture and installations. While in Los Angeles, she photographs the *Gum in Landscape* series (pp. 213–17).

My Count-ry 'Tis of Thee at the Albright-Knox Art Gallery, Buffalo, is Wilke's performance at the July 4 bicentennial celebration *Four for the Fourth*. The artist installs three twelve-foot-tall photographs of herself that echo the Saint-Gaudens caryatids on the building's facade, and invites visitors to chew gum, which she shapes into vaginal sculptures and mounts on sheets of paper to form a frieze on the museum's portico.

In Jean Dupuy's "Sunday on a Revolving Stage" at the Whitney, Wilke sings *I'd Be Rich as Rockefeller—My Count-ry 'Tis of Thee*, protesting the museum's bicentennial exhibition of the John D. Rockefeller III collection which includes only one African American artist and one woman artist.

Hannah Wilke Through the Large Glass is filmed at the Philadelphia Museum of Art for *C'est la Vie Rrose*, an homage to Duchamp made for German television. Wilke also directs her own video, *Philly*, in which she interacts with curator Anne D'Harnoncourt and prepares for her performance behind Duchamp's *Large Glass*.

Wilke receives a National Endowment for the Arts grant for sculpture and leads a workshop at the prestigious Alfred University Ceramic Arts Program, Alfred, New York, where she works in porcelain for the first time. One of the resulting works is *Elective Affinities*, 1978 (pp. 47, 138–39).

1977

Wilke learns that Oldenburg has married. Her Store Days Inc position ends. During the following years, she asserts her rights in a palimony case and engages legally with Oldenburg to recover her property and prevent censorship of her work.

The solo exhibition *Hannah Wilke: Sculpture and Drawings* opens at Marianne Deson Gallery in Chicago, where Wilke lectures at Artemisia Gallery and the University of Illinois Circle Campus.

Wilke's live performance *Intercourse with…* is videotaped at the London Art Museum and Library, Ontario, Canada (pp. 160–61).

Wilke's work is included in two shows at the Woman's Building, Los Angeles: *Contemporary Issues: Works by Women on Paper* and *What Is Feminist Art?* which Wilke answers with an iconic poster. Of that work, she later says: "I made *Marxism and Art: Beware of Fascist Feminism* (p. 66), because I felt feminism could easily become fascistic if people believe that feminism is only their kind of feminism, and not my kind of feminism, or her kind of feminism, or his kind of feminism."[4] The work is controversial, but she receives support from many feminists, especially Ruth Iskin and Arlene Raven, founders of the Woman's Building.

1978

Wilke is in a relationship with artist Richard Hamilton, and she has him photograph her near Duchamp's home in Cadaqués, Spain. She uses the photographs in the diptych *I Object: Memoirs of a Sugargiver*, 1977–78.

She performs *Give: Hannah Wilke Can—A Living Sculpture Needs to Make a Living* at a benefit of the Public Art Fund for City Walls, Susan Caldwell Gallery, New York. She asks visitors to place coins in the *Hannah Wilke Can* and those who buy them receive a signed certificate in which they agree to share the proceeds of any future sale with her (p. 163).

Selma Butter has a stroke, and her breast cancer returns. For the next four years, Wilke devotes time to her mother, who becomes a major subject in her work: "I took thousands of photographs of her… The images I made of myself and my mother kept me alive."[5]

Wilke conducts an interview with an elderly family member, which is published in the *Heresies* issue "Women's Traditional Arts, The Politics of Aesthetics."[6]

Through the Large Glass, her fourth solo exhibition at Feldman, includes videos and photographic work. Wilke shows in the group exhibitions *Feministische Kunst International*, De Appel, Amsterdam,

Still from *C'est La Vie Rrose* of Hannah Wilke in her Greene Street studio making gum sculptures, 1976

Performance view of *My Count-ry 'Tis of Thee*, Albright-Knox Art Gallery, Buffalo, New York, 1976

Performance view of *Give: Hannah Wilke Can—A Living Sculpture Needs to Make a Living*, Susan Caldwell Gallery, New York, 1978

231

and *The Sense of Self, From Self-Portrait to Autobiography*, Neuberger Museum of Art, Purchase, New York.

So Help Me Hannah: Snatch Shots with Ray Guns, with future husband Donald Goddard, is shown at P. S.1, Institute for Art and Urban Resources, Queens (now MoMA PS1). *So Help Me Hannah* performances follow at D.C. Space, Washington, and Kiplings, New York, 1979; A.I.R., New York, 1982; Forest City Gallery and Art Gallery of Windsor, Ontario, Canada, 1985. At the Art Gallery of Windsor, her performance is censored. Postcards of *So Help Me Hannah* photographs are censored by the US Postal Service.

1979

Washington Project for the Arts, Washington, DC, exhibits *Hannah Wilke: Performalist Self-Portraits*, 1942–79, curated by Adolfo V. Nodal. Wilke coins the term "performalist self-portrait," and introduces her concept of self-portraiture in which she is both the artist and the subject of the work. The show includes the triptych, *First Performalist Self-Portrait*, 1942–79, in which she uses a photograph of herself at age two.

A second NEA grant for sculpture and an Ohio University matching grant support a residency at Ohio University, Athens, where Wilke works with Professor Ed Mayer and casts bronze models for large-scale, outdoor sculpture (p. 164).

Wilke participates in the panel and exhibition *Contemporary Women in the Visual Arts* at Smith College, Northampton, Massachusetts. She lectures at five other colleges during the year.

Proud of its international recognition, Wilke shows her work in *Photographie als Kunst 1879–1979; Kunst als Photographie 1949–79*, at Tiroler Landesmuseum Ferdinandeum, Innsbruck; Neue Galerie am Wolfgang Gurlitt Museum, Linz; Neue Galerie am Landesmuseum Joanneum, Graz; and Museum des 20. Jahrhunderts, Vienna, Austria.

1980

The NEA awards Wilke a grant for performance art. She receives grants from the Alaska Council for the Arts and the University of Alaska, Fairbanks, where she leads a ceramics workshop.

The artist's work is in multiple shows, including: *A Decade of Women's Performance*, Contemporary Art Center, New Orleans; *Androgyny*, Studio Amazone,

Hannah Wilke teaching a sculpture workshop, University of Alaska, Fairbanks, 1980

Amsterdam; and *American Women Artists*, Museu de Arte Contemporânea da Universidade de São Paulo.

1981

Selma Butter's illness continues to impact Wilke's life and work. For *Portrait of the Artist with Her Mother, Selma Butter*, 1978–82, Wilke uses a photograph she takes of her mother (p. 73). Her mother's scars are echoed in Wilke's image in the diptych and in *Breastplate*, photographs of herself with a small cake she makes, decorates with gum sculptures, and places on a plate on her right breast. The cake is for the bake sale-style benefit at Franklin Furnace, New York.

At Sex and Language, the Fifth International Congress of Psychoanalysis, New York, Wilke performs *My Cunt-tree 'tis of Thee—Visual Prejudice* and *Be Careful It's My Art*. Among a list of notable speakers are Michelangelo Antonioni, William Burroughs, John Cage, Milan Kundera, and Lena Wertmüller.

Wilke teaches the workshop "Imaging the Self: From Self Analysis to Self-Portraiture," at the New York Feminist Art Institute Women's Center for Learning. She exhibits in *Pictures and Promises* at The Kitchen, curated by Barbara Kruger, and at a Heresies Benefit at the Grey Art Gallery, New York University.

1982

The John Simon Guggenheim Memorial Foundation awards Wilke a fellowship in sculpture.

Ronald Feldman exhibits *Revolutions Per Minute—The Art Record*, a recording of songs written by gallery artists along with their proposed cover art. Wilke records "Stand Up," which music critic Cynthia Rose describes as a "militant, melodic incantation."[7]

In April, Selma Butter passes away from breast cancer. The day after her funeral a lovebird flies into Donald Goddard's apartment, and he brings it to Wilke's loft. She and her sister name the love-bird Chaya, her mother's Hebrew middle name, from the word for animal and life. Lovebirds become a significant symbol for Wilke, representing love, caring, and the cycle of life, and she writes about Chaya and draws her in *The Book of Chaya*.[8]

1983

Wilke participates in *American Flower Painting from the Early 20th Century to Contemporary Art*, Dubois Gallery, Houston. Flowers are a polyvalent subject matter for Wilke, who often speaks of the connection between her vaginal sculptures and flowers. As Wilke recalls about her mother: "I used to draw flowers and watch the flowers die, sort of as preparation for her death, but the beautiful

colors of the flowers became the colors of the sculptures."[9]

Wilke lectures at Oberlin College, Oberlin, Ohio, and at Atlanta College of Art and High Museum of Art, Atlanta.

Chaya, Wilke's lovebird dies on the last day of mourning for her mother, and she and Goddard bury her at the Bronx Zoo in one of Wilke's sculptures. Wilke paints many watercolors of Chaya and continues to paint the birds they go on to adopt (p. 181).

1984

Wilke is included in *Art and Ideology* at the New Museum, New York. Each of the show's five curators works with two artists to represent a theme. Curator Lowery Stokes Sims addresses art and politics through the work of Wilke and Kaylyn Sullivan. Wilke debuts what she will later title *Advertisements for Living*, 1966–82, nine Cibachrome diptychs in which she contrasts the liveliness of intimate relationships with the names of male authorities.

For her fifth solo exhibition at Feldman, *Support Foundation Comfort*, Wilke presents what she describes as "a memorial exhibition for my mother, with life-size photographs of her and womblike sculptures…to comfort me, to be with her again, to watch her wave, to see her eat. To wear her wounds, to heal my own…circles becoming three-dimensional wombs representing the oneness of our relationship…sculptures juxtaposed together as burial mounds, as gardens in natural formations representing the reproductive process that created me."[10]

Melancholy Mama, Wilke's homage to her mother in latex, is shown in *American Women Artists, Part II, the Recent Generation*, at Sidney Janis Gallery, New York.

Wilke's solo exhibition, *Hannah Wilke*, at Joseph Gross Gallery, University of Arizona, Tucson, is curated by artist, art historian, and feminist scholar Joanna Frueh, who becomes a foundational Wilke scholar.

1985

The Guerrilla Girls include Wilke's work in *Women Artists at the Palladium*, New York. Wilke becomes an honorary member of this coalition of feminist activists who work to expose the art world's unfair treatment of women and advocate for gender equality.

After the controversial removal of Richard Serra's *Tilted Arc* from New York's Federal Plaza, artists propose new public art, which is shown in *After Tilted Arc*, Storefront for Art and Architecture, New York. Wilke submits *Color Fields: Model for Large-Scale Sculpture at Federal Plaza, New York*, a replica of the plaza with miniatures of her proposed large-scale sculptures arranged on platforms.

Wilke's work is also in the group exhibition *Das Aktfoto*, Münchner Stadtmuseum, Munich; Museum des 20. Jahrhunderts, Vienna; and Museum für Kunst und Kulturgeschichte, Dortmund, Germany.

1986

In December, Wilke begins to make abstract watercolor portraits of her face. In an interview, she says: "I realized that what I had done in the last few days, because I had been quite depressed, was to make gestural layered watercolors of only my face in which I took away my hair, creating circular patterns. But these portraits really became portraits of my mother, who had lost all of her hair from chemotherapy."[11]

Installation view of *Support Foundation Comfort*, Ronald Feldman Fine Arts, New York, 1984

Wilke participates in *The Heroic Female: Images of Power* at Ceres Gallery, New York Feminist Art Institute. Power dynamics and gender are explored in *The Male Nude: Women Regard Men* at Hudson Center Galleries, New York, where Wilke shows *Dear Claes*, 1970–76.

In *New Liberty Monuments*, curated by John Perreault, Wilke shows *Venus Pareve: Monument to Replace the Statue of Liberty*, 1982–86, created from her *Venus Pareve* self-portrait multiples (pp. 56–57), mounted together on a platform incised with the Star of David.

Hannah Manna (1985–86), a group of seventy-seven brightly painted sculptures, is shown on the grass in *A Garden of Knowledge*, Central Hall Gallery, New York (pp. 218–19).

1987

Wilke is on a panel about performance art and sculpture at the National Women's Sculpture Conference, Cincinnati, and lectures and gives ceramic, print, and sculpture workshops at the University of Texas, El Paso.

The artist visits her sister in Los Angeles and shows her a lump in her neck, which is later diagnosed as non-Hodgkin's lymphoma. As Wilke recalls: "I felt an immense loss of self."[12] Learning she has cancer she titles her watercolor self-portraits *B.C. Series* for "before cancer," and makes the diptych *Handle with Care*.

A Pollock-Krasner grant provides support following Wilke's diagnosis. She exhibits photographs of her mother during her own cancer treatment in *Family Portraits*, Wright State University Art Galleries, Dayton, Ohio; and *The Artist's Mother: Portraits and Homage*, Heckscher Museum, Huntington, New York, and the National Portrait Gallery, Washington, DC.

1988

In Los Angeles, Wilke exhibits work in *Hollywood, Portraits of the Stars*, at Otis Art Institute; and *Lost and Found in California, Four Decades of Assemblage Art*, at James Corcoran, and three other galleries. Her sister arranges a series of lectures for her at UCLA, CalArts, and Pasadena Art Institute.

She also contributes work to *Modes of Address: Language in Art Since 1960* at the Whitney Museum, and *Marcel Duchamp and the Avantgarde since 1950*, Museum Ludwig, Cologne.

1989

Wilke's first retrospective exhibition, *Hannah Wilke: A Retrospective*, curated by Thomas H. Kochheiser, is shown at Gallery 210, University of Missouri, St. Louis and Kansas City, and she lectures at both venues. Joanna Frueh contributes the catalogue essay. Oldenburg takes legal action to censor and remove his correspondence and images of him from the catalogue, including one with Wilke's niece Emmy. Richard Hamilton writes a letter in support of Wilke, which she uses in the work *Even-tu-ally*, 1969–91.

In *About Face*, her sixth solo show at Feldman, Wilke exhibits *B.C. Series* watercolors, along with *Seura Chaya*, 1978–89, large photographs of her mother with watercolor lovebirds below her image. Wilke also shows *Daughters*, a diptych pairing a photograph of Goddard and one of his two daughters with a photograph of herself and a lovebird. Throughout her life, Wilke photographs other people, including her lovers and her family, and keeps their images in files for use in her work.

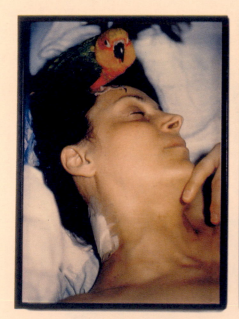

Handle with Care, 1987
Cibachrome prints
Left: 30 × 21 ½ inches (76.2 × 54.6 cm)
Right: 30 × 39 ½ inches (76.2 × 100.3 cm)

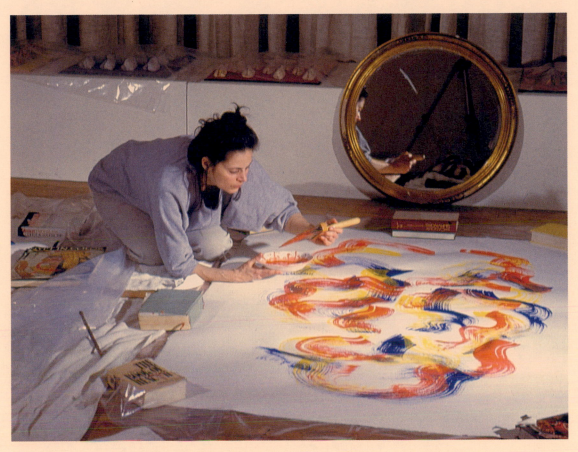

Hannah Wilke painting *B.C. Self-Portrait* in her Greene Street studio, New York, 1989

Wilke's work is included in *Image World: Art and Media Culture* at the Whitney, and in the traveling show of women's art *Making Their Mark*, at the Cincinnati Art Museum; New Orleans Museum of Art; Denver Art Museum; and Pennsylvania Academy of Fine Arts.

1990
At the St. Louis Art Museum's Cancer Survivors' Day event, Wilke delivers the keynote address.

A one-person show, *Hannah Wilke, Past and Present,* is shown at Genovese Graphics Gallery, Boston.

1991
Hername, 1978–91, an edition of etchings of Wilke's first name that spell out words that are meaningful to her, is printed by Patsfall Press and published by Volatile, both in Cincinnati.

Wilke's health prevents her from continuing to teach at the School of Visual Arts. Just as she documented her mother's life with cancer, Wilke, with Donald Goddard, begins a record of her own experience with cancer—the *Intra-Venus* photographs and videotapes (pp. 190–95, 198–99).

Wilke and her sister Marsie travel by bus to Mexico to visit alternative treatment programs and return disheartened. Wilke contributes to two shows that center on illness: *Imaging Illness* at the Boston Public Library and Everson Museum of Art, Syracuse, New York; and *AIDS: It Could Be You*, Triplex Gallery, The City University of New York.

Wilke engages a lawyer to have Oldenburg return the hundreds of photographs she made when they lived together. Some are returned.

1992
Wilke has chemotherapy and creates *Brushstrokes*, drawings made from her hair as it falls out. During hospital stays, she makes watercolors of her face and hands (pp. 197, 205–6, 221). In her studio, she completes the sculptural floor work *Blue Skies*, 1987–92, named for a hopeful song she sang as a child with her mother and sister (pp. 202–3).

For her second Pollock-Krasner grant, Wilke writes: "Nevertheless, I hope to continue working on my art in some fashion. I have already done hundreds of paintings, drawings, and other works in connection with my illness and I plan to continue as long as I can. These will be the basis of a forthcoming exhibition about the actual experience of living through serious illness that I hope will focus attention on the possibilities of cure and encourage others who are undergoing similar ordeals."

Untitled, 1992
Watercolor on hospital pillowcase
28 ½ × 19 ¼ inches (72.4 × 48.9 cm)

In May, her sister Marsie returns to New York to live with her. Wilke has a bone-marrow transplant, and during hospitalization she makes drawings and paints watercolor flowers on hospital pillowcases. The lymphoma recurs, however.

Wilke is in several exhibitions with themes significant to her throughout her life: *Taboo: Bodies Talk*, 494 Gallery, New York; *Love and Death: Growing Old in America (Is a Sin)*, Ghia Gallery, San Francisco; and *Seeing Red, White or Blue: Censored in the U.S.A.*, Visual Arts Center of Alaska, Anchorage.

Attended by family and friends, Wilke marries Donald Goddard on December 27 in her loft on Greene Street.

1993
Wilke travels with Goddard and her sister Marsie Scharlatt to Houston, Texas, where she receives alternative treatment. She passes away on January 28.

Since her death, Wilke's work has been shown in numerous solo and group exhibitions, including a retrospective at Nikolai Contemporary, Copenhagen, 1998, and a career-spanning presentation at Neuberger Museum, Purchase, NY, 2008.

NOTES
1 Lillian Roxen, "H. Wilke Ceramic Erotica," *Comment*, August 1966, 9.
2 Lucy Lippard, "Eros Presumptive," *The Hudson Review* 20, Spring 1967, 91–99.
3 Lil Picard, "Hannah Wilke: Sexy Objects," *Interview*, January 1973, 18.
4 Ernst Weber, "Artist Hannah Wilke Talks with Ernst," *Oasis d'Neon* 1, no. 2 (1978).
5 Hannah Wilke, "Seura Chaya," *New Observations* 58, June 1988, 12.
6 Hannah Wilke, "My Father's Brother's Wife's Mother," *Heresies* 1, Winter 1978, 75–76.
7 Cynthia Rose, "The Art Racket," *New Musical Express*, September 4, 1982, 12.
8 Wilke, "Seura Chaya," 12–13.
9 Ernst Weber, "Oasis d'Neon Video Magazine Talks With Artist Hannah Wilke," a one-hour videotape filmed at Wilke's Greene Street studio, March 21, 1985.
10 Wilke, "Seura Chaya," 12–13.
11 Cassandra Langer, "The Art of Healing," *Ms.* 17, January/February 1989, 32–33.
12 Tim Cone, "Life Over Art: Oldenburg's Privacy, Wilke's Publicity," *Arts Magazine*, September 1989, 25–26.

All images in chronology courtesy and © Hannah Wilke Collection & Archive, Los Angeles

Exhibition
Checklist

Self-Portrait with Flowers, ca. 1958
Unique woodcut on rice paper. Archival
pigment print, 2021
20 ⅝ × 16 ¾ inches (52.4 × 42.5 cm)
Hannah Wilke Collection & Archive, L.A.
Courtesy Alison Jacques
Page 220

Five Androgynous and Vaginal Sculptures,
ca. 1960–64
Terracotta
Dimensions variable
Hannah Wilke Collection & Archive, L.A.
Courtesy Alison Jacques
Page 12

Untitled, 1960
Pastel, paint, and pencil on board
20 × 29 ⅞ inches (50.8 × 75.9 cm)
Private collection, London
Courtesy Alison Jacques
Page 19

Untitled, ca. 1960s
Terracotta
3 ½ × 3 ⅜ × 4 ½ inches (8.9 × 8.6 × 11.4 cm)
Hannah Wilke Collection & Archive, L.A.
Courtesy Alison Jacques
Page 117

Untitled, ca. 1960s
Pastel, chalk, and graphite on paper
18 × 24 inches (45.7 × 61 cm)
Hannah Wilke Collection & Archive, L.A.
Courtesy Alison Jacques
Pages 120–21

Untitled, early 1960s
Ink and paint on onion paper
19 × 25 inches (48.3 × 63.5 cm)
Collection of Donald and Helen Goddard
Courtesy Ronald Feldman Gallery, New York
Pages 110–11

Untitled, ca. mid-1960s
Pastel on paper
18 × 24 inches (45.7 × 61 cm)
Collection of Larry and Susan Marx, Aspen
Courtesy Alison Jacques and Marc Selwyn
Pages 114–15

Untitled, ca. mid-1960s
Pastel and pencil on paper
18 × 24 inches (45.7 × 61 cm)
Hannah Wilke Collection & Archive, L.A.
Courtesy Alison Jacques
Page 20

Untitled, ca. 1963-65
Acrylic on canvas
48 × 60 ⅛ inches (121.9 × 152.7 cm)
Hannah Wilke Collection and Archive, L.A.
Courtesy Alison Jacques
Pages 128–29

Untitled, ca. 1964–66
Pastel and graphite on card
6 ½ × 4 ½ inches (16.5 × 11.4 cm)
Hannah Wilke Collection & Archive, L.A.
Courtesy Alison Jacques
Page 113

Untitled, ca. 1964–66
Pastel and graphite on card
6 ½ × 4 ½ inches (16.5 × 11.4 cm)
Hannah Wilke Collection & Archive, L.A.
Courtesy Alison Jacques
Page 113

Untitled, ca. 1964–66
Pastel and graphite on card
6 ½ × 4 inches (16.5 × 10.2 cm)
Hannah Wilke Collection & Archive, L.A.
Courtesy Alison Jacques
Page 112

Untitled, ca. 1964–66
Pastel and pencil on paper
18 × 24 inches (45.7 × 61 cm)
Hannah Wilke Collection & Archive, L.A.
Courtesy Alison Jacques
Page 119

Untitled, 1965
Ink on rice paper
12 ¼ × 17 ⅝ inches (31.1 × 44.8 cm)
Hannah Wilke Collection & Archive, L.A.
Courtesy Alison Jacques
Pages 116–17

Motion Sensor, ca. 1966–67
Terracotta
3 × 10 ¼ × 6 ¾ inches (7.6 × 26 × 17.1 cm)
Hannah Wilke Collection & Archive, L.A.
Courtesy Alison Jacques and Marc Selwyn
Page 118

San Antonio Rose, 1966
Painted terracotta
8 × 11 × 10 ½ inches (20.3 × 27.9 × 26.7 cm)
Collection of Gail and Tony Ganz, Los Angeles
Courtesy Alison Jacques and Michael Solway
Page 17

North American Candle Snuffer, ca. 1967
Terracotta
4 ⅛ × 10 ⅛ × 11 ¼ inches
(12.4 × 25.7 × 28.6 cm)
Private collection
Courtesy Acquavella Galleries
Page 13

Teasel Cushion, 1967
Terracotta, acrylic, and plastic
4 × 12 × 12 inches (10.2 × 30.5 × 30.5 cm)
Collection Walker Art Center, Minneapolis;
T.B. Walker Acquisition Fund, 2002
Page 130

Untitled, 1967
Pastel, charcoal, and graphite on paper
17 ⅜ × 24 inches (44.1 × 61 cm)
Collection of Donald and Helen Goddard
Courtesy Ronald Feldman Gallery, New York
Page 146

Untitled, ca. late 1960s
Terracotta
3 ¾ × 7 ⅛ × 8 ¼ inches (9.5 × 18.1 × 21 cm)
Hannah Wilke Collection & Archive, L.A.
Courtesy Alison Jacques
Pages 95, 118

Untitled, ca. late 1960s
Terracotta
3 ½ × 9 ¼ × 11 ¼ inches (8.9 × 23.5 × 28.6 cm)
Hannah Wilke Collection & Archive, L.A.
Courtesy Alison Jacques and Marc Selwyn
Pages 124–25

Untitled, ca. late 1960s
Terracotta
8 × 7 ¾ × 5 ¼ inches (20.3 × 19.7 × 13.3 cm)
Hannah Wilke Collection & Archive, L.A.
Courtesy Alison Jacques
Page 122

Untitled, ca. late 1960s
Terracotta
6 ¼ × 5 ¼ × 3 inches (15.9 × 13.3 × 7.6 cm)
Hannah Wilke Collection & Archive, L.A.
Courtesy Alison Jacques
Page 123

Untitled, ca. late 1960s
Pastel and pencil on cut-out paper
16 × 23 inches (40.6 × 58.4 cm)
Hannah Wilke Collection & Archive, L.A.
Courtesy Alison Jacques
Page 20

Untitled, ca. late 1960s
Pastel and pencil on cut-out paper
16 ½ × 24 inches (41.9 × 61 cm)
Hannah Wilke Collection & Archive, L.A.
Courtesy Alison Jacques and Marc Selwyn
Page 147

The Forgotten Man, ca. 1970
Pastel, pencil, and collage on paper
23 × 29 ½ inches (58.4 × 74.9 cm)
Collection of Donald and Helen Goddard
Courtesy Ronald Feldman Gallery, New York
Pages 142–43

Untitled (Vaginal Box), ca. 1970
Latex and ceramic
6 ¾ × 10 ½ × 5 inches (17.1 × 26.7 × 12.7 cm)
Collection of Donald and Helen Goddard
Courtesy Ronald Feldman Gallery, New York
Page 126

Untitled, ca. 1970
Latex, plywood, and metal push pins
20 ⅞ × 17 ¾ × 4 ¾ inches
(53 × 45.1 × 12 cm)
Collection of Alison Jacques, London
Page 152

Untitled, ca. early 1970s
Watercolor on paper
10 ⅜ × 17 ⅜ inches (26.4 × 44.1 cm)
Hannah Wilke Collection & Archive, L.A.
Courtesy Alison Jacques
Page 127

Untitled, ca. early 1970s
Terracotta
2 ⅜ × 4 ½ × 5 inches (6 × 11.4 × 12.7 cm)
Hannah Wilke Collection & Archive, L.A.
Courtesy Alison Jacques
Page 28

Untitled, ca. 1970s
Watercolor on paper
22 × 30 inches (55.9 × 76.2 cm)
Collection of Marguerite Steed Hoffman
Courtesy Alison Jacques
Page 131

Yellow Rose of Texas, 1970
Painted terracotta
5 ¼ × 9 ½ × 9 inches (13.3 × 24.1 × 22.9 cm)
Hannah Wilke Collection & Archive, L.A.
Courtesy Alison Jacques
Page 18

Wishing You a Very Happy Easter, 1971
Pastel, pencil, and collage on paper
18 × 24 inches (45.7 × 61 cm)
Hannah Wilke Collection & Archive, L.A.
Courtesy Alison Jacques and Marc Selwyn
Page 21

Roses, 1973
Watercolor and pencil on paper
18 × 24 inches (45.7 × 61 cm)
Hannah Wilke Collection & Archive, L.A.
Courtesy Alison Jacques
Page 153

To Sister, 1973
Pastel and collage on paper
18 × 23 ⅞ inches (45.7 × 60.6 cm)
Hannah Wilke Collection & Archive, L.A.
Courtesy Alison Jacques
Pages 144–45

Gestures, 1974
Black-and-white video with sound
35:30 min.
Hannah Wilke Collection & Archive, L.A.
Courtesy Electronic Arts Intermix
Page 81

Needed-Erase-Her, No. 12, 1974
Kneaded erasers on painted board
2 × 13 ½ × 13 ½ inches (5.1 × 34.3 × 34.3 cm)
Hannah Wilke Collection & Archive, L.A.
Courtesy Alison Jacques
Page 176

Needed-Erase-Her, No. 14, 1974
Kneaded erasers on painted board
2 × 13 × 13 inches (5.1 × 33 × 33 cm)
Los Angeles County Museum of Art. Gift
of Marsie, Emanuelle, Damon and Andrew
Scharlatt, Hannah Wilke Collection &
Archive, L.A.
Page 169

Roma Coliseum, 1974
Kneaded erasers on postcard and painted board
in Plexiglas box
Overall 15 ¾ × 17 ¾ × 2 ⅛ inches
(40 × 45.1 × 5.4 cm)
Collection of Marsie Scharlatt. Gift of the Artist
Page 23

S.O.S. Starification Object Series, 1974
Gelatin silver print
7 × 5 inches (17.8 × 12.7 cm)
Collection of Heidi and Erik Murkoff
Courtesy Alison Jacques
Page 158 (bottom left)

S.O.S. Starification Object Series, 1974
Gelatin silver print
7 × 5 inches (17.8 × 12.7 cm)
Collection of Donald and Helen Goddard
Courtesy Ronald Feldman Gallery, New York
Pages 33, 159 (top right)

S.O.S. Starification Object Series, 1974
Gelatin silver print
7 × 5 inches (17.8 × 12.7 cm)
Collection of Shezad and Miranda Dawood
Courtesy Alison Jacques
Page 159 (bottom right)

S.O.S. Starification Object Series, 1974
Gelatin silver print
7 × 5 inches (17.8 × 12.7 cm)
Collection of Michael and Sharon Young
Courtesy Alison Jacques
Page 158 (top right)

S.O.S. Starification Object Series, 1974
Gelatin silver print
7 × 5 inches (17.8 × 12.7 cm)
Collection of Olivia Walton
Courtesy Alison Jacques
Page 158 (top left)

S.O.S. Starification Object Series, 1974
Gelatin silver print
7 × 5 inches (17.8 × 12.7 cm)
Collection of Olivia Walton
Courtesy Alison Jacques
Page 159 (top left)

S.O.S. Starification Object Series, 1974
Gelatin silver print
7 × 5 inches (17.8 × 12.7 cm)
Collection of Teresa Tsai
Courtesy Alison Jacques
Page 159 (bottom left)

S.O.S. Starification Object Series, 1974
Gelatin silver print
7 × 5 inches (17.8 × 12.7 cm)
Collection of Tom and Alice Tisch
Courtesy Alison Jacques
Page 158 (bottom right)

S.O.S. Starification Object Series, 1974
Gelatin silver print
40 × 27 inches (101.6 × 68.6 cm)
Collection of Alison Jacques, London
Page 157

Barber's Pond, 1975
Kneaded erasers on postcard and painted
board in Plexiglas box
Overall 15 ⅜ × 17 ⅜ × 3 inches
(39.1 × 44.1 × 7.6 cm)
Hannah Wilke Collection & Archive, L.A.
Courtesy Alison Jacques
Page 178

Gum Landscape, 1975
101 chewing gum sculptures on painted wood
15 ⅞ × 17 ¹⁵⁄₁₆ × 2 ⅝ inches (40.3 × 45.6 × 6.7 cm)
Private collection, courtesy Ronald Feldman
Gallery, New York
Page 141

Hello Boys, 1975
Black-and-white video with sound
12 min.
Hannah Wilke Collection & Archive, L.A.
Courtesy Electronic Arts Intermix
Page 76

The Hudson River, West Point, NY, 1975
Kneaded erasers on vintage postcard and
painted board in Plexiglas box
Overall 15 ¾ × 17 ¾ × 1 ⅞ inches
(40 × 45.1 × 4.8 cm)
Collection of Marsie Scharlatt. Gift of the
Artist
Page 175

Ponder-r-rosa 4, White Plains, Yellow Rocks, 1975
Latex, metal snaps, and push pins
16 sculptures, each 17 × 26 × 5 ¾ inches
(43.2 × 66 × 14.6 cm)
Overall 68 × 250 × 5 ¾ inches
(172.7 × 635 × 14.6 cm)
The Museum of Modern Art, New York,
Committee on Painting and Sculpture Funds
and gift of Marsie, Emanuelle, Damon and
Andrew Scharlatt, Hannah Wilke Collection &
Archive, Los Angeles, 2008
Pages 26–27, 150–51

Sea Wall, 1975
Kneaded erasers on postcard and painted
board in Plexiglas box
Overall 15 ¾ × 17 ¾ × 2 ¾ inches
(40 × 45.1 × 7 cm)
Hannah Wilke Collection & Archive, L.A.
Courtesy Alison Jacques
Page 179

Seashore, 1975
Kneaded erasers on postcard and painted
board in Plexiglas box
Overall 15 ¾ × 17 ¾ × 2 inches
(40 × 45.1 × 5.1 cm)
Collection of Donald and Helen Goddard
Courtesy Ronald Feldman Gallery, New York
Page 23

*Pyramid Sculptures, Models for Large Scale
Outdoor Sculptures*, 1975–80
2 silver sculptures, 3 bronze sculptures
Dimensions variable
Hannah Wilke Collection & Archive, L.A.
Courtesy Alison Jaques
Page 166

Untitled, 1975–78
Ceramic
60 sculptures, overall 32 × 32 inches
(81.3 × 81.3 cm)
Collection of Marguerite Steed Hoffman
Courtesy Alison Jacques
Pages 136–37

Untitled, ca. late 1970s
Gum sculpture in Plexiglas box
2 ½ × 2 ½ × 1 inches (6.4 × 6.4 × 2.5 cm)
Hannah Wilke Collection & Archive, L.A.
Courtesy Alison Jacques and Marc Selwyn
Page 155

Untitled, ca. late 1970s
Gum sculpture in Plexiglas box
2 ½ × 2 ½ × 1 inches (6.4 × 6.4 × 2.5 cm)
Hannah Wilke Collection & Archive, L.A.
Courtesy Alison Jacques and Marc Selwyn
Page 155

Untitled, ca. late 1970s
Gum sculpture in Plexiglas box
2 ½ × 2 ½ × 1 inches (6.4 × 6.4 × 2.5 cm)
Hannah Wilke Collection & Archive, L.A.
Courtesy Alison Jacques and Marc Selwyn
Page 154

Untitled, ca. late 1970s
Gum sculpture in Plexiglas box
2 ½ × 2 ½ × 1 inches (6.4 × 6.4 × 2.5 cm)
Hannah Wilke Collection & Archive, L.A.
Courtesy Alison Jacques and Marc Selwyn
Page 154

Untitled, ca. late 1970s
Gum sculpture in Plexiglas box
2 ½ × 2 ½ × 1 inches (6.4 × 6.4 × 2.5 cm)
Hannah Wilke Collection & Archive, L.A.
Courtesy Alison Jacques and Marc Selwyn
Page 154

Untitled, ca. late 1970s
Gum sculpture in Plexiglas box
2 ½ × 2 ½ × 1 inches (6.4 × 6.4 × 2.5 cm)
Hannah Wilke Collection & Archive, L.A.
Courtesy Alison Jacques and Marc Selwyn
Page 154

Untitled, ca. late 1970s
Gum sculpture in Plexiglas box
2 ½ × 2 ½ × 1 inches (6.4 × 6.4 × 2.5 cm)
Hannah Wilke Collection & Archive, L.A.
Courtesy Alison Jacques and Marc Selwyn
Page 155

Corcoran Art Gallery, 1976
Kneaded erasers on postcard and painted
board in Plexiglas box
Overall 15 ¾ × 17 ¾ inches (40 × 45.1 cm)
Collection of Gail and Tony Ganz, Los Angeles
Courtesy Alison Jacques
Page 171

Untitled (*Gum with Berries*) from the *California
Series*, 1976
Archival pigment print, 2019
24 × 36 inches (61 × 91.4 cm)
Hannah Wilke Collection & Archive, L.A.
Courtesy Alison Jacques and Marc Selwyn
Page 212

Lincoln Memorial, 1976
Kneaded erasers on postcard and painted
board in Plexiglas box
Overall 15 ⅞ × 17 ¹³⁄₁₆ inches (40.3 × 45.2 cm)
Collection of Gail and Tony Ganz, Los Angeles
Courtesy Alison Jacques
Page 172

Rosebud, 1976
Latex, metal snaps, and push pins
24 × 92 × 8 inches (61 × 233.7 × 20.3 cm)
Collection of Edward Lee
Courtesy Alison Jacques
Pages 148–49

Untitled #4, 1976
Chewing gum on 16 sheets of rice paper framed
in Plexiglas
Overall 33 ⅞ × 25 ¾ inches (86 × 65.4 cm)
Collection of Marguerite Steed Hoffman
Courtesy Alison Jacques
Page 156

Untitled (*Gum on Acorn, Los Angeles*) from the
Gum in Landscape series, ca. 1976
Archival pigment print, 2019
24 × 36 inches (61 × 91.4 cm)
Hannah Wilke Collection & Archive, L.A.
Courtesy Alison Jacques and Marc Selwyn
Page 217

Untitled (*Gum on Palm Fronds, Los Angeles*)
from the *Gum in Landscape* series, 1976
Archival pigment print, 2019
24 × 36 inches (61 × 91.4 cm)
Hannah Wilke Collection & Archive, L.A.
Courtesy Alison Jacques and Marc Selwyn
Page 215

Untitled (*Gum on Red Flower, Los Angeles*) from
the *Gum in Landscape* series, 1976
Archival pigment print, 2019
24 × 36 inches (61 × 91.4 cm)
Hannah Wilke Collection & Archive, L.A.
Courtesy Alison Jacques and Marc Selwyn
Page 213

Untitled (*Gum on Rocks*) from the *Gum in
Landscape* series, 1976
Archival pigment print, 2019
24 × 36 inches (61 × 91.4 cm)
Hannah Wilke Collection & Archive, L.A.
Courtesy Alison Jacques and Marc Selwyn
Page 216

Untitled, 1976
Gum in Plexiglas box
2 ½ × 2 ½ × 1 inches (6.4 × 6.4 × 2.5 cm)
Hannah Wilke Collection & Archive, L.A.
Courtesy Alison Jacques and Marc Selwyn
Page 154

Baby Blue, 1977
Painted ceramic sculptures on board
36 sculptures, each 4–7 ⅛ inches (10.2–18.1 cm)
Board: 63 × 63 inches (160 × 160 cm)
Collection of Gail and Tony Ganz, Los Angeles
Courtesy Alison Jacques
Pages 134–35

Franklin's Tomb, Philadelphia, 1977
Kneaded erasers on postcard and painted
board in Plexiglas box
Overall 16 × 18 × 2 ¾ inches (40.6 × 45.7 × 7 cm)
Collection of Donald and Helen Goddard
Courtesy Ronald Feldman Gallery, New York
Page 173

Just Fifteen, 1977
Unglazed ceramic on compressed wood
particle board
Base: 39 × 39 inches (99.1 × 99.1 cm); ceramic
pieces vary, approximately 4 × 5 × 7 inches
(10.2 × 12.7 × 17.8 cm)
Cincinnati Art Museum. Gift of Kimberly P.
Klosterman and Michael Lowe, 1995.378a–o
Page 29

Sweet Sixteen, 1977
Painted ceramic on painted board
16 sculptures, each 3 ½ × 5 ½ × 2 ½ inches
(8.9 × 14 × 6.4 cm); board: 4 × 32 × 32 inches
(10.2 × 81.3 × 81.3 cm)
Hannah Wilke Collection & Archive, L.A.
Courtesy Alison Jacques
Page 133

Untitled (*Gum in Grass, Princeton NJ*) from the
Gum in Landscape series, 1977
Archival pigment print, 2019
24 × 36 inches (61 × 91.4 cm)
Hannah Wilke Collection & Archive, L.A.
Courtesy Alison Jacques and Marc Selwyn
Page 214

Untitled, 1977
Gum sculpture in Plexiglas box
2 ½ × 2 ½ × 1 inches (6.4 × 6.4 × 2.5 cm)
Hannah Wilke Collection & Archive, L.A.
Courtesy Alison Jacques and Marc Selwyn
Page 155

Atrophy from the *So Help Me Hannah* series,
1978–84
Vintage black-and-white photograph in
yellow frame
60 × 40 inches (152.4 × 101.6 cm)
Hannah Wilke Collection & Archive, L.A.
Courtesy Alison Jacques
Page 162

Elective Affinities, 1978
Porcelain and wood
Overall display dimensions variable
Partial purchase with funds provided by Tate
Americas Foundation, Tate International
Council and an Anonymous donor (Tate) and
partial gift of Marsie, Emanuelle, Damon and
Andrew Scharlatt, Hannah Wilke Collection
& Archive, Los Angeles (Tate Americas
Foundation) 2015
Pages 47, 138–39

Hannah Wilke Can, 1978
Photo-reproduction on 5 coin collection cans
Each 6 × 3 inches (15.2 × 7.6 cm)
Hannah Wilke Collection & Archive, L.A.
Courtesy Alison Jacques
Page 163

Intercourse with…, 1978
Black-and-white video with sound
27 min.
Hannah Wilke Collection & Archive, L.A.
Courtesy Electronic Arts Intermix
Pages 160–61

*Portrait of the Artist with Her Mother,
Selma Butter*, 1978–81
Cibachrome diptych. Exhibition prints, 2003
Each 40 × 30 inches (101.6 × 76.2 cm)
Hannah Wilke Collection & Archive, L.A.
Courtesy Alison Jacques
Page 73

Untitled, 1978
Sepia ink on paper
22 ¼ × 30 inches (56.5 × 76.2 cm)
Hannah Wilke Collection & Archive, L.A.
Courtesy Alison Jacques and Marc Selwyn
Page 210

Untitled, ca. 1978
Sepia ink on paper
17 × 22 ¾ inches (43.2 × 57.8 cm)
Hannah Wilke Collection & Archive, L.A.
Courtesy Alison Jacques and Marc Selwyn
Page 211

In Memoriam: Selma Butter (Mommy), 1979–83
Photographic triptych with floor sculpture
Triptych: 3 groups of 6 gelatin silver prints,
with press type and paper, mounted on board
Each 41 × 61 inches (101.1 × 155 cm), framed
Sculpture: 3 groups of 2 acrylic painted
ceramics on acrylic painted Masonite board
Each 13 × 20 × 4 inches (33 × 50.8 × 10.2 cm)
Hannah Wilke Collection & Archive, L.A.
Courtesy Alison Jacques
Pages 182–83

*Model for Large Scale Sculpture in Steel or
Bronze Cast*, 1979
Magazine image and ink on paper
24 × 18 inches (61 × 45.7 cm)
Hannah Wilke Collection & Archive, L.A.
Courtesy Alison Jacques
Page 167

Ohio, 1979
3 matte patina bronze sculptures
Dimensions variable
Hannah Wilke Collection & Archive, L.A.
Courtesy Alison Jacques
Page 164

Untitled, 1979
Gum sculpture in Plexiglas box
2 ½ × 2 ½ × 1 inches (6.4 × 6.4 × 2.5 cm)
Hannah Wilke Collection & Archive, L.A.
Courtesy Alison Jacques
Page 155

Untitled, 1979
Gum sculpture in Plexiglas box
2 ½ × 2 ½ × 1 inches (6.4 × 6.4 × 2.5 cm)
Hannah Wilke Collection & Archive, L.A.
Courtesy Alison Jacques
Page 154

Generation Process Series #6, 1982
Acrylic on ceramic and wood
3 ½ × 19 ½ × 19 ½ inches (8.9 × 49.5 × 49.5 cm)
Hannah Wilke Collection & Archive, L.A.
Courtesy Alison Jacques
Page 184

Generation Process Series #15, 1982
Acrylic on ceramic and wood
3 ½ × 19 ½ × 19 ½ inches (8.9 × 49.5 × 49.5 cm)
Hannah Wilke Collection & Archive, L.A.
Courtesy Alison Jacques
Page 185

Generation Process Series #16, 1982
Acrylic on ceramic and wood
3 ½ × 19 ½ × 19 ½ inches (8.9 × 49.5 × 49.5 cm)
Hannah Wilke Collection & Archive, L.A.
Courtesy Alison Jacques
Page 37

Untitled, 1983
Painted ceramic
4 ³⁄₁₆ × 10 ¼ × 5 inches (10.6 × 26 × 12.7 cm)
The Jewish Museum, New York, Gift of Ellen
and Fred Harris, 2012-37
Pages 186–87

Untitled (Seura Chaya), 1983
Watercolor on paper
7 × 10 inches (17.8 × 25.4 cm)
Hannah Wilke Collection & Archive, L.A.
Courtesy Alison Jacques
Page 181

Untitled, 1984
Gum sculpture in Plexiglas box
2 ½ × 2 ½ × 1 inches (6.4 × 6.4 × 2.5 cm)
Hannah Wilke Collection & Archive, L.A.
Courtesy Alison Jacques
Page 35

Untitled, 1984
Gum sculpture in Plexiglas box
2 ½ × 2 ½ × 1 inches (6.4 × 6.4 × 2.5 cm)
Hannah Wilke Collection & Archive, L.A.
Courtesy Alison Jacques
Page 35

Untitled, 1984
Gum sculpture in Plexiglas box
2 ½ × 2 ½ × 1 inches (6.4 × 6.4 × 2.5 cm)
Hannah Wilke Collection & Archive, L.A.
Courtesy Alison Jacques
Page 155

Hannah Manna, 1985–86
77 painted sculptures with hand-typed, signed
wall plaque under glass
Dimensions variable
Hannah Wilke Collection & Archive, L.A.
Courtesy Alison Jacques
Pages 218–19

Blue Skies, 1987–92
Acrylic on ceramic and wood
7 × 59 × 59 inches (17.8 × 149.9 × 149.9 cm)
Hannah Wilke Collection & Archive, L.A.
Courtesy Alison Jacques
Pages 202–3

B.C. Series, Self-Portrait, April 24, 1988, 1988
Watercolor on Arches paper
71 ½ × 51 ½ inches (181.6 × 130.8 cm)
Hannah Wilke Collection & Archive, L.A.
Courtesy Alison Jacques and Marc Selwyn
Page 189

B.C. Series, Self-Portrait, May 13, 1988, 1988
Watercolor on Arches paper
71 ½ × 51 ½ inches (181.6 × 130.8 cm)
Hannah Wilke Collection & Archive, L.A.
Courtesy Alison Jacques and Marc Selwyn
Page 188

B.C. Series, Self-Portrait, May 22, 1988, 1988
Watercolor on Arches paper
71 ½ × 51 ½ inches (181.61 × 130.8 cm)
Hannah Wilke Collection & Archive, L.A.
Courtesy Alison Jacques and Marc Selwyn
Page 39

Untitled (Cityscape with Large Scale Sculpture),
1988
Ink and watercolor on cardboard with
reverse image
8 ½ × 11 inches (21.6 × 27.9 cm)
Hannah Wilke Collection & Archive, L.A.
Courtesy Alison Jacques
Page 165

About Face #4, 1989
9 watercolors on paper
49 ¼ × 40 ¼ inches (125.1 × 102.2 cm), framed
Hannah Wilke Collection & Archive, L.A.
Courtesy Alison Jacques
Page 201

Untitled, 1990
Ink on paper
22 ¼ × 30 inches (56.5 × 76.2 cm)
Collection of Marsie Scharlatt. Gift of the Artist
Pages 208–9

Intra-Venus Hand (NYC Hospital), October 18,
1991, 1991
Watercolor on paper
12 ½ × 9 ¼ inches (31.8 × 23.5 cm)
Hannah Wilke Collection & Archive, L.A.
Courtesy Alison Jacques
Page 206

Untitled, 1991
Watercolor on paper
12 × 9 inches (30.5 × 22.9 cm)
Hannah Wilke Collection & Archive, L.A.
Courtesy Alison Jacques
Page 221

Untitled, 1991
Watercolor on paper
12 × 9 inches (30.5 × 22.9 cm)
Hannah Wilke Collection & Archive, L.A.
Courtesy Alison Jacques
Page 205

Intra-Venus Face No. 10, February 8, 1992, 1992
Watercolor on paper
12 ½ × 9 ½ inches (31.8 × 24.1 cm)
Hannah Wilke Collection & Archive, L.A.
Courtesy Alison Jacques
Page 197

Intra-Venus Series No. 1, June 15 and January 30,
1992, 1992
Chromogenic supergloss prints with
overlaminate
Each 71 ½ × 47 ½ inches (181.6 × 120.7 cm)
Collection of Donald and Helen Goddard
Courtesy Ronald Feldman Gallery, New York
Pages 192–93

Intra-Venus Series No. 4, July 26 and February 19,
1992, 1992
Chromogenic supergloss print with
overlaminate
Each 72 ¼ × 48 ¼ inches (183.6 × 122.6 cm)
Hannah Wilke Collection & Archive, L.A.
Courtesy Alison Jacques
Pages 194–95

Intra-Venus Series No. 6, February 19, 1992, 1992
Chromogenic supergloss print with
overlaminate
47 ½ × 71 ½ inches (120.7 × 181.6 cm)
Collection of Donald and Helen Goddard
Courtesy Ronald Feldman Gallery, New York
Pages 198–99

Intra Venus Triptych, 1992–93
Chromogenic supergloss prints with
overlaminate
Each 26 ¼ × 39 ½ inches (66.7 × 100.3 cm)
Hannah Wilke Collection & Archive, L.A.
Courtesy Alison Jacques
Page 190 and gatefold

ILLUSTRATION INFORMATION

Performalist Self-Portrait is the term Hannah
Wilke used to credit those who, as she
described, assisted her in her self-portraits,
performances, and other conceptual works
that she posed for and directed herself. By
including this unique form of acknowledgment,
this volume follows the precedent that Wilke
established in her 1989 retrospective catalogue,
and that Nancy Princenthal adopted in her 2010
monograph of Wilke's work.

Pp. 30–31, S.O.S. Starification Object Series,
An Adult Game of Mastication (detail from
installation). Performalist Self-Portraits with
Les Wollam.
P. 33, S.O.S. Starification Object Series.
Performalist Self-Portrait with Les Wollam.
P. 34, S.O.S. Starification Object Series (Back).
Performalist Self-Portrait with Les Wollam.
P. 64, Hannah Wilke Super-T-Art. Performalist
Self-Portraits with Christopher Giercke.
P. 73, Portrait of the Artist with Her Mother,
Selma Butter. Left photograph: Performalist
Self-Portrait with Donald Goddard.
P. 107, The Artist in Her Studio at the Chateau
Marmont. Performalist Self-Portrait with Claes
Oldenburg.
Pp. 157–59, S.O.S. Starification Object Series.
Performalist Self-Portraits with Les Wollam.
P. 162, Atrophy, from the So Help Me Hannah
series. Performalist Self-Portrait with Donald
Goddard.
P. 190 and gatefold: Intra-Venus Triptych.
Performalist Self-Portraits with Donald
Goddard.
Pp. 192–93, Intra-Venus Series No. 1, June 15 and
January 30, 1992. Performalist Self-Portraits
with Donald Goddard.
Pp. 194–95, Intra-Venus Series No. 4, July 26 and
February 19, 1992. Performalist Self-Portraits
with Donald Goddard.
Pp. 198–99, Intra-Venus Series No. 6, February 19,
1992. Performalist Self-Portrait with Donald
Goddard.
P. 225, Polaroid photograph of Arlene Butter
posing in her mother's mink stole. Performalist
Self-Portrait with Marsie (Butter) Scharlatt.
P. 234, Handle with Care, 1987
Left: Performalist Self-Portrait with
eeva-inkeri.
Right: Performalist Self-Portrait with Donald
Goddard.

Selected Bibliography

MONOGRAPHS

Fitzpatrick, Tracy, ed. *Hannah Wilke: Gestures*. Purchase, NY: Neuberger Museum of Art, 2009.

Goddard, Donald, Kirsten Dybbøl, and Elisabeth Delin Hansen, eds. *Hannah Wilke, A Retrospective*. Copenhagen: Nikolaj, Copenhagen Contemporary Art Center, 1998.

Goldman, Saundra. "'Too Good Lookin' to Be Smart': Beauty, Performance, and the Art of Hannah Wilke." PhD diss., University of Texas at Austin, 1999.

Jones, Amelia. *The Rhetoric of the Pose: Rethinking Hannah Wilke*. Santa Cruz: Mary Porter Sesnon Art Gallery, University of California, 2005.

Jones, Amelia, Robert McKaskell, Donald Goddard, Marsie Scharlatt, and Renny Pritikin. *Intra-Venus: Hannah Wilke*. New York: Ronald Feldman Fine Arts, 1995.

Kochheiser, Thomas H., ed. *Hannah Wilke: A Retrospective*. Columbia: University of Missouri Press, 1989.

Kreuzer, Stefanie, Thomas Michalak, Ingo Taubhorn, and Frank Wagner. *Hannah Wilke, 1940–1993*. Berlin: Neue Gesellschaft für bildende Kunst, 2000.

Orgaz, Laura Fernandez, and Juan Vicente Aliaga. *Hannah Wilke: Exchange Values*. Vitoria-Gasteiz, Spain: ARTIUM Centro-Museo Vasco de Arte Contemporáneo, 2006.

Pollock, Griselda. *Hannah Wilke: Sculpture 1960s–80s: Works from the Hannah Wilke Collection & Archive, Los Angeles*. London: Alison Jacques, 2014.

Princenthal, Nancy. *Hannah Wilke*. London: Prestel, 2010.

Raven, Arlene, Marsie Scharlatt, and Michael Solway. *Hannah Wilke: Selected Work 1960–1992*. Los Angeles: Hannah Wilke Collection & Archive and Solway Jones Gallery, 2004.

Rosenblum, Lauren, Andrew Scharlatt, and Marsie Scharlatt. *Hannah Wilke: Sculpture in the Landscape*. Philadelphia: Temple Contemporary, 2019.

ARTIST'S WRITINGS AND INTERVIEWS

Berman, Avis. "A Decade of Progress, But Could a Female Chardin Make a Living?" *Artnews* 79, October 1980, 73–79.

Finberg, Bonnie. "Body Language. Hannah Wilke Interview." *Cover*, September 1989, 16.

Heustis, Chris, and Marvin Jones. "Hannah Wilke's Art, Politics, Religion and Feminism." *The New Common Good*, May 1985, 1, 9–11.

Iskin, Ruth. "Hannah Wilke in Conversation with Ruth Iskin." *Visual Dialog* 2, Summer 1977, 17–20.

Langer, Cassandra. "The Art of Healing." *Ms.* 17, January/February 1989, 132–33.

Margolin, Ruth. "An Interview with Hannah Wilke." *Forum* (November/December 1989): 9–11.

Montano, Linda. "Hannah Wilke Interview." In *Performance Artists Talking in the Eighties*. Berkeley: University of California Press, 2000.

Picard, Lil. "Hannah Wilke: Sexy Objects." *Interview*, January 1973, 18, 24.

Rose, Cynthia. "The Art Racket." *New Musical Express* [London], September 4, 1982.

Siegel, Judy. "Hannah Wilke: Censoring the Muse?" *Women Artists News* 11, Winter 1986/87, 4, 47–48.

Weber, Ernst. "Artist Hannah Wilke Talks with Ernst." *Oasis d'Neon* 1, no. 2 (1978).

——. "Artist Hannah Wilke Talks with Ernst, Part Two." *Oasis d'Neon* 1, no. 3 (1978).

Wilke, Hannah. "Hannah Wilke: A Very Female Thing." *New York*, February 1974, 58.

——. "Intercourse with…" *Re-View* 1, no. 1 (1977): 41–42 and back cover.

——. "I OBJECT: Memoirs of a Sugargiver." In *Übrigens Sterben Immer Die Anderen: Marcel Duchamp und die Avantgarde seit 1950*. Edited by Alfred M. Fischer and Dieter Daniels, 263–71. Cologne: Museum Ludwig, 1988.

——. "Letters to the Editor." *Art-Rite*, Spring 1974, 7.

——. "Letter to Women Artists [1975]." In *Art: A Woman's Sensibility, Feminist Art Program*, 76. Valencia: California Institute of the Arts, 1975, 76.

——. "Mrs. Bund, My Father's Brother's Wife's Mother." *Heresies* 1, Winter 1978, 75–76.

——. "One Afternoon on a Revolving Stage." In *Collective Consciousness: Art Performances in the Seventies*. Edited by Jean Dupuy, 222. New York: Performing Arts Journal Publications, 1980.

——. "Seura Chaya," *New Observations* 58, June 1988, 12–13.

———. "Super-T-Art (Soup and Tart)." In *Collective Consciousness: Art Performances in the Seventies*. Edited by Jean Dupuy, 221–22. New York: Performing Arts Journal Publications, 1980.

———. "Visual Prejudice [1980]." In *Hannah Wilke: A Retrospective*. Edited by Thomas H. Kochheiser, 141. Columbia: University of Missouri Press, 1989.

ARTICLES, ESSAYS, AND GROUP EXHIBITION CATALOGUES

Baker, Simon, and Fiontan Moran, eds. *Performing for the Camera*, London: Tate Modern; Tate Publishing, 2016.

Butler, Cornelia H., and Lisa Gabrielle Mark, eds. *WACK! Art and the Feminist Revolution*. Los Angeles: Museum of Contemporary Art; and Cambridge, MA: MIT Press, 2007.

Chave, Anna C. "'I Object' Hannah Wilke's Feminism." *Art in America* 97, March 2009, 104–9, 159.

Chen, Nancy N., and Helene Moglen. *Bodies in the Making: Transgressions and Transformations*. Santa Cruz, CA: New Pacific Press, 2006.

Frueh, Joanna. *Erotic Faculties*. Berkeley: University of California Press, 1996.

Goddard, Donald, and Tina Takemoto. "Looking through Hannah's Eyes: Interview with Donald Goddard." *Art Journal* 67, no. 2 (Summer 2008): 126–39.

Jones, Amelia. *Body Art/Performing the Subject*. Minneapolis: University of Minnesota Press, 1998.

Kohl, Jeanette. "Intra-Venus." In *Venus as Muse: From Lucretius to Michel Serres*. Edited by Hanjo Berressem, Günter Blamberger, and Sebastian Goth, 73–117. Leiden, The Netherlands: Koninklijke Brill, 2015.

McCaskell, Robert. *Dazzling Phrases: Six Performance Artists*. Forest City, Ont.: Forest City Gallery, 1985.

Middleman, Rachel. *Radical Eroticism: Women, Art, and Sex in the 1960s*. Oakland: University of California Press, 2018.

Morineau, Camille et al. *elles @ Centre Pompidou, Women Artists in the Collection of the Musée National d'Art Moderne*. Paris: Centre Pompidou, 2009.

Nairne, Eleanor, ed. *Eva Hesse/Hannah Wilke: Erotic Abstraction*. New York: Acquavella Galleries/Rizzoli, 2020.

Sims, Lowery. "Body Politics: Hannah Wilke and Kaylynn Sullivan." In *Art & Ideology*. Edited by Fred Lonidier, 45–56. New York: New Museum of Contemporary Art, 1984.

Thompson, Margo Hobbs. "Agreeable Objects and Angry Paintings: 'Female Imagery' in Art by Hannah Wilke and Louise Fishman, 1970–1973." *Genders Journal* 43 (2006). https://www.colorado.edu /gendersarchive1998-2013/2006/04/01/agreeable-objects-and -angry-paintings-female-imagery-art-hannah-wilke-and-louise-fishman.

Wacks, Debra. "Playing with Dada: Hannah Wilke's Irreverent Artistic Discourse with Duchamp." In *From Diversion to Subversion: Games, Play, and Twentieth-Century Art*. Edited by David J. Getsy, 105–17. University Park: Pennsylvania State University Press, 2011.

REVIEWS

Bradley, Paige K. "Hannah Wilke, Alison Jaques Gallery." *Artforum*, October 1, 2014.

Cotter, Holland. "Landscape of Eros, Through the Peephole," *The New York Times*, August 27, 2009.

Crimp, Douglas. "Reviews and Previews." *Artnews* 71, October 1972, 83.

DeAk, Edit. "Hannah Wilke at Feldman." *Art in America*, May/June, 1974, 110–11.

Dick, Leslie. "Hannah Wilke." *X-Tra* 6, no. 4 (Summer 2004): 22–27.

Diehl, Carol. "Hannah Wilke, Ronald Feldman." *Artnews*, April 1994, 164.

Eckstrom, Kevin. "Wilke Exhibit Carries on UMSL's Daring Tradition." *St. Louis Post-Dispatch*, April 9, 1989.

Henry, Gerrit. "Hannah Wilke at Feldman." *Art in America*, July 1985, 139.

Hesse, Thomas B., "Private Art Where the Public Works," *New York*, October 13, 1975, 84.

Kingsley, April. "Hannah Wilke." *Artforum*, December 1972, 84.

Lippard, Lucy R. "Eros Presumptive." *The Hudson Review* 20, Spring 1967, 91–99.

———. "The Pains and Pleasures of Rebirth: European and American Women's Body Art." *Art in America*, May/June 1976, 73–81.

Paice, Kim. "Resisting, Essentially. The Case of Hannah Wilke." *Art + Text* 48 (1994): 24–25.

Pollock, Griselda. "Hannah Wilke: Elective Affinities; Alison Jacques Gallery, London." *Art Monthly*, September 10, 2010.

Richard, Paul. "Hannah Wilke." *The Washington Post*, May 19, 1979.

Roxen, Lillian. "H. Wilke Ceramic Erotica." *Comment* [Sydney, Australia], August 1966, 9.

Russell, John. "Hannah Wilke." *The New York Times*, March 24, 1978.

Savitt, Mark. "Hannah Wilke: The Pleasure Principle." *Arts Magazine*, September 1975, 56–57.

Smith, Roberta. "Hannah Wilke." *Arts Magazine*, November 1972, 72.

Watlington, Emily. "A Survey of Hannah Wilke's Work Traces Her Engagement with Bodily Vulnerability." *Art in America*, November 21, 2019.

Wooster, Ann-Sargent. "Hannah Wilke: Whose Image Is It?" *High Performance*, Fall 1990, 30–33.

Contributors

GLENN ADAMSON is a curator and writer who works at the intersection of craft, design history, and contemporary art. Currently senior scholar at the Yale Center for British Art, he has previously been director of the Museum of Arts and Design in New York; head of research at the Victoria and Albert Museum in London; and curator at the Chipstone Foundation in Milwaukee. His forthcoming book, *Craft: An American History*, will be published by Bloomsbury in 2021.

CONNIE BUTLER is chief curator at the Hammer Museum in Los Angeles, where she has overseen the exhibition program since 2013. Butler was previously the Robert Lehman Foundation Chief Curator of Drawings at the Museum of Modern Art in New York, where she co-curated exhibitions including *On Line: Drawing Through the Twentieth Century*; *Adrian Piper: A Synthesis of Intuitions*; and *Lygia Clark: The Abandonment of Art, 1948–1988*, the artist's first retrospective in the United States. From 1996 to 2006 she was curator at The Museum of Contemporary Art, Los Angeles, where she organized *WACK! Art and the Feminist Revolution*. She is the 2020 recipient of the Bard College Audrey Irmas Award for Curatorial Excellence.

HAYV KAHRAMAN is an Iraqi artist based in Los Angeles. Her figurative paintings examine the gendered and racialized body politics of migrant consciousness and are a reflection on otherness as a form of dehumanization. Her work has been exhibited at the Institute of Contemporary Art, Boston; Henry Art Gallery, Seattle; De La Warr Pavilion, East Sussex, United Kingdom; Nottingham Contemporary, United Kingdom; Benton Museum of Art at Pomona College, California; Contemporary Art Museum, St. Louis; Joslyn Art Museum, Omaha; Rubell Museum, Miami; Cantor Arts Center at Stanford University, California; and the Sharjah Biennial, United Arab Emirates.

Art critic, historian, and feminist CINDY NEMSER (1937–2021) was renowned for her long-standing commitment to women in the arts. A graduate of Brooklyn College and the Institute of Fine Arts, New York University, she wrote prolifically for journals and publications. From 1972 to 1977 she published and edited the *Feminist Art Journal*, a magazine that focused on women in the arts, and curated the exhibition *In Her Own Image* for Fleisher Art Memorial Gallery, Philadelphia, in 1974. Her *Art Talk: Conversations with 12 Women Artists* (1975), the first book about women artists since the 1930s, is considered a classic; expanded in 1995, it has been translated into numerous languages.

NADIA MYRE is an artist whose interdisciplinary practice speaks to identity, resilience, and the politics of belonging. She is a distinguished recipient of the Ordre des arts et des lettres du Québec, Banff Centre's Walter Phillips Gallery Indigenous Commission Award, Sobey Art Award, and the Eiteljorg Contemporary Art Fellowship. Her works are on permanent exhibition at the Montreal Museum of Fine Arts, Art Gallery of Ontario, National Gallery of Canada, and Canada's embassies in Paris, London, and Athens. A member of the Kitigan Zibi Anishinabeg First Nation, Myre holds a Canada Research Chair in Indigenous Arts Practice at Concordia University.

JEANINE OLESON is an artist who makes interrelated and humorous objects, images, videos, and performances. Her work was recently exhibited at the Cubitt Gallery in London, the Hammer Museum in Los Angeles, Commonwealth and Council in Los Angeles, SculptureCenter in New York, the Coreana Museum of Art in Seoul, Atlanta Contemporary, and the New Museum in New York. A book on her work, *Conduct Matters*, was published by Dancing Foxes Press in 2020. She lives in Brooklyn, New York, and teaches at Rutgers University.

CATHERINE OPIE is one of the preeminent artists of her generation working with photography. She holds a BFA degree from the San Francisco Art Institute and is an MFA graduate from California Institute of the Arts. Opie is the recipient of numerous awards, including the Guggenheim Fellowship, the Smithsonian's Archives of American Art Medal, and a United States Artists Fellowship. She holds the Lynda and Stewart Resnick Endowed Chair in Art at The University of California, Los Angeles, where she is a professor of photography.

TAMARA H. SCHENKENBERG is the curator at the Pulitzer Arts Foundation in St. Louis. Since joining the Pulitzer in 2012, she has organized a wide range of exhibitions, including *Medardo Rosso: Experiments in Light and Form* (co-curated); *Ruth Asawa: Life's Work*; *Zarina: Atlas of Her World*; and *Mona Hatoum: Terra Infirma* (in-house curator). Her primary focus is on modern and contemporary art, with research interests in identity and displacement, as well as feminist practices. A native of Bosnia and Herzegovina, Schenkenberg was a Fulbright scholar at the Free University of Berlin (2010–11) and holds a PhD in art history from the University of Wisconsin-Madison.

245

Photo Credits

Lenders

Cincinnati Art Museum
Shezad and Miranda Dawood
Electronic Arts Intermix, New York
Gail and Tony Ganz, Los Angeles
Donald and Helen Goddard, courtesy Ronald Feldman Gallery,
 New York
Marguerite Steed Hoffman
Alison Jacques, London
The Jewish Museum, New York
Edward Lee
Los Angeles County Museum of Art
Larry and Susan Marx, Aspen
Heidi and Erik Murkoff
The Museum of Modern Art, New York
Private collection, London, courtesy Alison Jacques
Private collection, courtesy Ronald Feldman Gallery, New York
Private collection, courtesy Acquavella Galleries
Marsie Scharlatt
Marsie, Emanuelle, Damon, and Andrew Scharlatt, Hannah Wilke
Collection & Archive, Los Angeles
Tate
Tom and Alice Tisch
Teresa Tsai
Walker Art Center
Olivia Walton
Michael and Sharon Young

Board of Directors

This book is published on the occasion of the exhibition *Hannah Wilke: Art for Life's Sake* Organized by Tamara H. Schenkenberg, Curator, with Katherine B. Harnish, Curatorial Assistant, Pulitzer Arts Foundation

Pulitzer Arts Foundation
June 4, 2021–January 16, 2022

Published by
Pulitzer Arts Foundation
3716 Washington Boulevard
St. Louis, MO 63108
pulitzerarts.org

Published in association with
Princeton University Press
Princeton and Oxford

41 William Street
Princeton, NJ 08540
USA

6 Oxford Street
Woodstock, Oxfordshire
OX20 1TR
UK

press.princeton.edu

Produced by
Lucia | Marquand, Seattle
luciamarquand.com

Editors: Donna Wingate and Marc Joseph Berg
Publication Coordinator: Brittny Koskela
Proofreader: Jane Hyun
Designer: Jayme Yen
Indexer: Enid Zafran
Color management: iocolor, Seattle
Printed and bound in Turkey by Ofset Yapimevi

Library of Congress Cataloging-in-Publication Data

Names: Schenkenberg, Tamara H., editor. | Wingate, Donna, editor. | Nemser, Cindy, interviewer. | Pulitzer Arts Foundation, organizer, host institution.
Title: Hannah Wilke : art for life's sake / edited by Tamara H. Schenkenberg and Donna Wingate ; texts by Glenn Adamson, Connie Butler, Hayv Kahraman, Nadia Myre, Cindy Nemser, Jeanine Oleson, Catherine Opie, and Tamara H. Schenkenberg.
Description: St. Louis, MO : Pulitzer Arts Foundation ; Princeton : in association with Princeton University Press, [2021] | Includes bibliographical references and index.
Identifiers: LCCN 2021013218 | ISBN 9780691220376 (hardcover)
Subjects: LCSH: Wilke, Hannah—Exhibitions.
Classification: LCC N6537.W48 A4 2021 | DDC 709.2—dc23
LC record available at https://lccn.loc.gov /2021013218

British Library Cataloging-in-Publication Data is available

Front cover: Hannah Wilke
Untitled, ca. 1970
Latex, plywood, and metal push pins
20⁷⁄₈ × 17³⁄₄ × 4³⁄₄ inches (53 × 45.1 × 12 cm)
Collection of Alison Jacques, London
Photo by Michael Brzezinski, courtesy Alison Jacques

Page 4: Photograph by Fred W. McDarrah, via Getty Images

All unidentified installation views are from the exhibition *Hannah Wilke: Art for Life's Sake*, Pulitzer Arts Foundation, St. Louis
June 4, 2021–January 16, 2022
Photos by Alise O'Brien
© 2021 Pulitzer Arts Foundation

10 9 8 7 6 5 4 3 2 1